RED SCARED!

RED SCARE

THE COMMIE MENACE IN

RED!

PROPAGANDA AND POPULAR CULTURE

BY MICHAEL BARSON
AND STEVEN HELLER

CHRONICLE BOOKS
SAN FRANCISCO

ACKNOWLEDGMENTS

We want to thank the following persons for their aiding and abetting the cause: James Fraser, Fairleigh Dickenson University; Rich West, Periodyssey Books; Stefan Kanfer; Eric Rachlis of Archive Photos; and, of course, the fabulous gang at Funny Garbage—Peter Girardi, Helene Silverman, and Hope Moore —who wrangled this book into utter submission.

Copyright © 2001 by Michael Barson and Steven Heller.

All rights reserved. No part of this book may be reproduced in any form without written permission from the publisher.

Library of Congress Cataloging-in-Publication-Data:

Barson, Michael.
 Red Scared! : The commie menace in propaganda and popular culture / by Michael Barson and Steven Heller.
 p.cm.
 Includes bibliographical references.
 ISBN 0-8118-2887-5
1. Anti-Communist movements—United States—History. 2. Cold War—Social aspects—United States. 3. Internal security—United States—History—20th century. 4. Communism—History. I. Heller, Steven. II. Title.

E743.5 .B3 2000
973.9—dc21

Printed in Hong Kong

Designed by Helene Silverman / Funny Garbage

Distributed in Canada by Raincoast Books
9050 Shaughnessy Street
Vancouver, BC V6P 6E5

10 9 8 7 6 5 4 3 2 1

Chronicle Books LLC
85 Second Street
San Francisco, California 94105

www.chroniclebooks.com

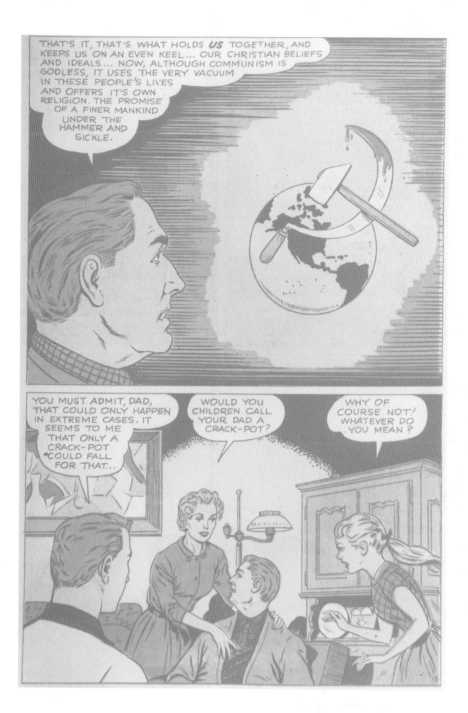

DEDICATED TO RALPH SHIKES,
AUTHOR AND PUBLISHER,
WHO GAVE WORK TO VICTIMS
OF THE BLACKLIST
WHEN OTHERS
HAD FORSAKEN THEM.

PREFACE

COLD WAR STYLE 8

TIMELINE: 1848 – 1927

1 THE FIRST RED SCARE 16

TIMELINE: 1928 – 1944

2 BETWEEN RED SCARES 24

The Hitler-Stalin Pact Foments a New Red Scare 32

The Soviet Pavilion at the New York World's Fair 35

Hollywood Kids the Commissars 36

TIMELINE: 1944 – 1947

3 JUST A GUY NAMED IVAN 42

Comrades in Arms: Hollywood Warms up to Russia 47

TIMELINE: 1947 – 1950

4 THE IRON CURTAIN DESCENDS 60

Could the Reds Seize Detroit? 62

How to Identify an American Communist 64

The Cold War Hits the Silver Screen 74

How Hollywood Told the Tale of the Cold War 78

TIMELINE: 1950 – 1953
"I'M NO COMMUNIST" 90
HUAC's So-Called Communist Front Organizations
to Which Dashiell Hammett Was Linked 93
The Love Song of J. Edgar Hoover 95
"I Led Three Lives," Maybe More 102
Mickey Spillane's *One Lonely Night* 105
Television and the Red Menace 106
INSERT: McCarthy 108
INSERT: Reds, By Gum! 110

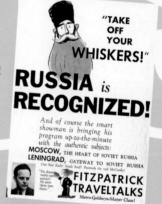

TIMELINE: 1953 – 1957
"WE WILL BURY YOU!" 114
Sputnik and the Space Race 120
Red Star Over Cuba 124
INSERT: Spy vs. Spy 126
Beyond Stalin 128
INSERT: Bomb Shelter Chic 134

TIMELINE: 1957 – 1962
PAMPHLETS ON PARADE 138
INSERT: Red Readings 152

TIMELINE: 1963 – 2000
KREMLIN KOMICS 156
"Communist Kisses!" 159

BIBLIOGRAPHY 160

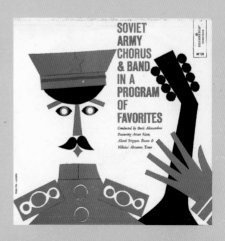

COLD WAR STYLE

PREFACE

"A RED IS ANY SON OF A BITCH THAT WANTS THIRTY CENTS WHEN WE'RE PAYING TWENTY-FIVE."
— JOHN STEINBECK, THE GRAPES OF WRATH

With the Cold War already ten years over, anti-Communist propaganda from the Forties and Fifties now seems as quaint as patent medicine ads from the last century. The stereotypes are often so ludicrous that it's hard to believe we ever gave them much credence. Yet postwar rhetoric about Godless Communism infused all media and invaded Americans' everyday lives for decades on end. Just the word "communism" was provocative enough to inspire a host of irrational laws and decrees. People truly believed that Reds were under the bed—not to mention in the water supply, creeping through the halls of government, and even spying from space. The power of anti-Communist propaganda was so effective (and, perhaps, so seductive) that Americans shamefully relinquished basic rights and liberties so that the government could persecute its opponents. Talk about un-American!

While RED SCARED! is not an apology for the real Soviet menace, which (with the cooperation of the U.S., it must be admitted) did threaten the world with atomic conflagration, it does provide at least a partial explanation of how and why anti-Communist propaganda was so virulent. Propaganda is based on the creation of recognizable stereotypes that oversimplify complex issues for the purpose of controlling mass opinion. Our government encouraged Red-baiting and witch-hunting (much as the Nazis did anti-Semitism) through the mass media of the day. It was the longest continuous American propaganda campaign of its kind.

Years before our wartime alliance with Russia began, Americans were conditioned by politicians, businessmen, clergy, and the press to fear Communists. Editorial cartoons portrayed them as bomb-throwing thugs. In fact, *The New York Times* showed more respect for Mussolini than for Lenin or Stalin because Il Duce promised a social revolution that was more palatable to ruling class Americans than the Soviet model.

Red Channels

The Report of
COMMUNIST INFLUENCE IN RADIO AND TELEVISION

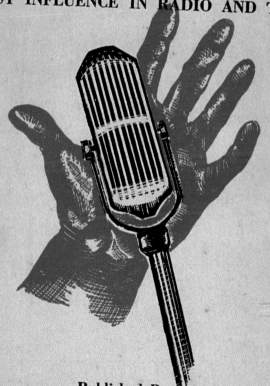

Published By
COUNTERATTACK
THE NEWSLETTER OF FACTS TO COMBAT COMMUNISM
55 West 42 Street, New York 18, N. Y.

$1.00 per copy

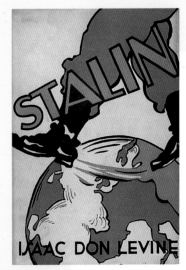

ISAAC DON LEVINE

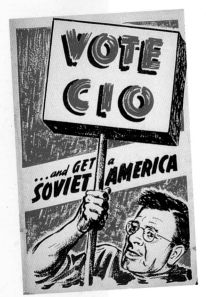

VOTE CIO
...and GET a SOVIET AMERICA

After the Russian Revolution, communism was the dread of America's business and industrial leaders, who feared labor unrest owing to their own exploitative practices. These same leaders forged secret alliances with racists, jingoists, and other America-first fanatics in spreading anti-Communist propaganda throughout the nation. In turn, they succeeded in convincing a mass of Americans that their lives were threatened by Communists who were nestled among the immigrants entering the United States.

Theodore Roosevelt once trumpeted, "Keep up the fight for Americanism," pointing his finger at those who preferred systems other than our own. Huey Long, the populist governor of Louisiana, announced that if fascism came to America it would be on a program of Americanism. Years before the American Communist Party was founded, the word "communism" was synonymous with un-Americanism. Publications proffering Bohemian or radical points of view, such as *The Masses*, were hounded by the authorities who foolishly believed that these relatively small circulation journals could alter American public opinion. The diehard anti-Communists may well have been alarmed by the rapidity of social change and invented the threat of insurrection in America as a red herring to dupe people into believing that escalating labor problems were part of a foreign plot to foment a coup d'etat. But America was rich and powerful, impervious to revolution, and as Carl Marzani wrote in *A Quarter Century of Unamericana*, "the opponents of organized labor saw communism as a convenient smokescreen to obliterate trade unionism."

After the 1917 Russian Revolution, the worst nightmare of American anti-Communists was realized when Bolshevism became totally entrenched in Russian life; to add to their fears, in 1919 the American Communist Party was founded in Chicago. Refusing to recognize Lenin's government, President Wilson committed arms and troops to the war against Bolshevism abroad and increased the level of anti-Communist propaganda at home, or at least created a milieu in which it was encouraged. By 1923, communism had indeed become a force to be reckoned with, but the myth that a monolithic Communist vanguard was infiltrating America was still unfounded. America's misperception was based on the tenet that Marxism/Leninism promised—indeed, insisted upon—the eventual demise of capitalism.

During the Great Depression, communism gained a foothold among American working and intellectual classes who opposed the policies of President Hoover (and Treasury Secretary Mellon) that had plunged the nation into economic disaster. Of course, the Nazis

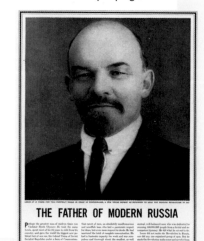

THE FATHER OF MODERN RUSSIA

smashed labor unions and undermined demo-
cratic reforms while the New Deal strength-
ened them. But owing to the New Deal's nod
to socialism, acrimony between diehard anti-
Communists and New Dealers continued
throughout Franklin Roosevelt's presidency.
FDR's congressional opponents spent much
of their time proposing bills that would limit
immigration, free speech, and free assembly for
suspected Communists, and deport foreign-
born Communists in the bargain. Congress
often flirted with the idea of legally prohibiting
the Communist Party.

The war against Germany and the
wartime alliance with the Soviet Union tem-
porarily changed the dominant stereotypes.
Official government posters and commercial
advertising portrayed the Big Three Allies
marching towards victory. Hollywood films, such as *Mission to
Moscow, The North Star,* and *Song of Russia* sanitized Stalin's
dictatorship. In fact, *Mission to Moscow* was characterized by James
Agee in *The Nation* as "almost describable as the first Soviet produc-
tion to come from a major American studio." After the war these films
would be investigated by the House Un-American Activities
Committee (HUAC) as evidence of Communist infiltration in the film
industry. Also after the war, the USSR was demonized once again.

By 1948 anti-Communist militancy had swept the country.
Joseph C. Goulden notes that "the American Legion, such news-
paper chains as Hearst and Scripps-Howard, and any number of ad
hoc business and 'patriotic' organizations were providing investigators
with information on the Communist conspiracy."
They were also contributing to the ever-expanding
volume of anti-Communist literature. Sadly, the
media was not always in the forefront of free expres-
sion. Many publishing houses gave ultimatums to their
employees who were called to testify before the
Committee: cooperate or be fired. Others would not
publish or buy work by suspected Reds. Media
executives supported the blacklist by subscribing to
publications like *Red Channels,* a regularly updated
list of known or suspected Communists.

The American Legion was also behind attacks
on Reds, including a major assault on comic books
during the mid-Fifties. Typical of the mail in one
Legionnaire newsletter is this: "We parents and the

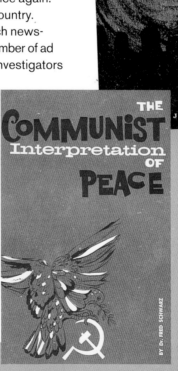

Tickets Now on Sale for the

**National Nominating
Convention**

**COMMUNIST
PARTY**
of the United States of America

Public Session

SUNDAY, JUNE 2, at 2 P. M.

Madison Square Garden

•

ALL SEATS RESERVED

ADMISSION 40c, 55c, 83c, and $1.10

TICKETS At: Workers Bookshop, 50 East 13th St.; Bronx Coop-
erative Houses Renting Office, 2800 Bronx Park East; State
Office, Communist Party, 35 East 12th St.

communist
america . . .

must it be?

James Hargis

THE
COMMUNIST
Interpretation
OF
PEACE

BY Dr. FRED SCHWARZ

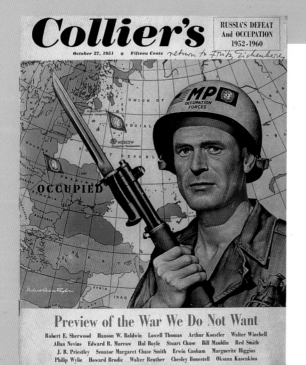

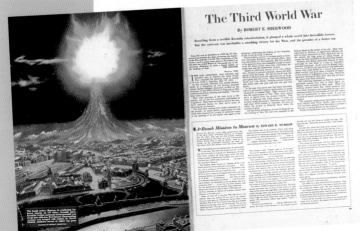

teachers and the principals do not like the horrors created by the comics. Are the Commies behind these books which appear in print by the thousands?" As a result of this forced hysteria, the self-regulating Comics Code was instituted by the comics industry not only to prohibit horror and violence, but to uphold American values. Nevertheless, violence was the prescribed cure for communism in comics sanctioned by the Code.

The comic book was a popular medium for anti-Communist groups. Typical of these was one published by the Houston-based Christian Anti-Communism Crusade, whose *Two Faces of Communism* was mailed free of charge to anyone sending in a self-addressed, stamped envelope. The premise was predictable: Youth of America are oblivious to the Communist menace, but after thirty-six pages they are convinced by their elders to see things the way they really are, and to help others see the light by starting a Teens for America group. "Everyone of us personally is needed in this battle, if we expect to survive," says an elder. "I received an excellent free pamphlet today, entitled 'What Can I Do?' from the crusade. Let's look it over together and get into action." Another comic, published by the Minneapolis–based Catechetical Guild Education Society, titled *Is This Tomorrow,* offers a cautionary "this *can* happen here" scenario, very much like late–Cold War absurdities such as the 1985 movie *Red Dawn* and the 1988 ABC-TV mini-series *Amerika,* both about an America overrun by the Russians. This kind of myth was also perpetuated through the pulp magazines, which sometimes offered a prurient mix of evil Reds and imperiled babes. Actually, many of the stories in *Man's, All Male, Men's Stories,* and *Siren* were originally about Nazis; only the uniforms were changed.

Communism could be blamed for a multitude of sins, and reality fed into Americans' escalating fears. Spies *were* employed by Moscow to pilfer military and business secrets, but of course spies were also employed by the U.S. to gather itsown intelligence. The Soviets obtained A-bomb and H-bomb secrets through their spy network, and so vigilance was cautioned as a practical matter. The Soviets were indeed menacing as evidenced

by the blockade of Berlin and other Cold War maneuvers, but on the homefront this aggressive behavior was exaggerated when related to American Communist activity. The American press, particularly *Time* magazine—which in the early Sixties coined the term *peacenik* to suggest that anti-nuclear and pro-peace advocates were somehow tied to Moscow—perpetuated the stereotype of the Red tyrant on their covers (iron-ically, many of those covers were painted by Russian émigré Boris Artzybasheff). Other national magazines overtly and covertly kept the fear of Russia percolating. A special issue of Colliers from 1951 vividly imag-ines the hypothetical "War We Did Not Want," in which American troops under the flag of the United Nations (Korea redux) fight and win a tactical nuclear war against the USSR. Unfortunately, Moscow, Washington, and Philadephia were radi-ated in the bargain, but it was a small price for victory.

Fear of spies, threats of a Communist takeover, and paranoia about nuclear war were exploited as reality as well as fantasy and offered in large doses in print and on film, often as entertainment but with psycho-logically devastating results for the audience. If an older generation might have been skeptical, the barrage of nuclear metaphors definitely influenced the younger one for decades to come.

The legacy of Red-baiting is unsavory at best. Although the most vile period of Red-baiting in the United States reached its nadir in the mid- to late Fifties, it remained a foolproof tactic for waging war at home and abroad, until the "Evil Empire" finally hit the mat. Justice William O. Douglas warned in 1952 that the "restric-tion of free thought and free speech is the most dangerous of all subversions. It is the one un-American act that could most easily defeat us."

It almost did.

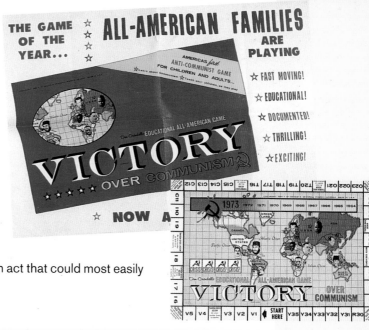

TIMELINE:

1848: Karl Marx and Frederic Engels write their historic *Manifesto of the Communist Party,* which makes the boast, "A specter is haunting Europe, and that specter is Communism." **1879:** Josef Stalin, christened Iosif Vissarionovich Dzhugashvili, is born in the Georgian village of Gori. In 1912, Lenin gives him the name "Stalin"—literally, "man of steel"—and he makes it his own from that day on. **DECEMBER 26, 1893:** Mao Zedong is born in the farm village of Shaosan, not far from Changsha, the capital city of Hunan province. **1903:** Lenin leads split from the Russian Social Democrat Labor Party, founded five years earlier, to form the Bolshevik Party. **JANUARY 9, 1905:** "Bloody Sunday" explodes. The Imperial Guard of the absent Czar Nicholas II, at the direction of the grand duke, opens fire on a crowd of several thousand unarmed laborers marching on the Winter Palace in St. Petersburg to protest mistreatment; fifteen hundred demonstrators are wounded or killed. **1905:** Eugene V. Debs, who in 1900 and 1904 was the Socialist Party candidate for the presidency of the United States, founds the Industrial Workers of the World (IWW), soon to be known in popular parlance as "the Wobblies." **NOVEMBER 7, 1917:** The October Revolution, so-called because the Russian calendar was employed, marks the Bolsheviks' seizure of power, with forces that numbered no more than 250,000. Immediately, the fifteen-member Politburo is formed; Josef Stalin, one of its founding members and an experienced revolutionary activist, is given the post of People's Commissar of Nationalities. **1917:** Lenin's *State and Revolution is published* **1917:** Congress passes the Espionage Act, making it illegal to mail literature "advocating or urging treason, insurrection, or forcible resistance" to the laws of the United States. **APRIL 1918:** Lenin forms the Revolutionary Military Council. **JULY 6, 1918:** The Romanov royal family—the czar, the empress, and their children—are shot to death by the Bolshevists. Their bodies are buried in a remote forest, where their graves are rediscovered in 1992. **1918:** Congress passes the Sedition Act, which forbids anything "disloyal, profane, scurrilous, or abusive" being either spoken or written about the U.S. government or the Constitution. **SEPTEMBER 1918:** Eugene V. Debs is tried in Cleveland and found guilty of having violated the Espionage Act. While being sentenced to two concurrent ten-year sentences, Debs makes his famous remark: "While there is a lower class, I am in it; while there is a criminal element, I am of it; while there is a soul in prison, I am not free." He served his time in an Atlanta penitentiary, with President Wilson resisting advice from many quarters (including, of all people, Attorney General A. Mitchell Palmer), to grant him clemency. **MARCH 1919:** The Comintern, the Third Communist International, is established by Lenin. Its mandate: to coordinate all Communist activity the world over via decree from Moscow. **APRIL 30, 1919:** A postal clerk in New York discovers twenty packages addressed to a variety of government officials. Each contains a bomb that is set to explode the next day—May Day. The attack

1848-1927

launches America's first Red Scare. **AUGUST 1919:** The Justice Department creates the General Intelligence Division. Its first director is a young graduate of George Washington University Law School, J. Edgar Hoover. **AUGUST 1919:** Attorney General A. Mitchell Palmer asks Immigration to deport black activist Marcus Garvey. It doesn't happen then, but after his arrest in January 1922 on charges of mail fraud, Garvey goes to prison. When his sentence is commuted late in 1927, he is deported back to his native Jamaica. **1919:** John Reed's books *Red Russia* and *Ten Days That Shook the World,* based on his experiences witnessing the 1917 Revolution firsthand, are published. Back in the U.S., Reed is expelled from the Socialist Party, so he and Benjamin Gitlow form the Communist Labor Party, which for a few years competes with the Russian-led Communist Party of America. Later in 1919, Reed returns to Russia, where the newly formed Comintern gives him funds and detailed instructions on how to spend them to further the growth of the Communist movement in America. But jailed in Finland while trying to gain passage back to the U.S., Reed falls into ill health. He dies in Moscow in 1920, and Lenin sees to it that he is buried within the walls of the Kremlin—the only American ever to be so honored. **JANUARY 10, 1920:** The League of Nations is formed. It is dissolved on the same date in 1946, shortly after the founding of the United Nations. **SEPTEMBER 16, 1920:** A bomb explodes on Wall Street, killing thirty bystanders and injuring scores of others. Anarchists are blamed, probably correctly. **1920:** The Red Army, led by Georgi Zhukov, defeats the White Army of the Cossacks and other counter-Revolutionaries to end Russia's civil war. **NOVEMBER 1920:** The first Chinese Communist Manifesto is published in Shanghai. **MAY 1921:** The Communist Party of America (CPA) and the Communist Labor Party (CLP), cofounded by John Reed, merge into the American Communist Party (ACP) at a convention held in Woodstock, New York. **DECEMBER 24, 1921:** Newly elected President Warren G. Harding orders the release of Eugene V. Debs from prison. While imprisoned, Debs had run as the Socialist Party candidate for president in the 1920 elections, boldly stating, "I consider [the Russian Revolution] the greatest single achievement in all history. I am still a Bolshevik. I am fighting for the same thing here they are fighting for there." **APRIL 3, 1922:** Stalin is elected general secretary to the Central Committee, the most important post in the Party. **DECEMBER 1922:** The USSR is officially formed. **JANUARY 21, 1924:** Lenin dies and is succeeded by Josef Stalin. **JANUARY 1925:** Leon Trotsky is removed from his position as commissar for the army and navy and chairman of the military council. **OCTOBER 1925:** The National Negro Labor Congress is organized by the Communist Party. **AUGUST 23, 1927:** Anarchists Nicola Sacco and Bartolomeo Vanzetti, convicted of robbery and murder in 1921, are electrocuted. Their trial and eventual execution become rallying points for American progressives.

THE FIRST RED SCARE

TWO YEARS THAT SHOOK THE U.S.A.

he Russian Revolution of November 7, 1917, may have been greeted with delight by members of the American Left, as most recently dramatized in Warren Beatty's 1981 film Reds, *but for most Americans, that historic moment was of far less import than World War I, which we were then in the thick of. But as the postwar era dawned, a series of bitter conflicts involving the Industrial Workers of the World (the IWW, aka the Wobblies), other arms of the labor movement (such as the Boston police strike) and radical socialists (including the Socialist May Day Parade riot of 1919 in Cleveland) began to set the teeth of many Americans on edge.*

Then, one night early in June of 1919, newly appointed U.S. Attorney General A. Mitchell Palmer had his sleep interrupted by the sound of a bomb exploding on his front doorstep. Across the street, Assistant Secretary of the Navy Franklin Delano Roosevelt heard the blast and rushed to Palmer's aid—stepping over pieces of the unfortunate bomber, who apparently had tripped and blown himself up, thus becoming the sole casualty of the evening. Several weeks earlier, bombs had exploded at the homes of several lawmakers, most of whom had, in some way, taken a public stand against Bolshevism and immigrant anarchists. Sent through the U.S. Mail, several of these brown-paper–wrapped bombs ended up on their target's doorstep, including the Atlanta home of Georgia's Senator Hardwick, chairman of the Senate's Immigration Committee; some of the parcels, like the one addressed to John D. Rockefeller, were discovered before being delivered. After the Palmer incident, *The New York Times* reported that the attack was "plainly of Bolshevik or IWW origin." The first Red Scare had begun to sweep the country.

Palmer, who had earned the epithet "the Fighting Quaker," wanted to create special task forces to investigate and prosecute the anarchists who were now holding America in the grip of terror (when they weren't busy blowing themselves to

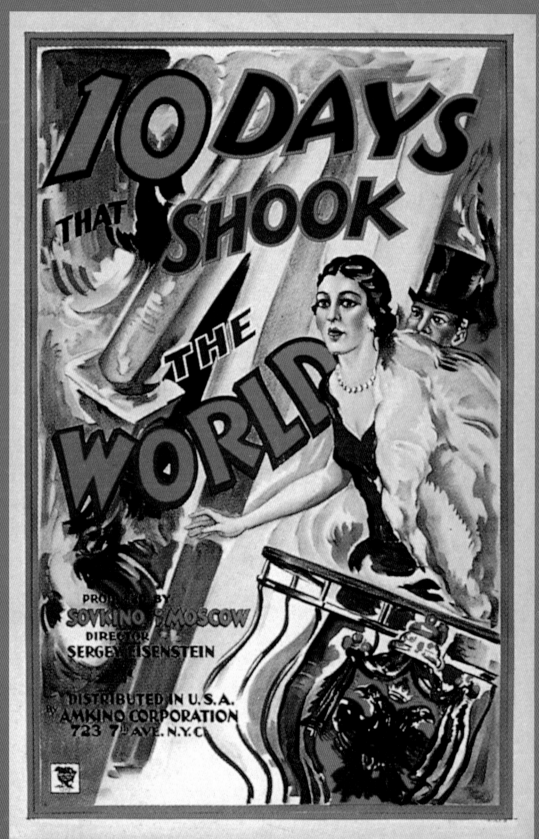

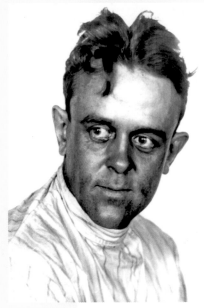

JOHN REED
(ARCHIVE PHOTOS)

smithereens). He begged Congress to increase funding for the Department of Justice to meet this sudden crisis, but was turned down. Undaunted, Palmer and his chief assistant, Francis Garvan, went before the Senate and convinced that body that the wave of bombings was part of a well-organized conspiracy to overthrow the U.S. government, and that a mass revolution was being readied for the Fourth of July. Alarmed, the Senate gave Palmer the extra $500,000 he wanted. Apparently, the senators hadn't read the recent issue of the *New York World* that argued there was "no Bolshevist menace in the United States and no IWW menace that an ordinarily capable police force is not competent to deal with."

Now properly funded, Palmer and his lieutenants decided that the best method of squelching the new menace was to implement a mass roundup of "alien radicals," who could then be deported in short order. (Of course, the

Immigration Department was the only agency legally authorized to deport undesirables and there was no actual law on the books that prohibited membership in the IWW, the Communist Party, or, for that matter, Anarchists Anonymous.) The $500,000 appropriation was put to work establishing a new agency within Justice, the function of which would be to gather information about radicals from local police, the military, the Bureau of Investigation, and John Q. Citizen. To head the new Anti-Radical Division, as it was first called, Garvan selected an up-and-comer from Justice who already had a little experience working with the Enemy Alien Registration agency. He was only twenty-four years old, but John Edgar Hoover appeared to possess true grit and dogged determination.

A former librarian, Hoover immediately began collating membership lists of subversive organizations, like the IWW, with names supplied by local Red squads and private detective agencies. In no time he had assembled over 150,000 names to work with, including

the 60,000-plus combined membership of the two branches of the American Communist movement, the Communist Labor Party and the Communist Party of America—bitter rivals who had gone their separate ways after an intramural dispute at the Socialist Party convention in Chicago in 1919. Studying the works of Marx and Lenin to better know the mind of this enemy, Hoover soon came to the modest conclusion that communism was "the most evil, monstrous conspiracy against man since time began."

With the agency renamed the General Intelligence Division (GID), Palmer and Hoover worked hand-in-hand to coordinate a raid on a national scale of the Federation of the Union of Russian Workers (FURW), an organization comprised of Russian immigrants. On the second anniversary of the Russian Revolution, November 7, 1919, at 8:00 P.M. sharp, agents of the GID and the Bureau of Investigation, along with the local police force, swooped down on the Russian People's Houses in twelve cities. This test raid, which netted 184 hapless FURW members, worked smoothly and got the fledgling GID acres of publicity. The "blasphemous creatures," as they were deemed by *The New York Times,* were deported to Russia, via Finland, on a ramshackle ship named the *Buford.* Joining the bewildered and bruised members of FURW on the voyage were a handful of actual anarchists, the most notorious of them being Emma Goldman— "The Red Queen of Anarchy"—who supposedly had helped plan the assassination of President McKinley back in 1901. (Her speeches and pamphlets in favor of free love may have been even more noxious to the GID than her brazenly radical politics.)

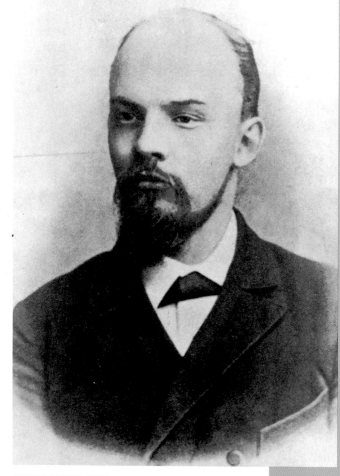

LENIN, CIRCA 1905
(ARCHIVE PHOTOS)

Palmer and Hoover now invoked the wartime Sedition Act, which under emergency conditions had empowered the secretary of labor to deport any aliens who were proven to be anarchists, or who advocated the violent overthrow of the U.S. government. Moving ahead with their plans for a second, all-inclusive series of raids, Palmer and Hoover conveniently ignored the fact that neither of them carried the

title of secretary of labor, and that the war was now over. Three thousand warrants of arrest were prepared for the mass roundup of alien radicals in thirty-three cities. On the night of January 2, 1920, more than six thousand suspects were arrested around the country—many without the benefit of a warrant, few advised of their right to counsel. In Hartford, anyone who came to visit one of the arrestees was also thrown into a cell; in Detroit, a hundred men were shoehorned into a mass cell for a week under conditions that even the mayor publicly deplored.

Thousands of the bewildered arrestees were released within a few days, once it had been determined they weren't Party members. But the unlucky ones who

remained soon learned they were being held for deportation to Russia in a series of "Soviet Arks." The motto of many now was "S.O.S.–Ship or Shoot." And, in the end, 246 men and three women were shipped (rather than shot) back to Russia.

Super-patriotic organizations now came to the fore. The American Defense Society, the National Security League, the National Civic Federation and the Allied Patriotic Societies, among others, evaluated organizations that had at least a whiff of left-leaning (including the Russian Famine Fund and the National League of Women Voters), and judged books (*Main Street*) and periodicals (like *The New Republic* and *The Nation*). Even movie stars (the names of Norma Talmadge and Charlie Chaplin came up more than once) were examined for signs of creeping Bolshevism. Teachers and professors who espoused some form of radical philosophy were asked to leave their place of employ. Henry Ford warned of the menace of "the International Jew." And Socialists– "the little Lenins and little Trotskys in our midst"—were no longer welcome to hold the seats in the New York State Assembly to which they had been elected. One film that dramatized these sentiments was the 1920 opus made by the Ince/Paramount studio, *Dangerous Hours,* in which bomb-tossing Bolsheviks foment revolution as they give incendiary speeches in American mills and shipyards, picking up converts along the way.

The day belonged to Palmer and Hoover. But what appeared to be an outright triumph soon turned to ashes in their mouths. Details of the illegal arrests became known to outraged lawmakers across the U.S., and the outcry was so loud that, on June 1, 1920, Palmer was hauled before the House Rules Committee to defend the actions of the GID and the Department of Justice in the Red raids. With Hoover at his side, Palmer described the arrestees as "moral rats" whose "sly and crafty eyes" revealed "cruelty, insanity, and crime," and whose "lopsided faces, sloping brows and misshapen features" clearly indicated congenital thuggery of the Communist persuasion. He went on to deny that anyone's rights had been abrogated, or that force or violence had been used during or after the arrests. (That must have come as news to the hundreds of aliens whose heads had been used for batting practice by the overly enthusiastic constables, as depicted in photographs in the next day's *New York Times.*)

Palmer escaped formal chastisement by the Rules Committee, though it is doubtful they believed much of the 209-page statement he read into the record. Then "the Great Red Hunter," who longed for the Democratic Party's nomination for the presidency, was further humiliated by having to again defend himself early in 1921, this time before the Senate Judiciary Committee. His political hopes now dashed, Palmer began updating his resume in November, when Republican Warren G. Harding was elected president.

While the first Red Scare had now subsided, a pattern had been set that would be repeated many times in the years to come. J. Edgar Hoover, who would assume the directorship of the Bureau of Investigation in 1924 (the same year Stalin rose to power in Russia . . . good grief!) would spend the rest of his long tumultuous career bashing Reds at every opportunity, be they veterans of the Spanish Civil War, well-meaning fellow travelers, "moral rats," Supreme Court justices, or just big-mouthed liberals.

THE GREAT

STALIN FIVE-YEAR PLAN

FOR THE RESTORATION AND DEVELOPMENT OF THE
NATIONAL ECONOMY OF THE USSR FOR 1946-1950

TIMELINE:

1928: Trotsky is expelled from the Party and sent into exile in Central Asia. **1928:** Stalin implements the USSR's First Five Year Plan, one element of which requires the *kulaks*—wealthy peasant farmers in the hinterlands—to surrender their entire yield of crops for the consumption of the city dwellers. When they resist this notion, the Red Army seals off the borders of the Ukraine and begins deporting the *kulaks* to prisons and labor camps in Siberia. Between 13 and 14 million deaths over the next ten years are the result. **1929:** The ACP becomes the Communist Party of America (CPUSA). **JUNE 1930:** The first version of the House Un-American Activities Committee is assembled to combat the threat of communism on U.S. shores. Its first hearings are under the stewardship of Chairman Hamilton (Ham) Fish of New York, who promises, "We propose to deport all alien Communists." **JANUARY 1931:** The Fish Committee hearings conclude with thirteen recommendations, among them that the Communist Party be outlawed, and that an embargo be placed on all items being imported from Russia. **SEPTEMBER 1931:** Hollywood director Cecil B. DeMille visits the director of the Society for Cultural Relations, Comrade Petrov, in Moscow. **1932:** William Z. Foster, then Chairman of the Communist Party in the United States, publishes his book, *Toward a Soviet America*. **NOVEMBER 8, 1932:** Stalin's second wife, Nadezhda Alliluieva, commits suicide. **1933:** Newly elected President Franklin Delano Roosevelt recognizes the Soviet government for the first time. That same year, some 4.2 million Ukrainian peasants die of starvation and disease, victims of Stalin's collectivization plan, which prevented them from planting crops, importing food, or leaving their barren farms. **SEPTEMBER 18, 1934:** The Soviet Union joins the League of Nations. **1935:** Clifford Odets's comradely drama, *Waiting for Lefty,* is staged. **1936–1938:** At the height of Stalin's Great Terror, almost 700,000 Russians are executed by the NKVD (later KGB) death squads, headed by recent appointee Lavrenti Beria. Tens of thousands of the country's highest ranking military veterans, most of them officers, are purged along with their families and even their friends. **AUGUST 12, 1938:** The Martin Dies era of the House Un-American Activities Committee (HUAC) commences, as the Texas congressman spearheads a wide-ranging investigation into Communist infiltration of the C.I.O. and other branches of American Labor. "This Committee will not permit any 'character assassination' or any 'smearing' of innocent people," Dies solemnly promises. At the same time, top lieutenant J. Parnell Thomas (R-New Jersey) demands a full-scale investigation into the W.P.A.'s Federal Theatre and Writers Project, which he describes as "a hotbed for Communists [and] radicals." **JANUARY 3, 1939:** The Dies Committee on Un-American Activities (aka HUAC) submits a Report to Congress that identifies the American Youth Congress as including "over a dozen" Communist front organizations.

1928-1944

AUGUST 24, 1939: Stalin and Hitler agree to the Soviet-German nonaggression pact, signed in Moscow by top lieutenants Molotov and von Ribbentrop. This allows Hitler to invade Poland a week later, effectively igniting the Second World War. **OCTOBER 23, 1939:** Earl Browder, general secretary of the Communist Party in America, is arrested on the charge of having applied for passports in 1921 and 1927 under false names, before obtaining one under his proper name in 1934. Browder had implicated himself during testimony before the Dies Committee on September 5. **1940:** The Alien Registration Act, commonly called the Smith Act, is passed. Like the Sedition Act from World War I days, it makes advocating the violent overthrow of the United States government a crime. **AUGUST 21, 1940:** Leon Trotsky dies of wounds suffered from an icepick in an attack by Ramon Mercader, whose actions Moscow disavowed. The rival heir to the mantle of Lenin, who had been living outside Mexico City in exile, had earlier had his home strafed by twenty men firing machine guns, but escaped injury. **SEPTEMBER 1940:** HUAC Chairman Martin Dies's *The Trojan Horse in America,* coauthored with J. B. Matthews, is published. Typically, its main concern is the exposure of Communist front groups, although Dies also warns of the domestic Nazi threat. **JUNE 22, 1941:** Putting Operation Barbarossa into motion, Nazi forces invade the Soviet frontier, making Russia an instant ally of the U.S., Britain, and France in what Stalin would christen The Patriotic War. **SEPTEMBER 1941:** Russian War Relief supplants the American Committee for Medical Aid to Russia, founded a month earlier by a group of New York City business leaders, as a major source of aid to Russia. Its president is Edward C. Carter, secretary-general of the Institute of Pacific Relations. **DECEMBER 1941:** Former U.S. Ambassador to the Soviet Union Joseph E. Davies's memoir, *Mission to Moscow,* is published, following an excerpt in *Reader's Digest.* The book sells 50,000 copies in its first six weeks. **MAY 26, 1942:** The Anglo-Soviet Treaty is signed. **MARCH 29, 1943:** *Life* magazine publishes "Special Issue: The USSR." Almost all of its 116 pages are devoted to the government, peoples, and culture of our new ally against Hitler. **MAY 1943:** The Comintern is "dissolved" by Stalin, as a sop to his Western allies. But its work continues on apace even after the announcement is made. **NOVEMBER 1943:** Stalin convenes with Churchill and Roosevelt in Teheran, where concessions to Russia's new borders (particularly involving Poland) are made, with little being promised to either England or America by way of return. **MAY 22, 1944:** The Communist Party of the USA is dissolved, and, under the leadership of President Earl Browder, is renamed the Communist Political Association. The CPA slogan remains that of the CPUSA: "Communism is Twentieth-Century Americanism."

BETWEEN RED SCARES

★ 2

So many pungent philosophies were swirling around the U.S. after the Red Scare of 1919–1921, the American public seemed at a loss to decide how it should mold its sentiments toward communism and the Soviet Union—which, not to put too fine a point on it, weren't always perceived as being spooned from the same tin of caviar.

In this pre-television period, news from the distant universe of the USSR was much easier to control, and control it Stalin did, in a manner both tireless and virtually absolute. During the late 1920s and into the 1930s, Stalin was boldly inviting journalists from the major American publications and newsreel units to visit and observe his works. One newsreel, *New Glimpses from Red Russia,* played in American theaters in the fall of 1922 as an installment of the *International News* series, on a bill with features about bullfighting, football, and auto racing.

Many of the journalists who were permitted to visit the Soviet Union—and Stalin was selective about whom that included—came away having filed reports that glowed with admiration for what they observed. In turn, those stories helped fuel sympathy in the United States for the growing popular front of the Communist Party of the United States of America (CPUSA)—even though estimates of actual membership in that body fluctuated between modest (alarmists warned it might run a half million or so) and miniscule (the more accurate number probably was well under 100,000).

With his actions largely shielded from the eyes of the world, Stalin was able to implement whatever plans and programs appealed to him, ruthless or otherwise. One that would go down in infamy once the details became known many years later was the collectivization program. A large part of this ambitious revision of the Soviet class system revolved around Stalin's 1929 decree that the *kulak* class—which at that point was managing the many villages and farmlands spread across the vastness of Russia—should be liquidated in its entirety. An agonizing relocation process followed; the final cost has been estimated to be millions of lives.

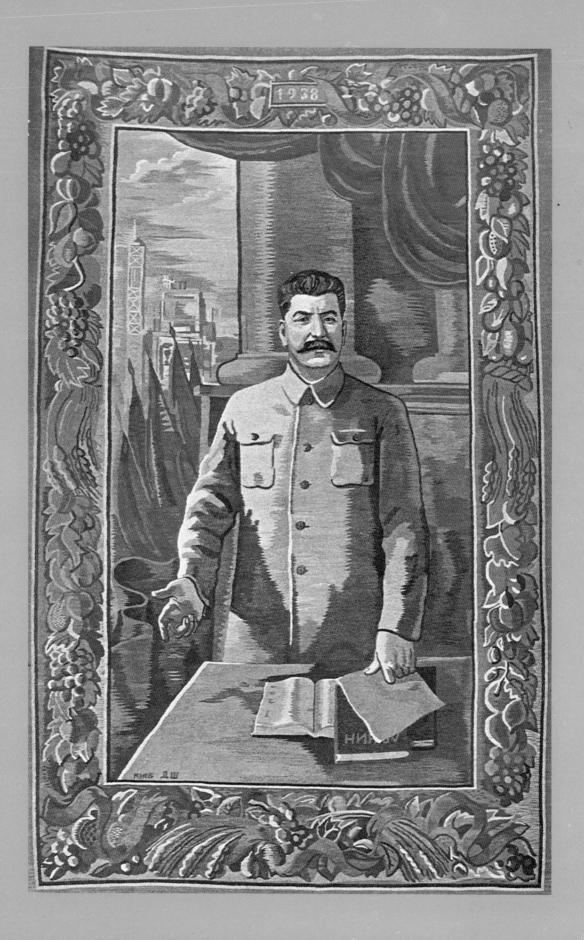

And yet, because of Stalin's uncanny ability to manipulate and suppress information, the West often remained blissfully unaware that such radical social reforms were even taking place. This permitted Stalin the luxury, unimaginable in today's world of instantaneous communication, of not even needing to deny that he was committing crimes of a frightening magnitude against humanity. There were whispers, but little more.

Even as these atrocities were being committed, the American press continued its polite, mild coverage of the Soviet Union. *Fortune* magazine, the $1-an-issue business extravaganza published by *Time*'s Henry Luce, devoted much of its March 1932 issue to the Soviet Union, with a striking Diego Rivera illustration of Moscow and the hammer and sickle gracing the cover. Inside, the special thirty-page section, entitled "Russia, Russia, Russia," featured five in-depth articles, including "The Soviet State,"

"The Eternal Peasant," "The Five-Year Plan," "Communist Life," and an appendix explicating the philosophy of Karl Marx.

In the preface to this special issue, the uncredited but clearly skeptical writer notes, "The old fable of the Soviet mystery remains. A fog of misinformation [about Russia] has blown in on every wind eastward . . . Americans have developed what might be called an ignorance complex." He also expresses pique that *Fortune*'s request for a face-to-face with Stalin was declined on the "ludicrous" basis that he "never grants an interview unless directed to do so by the Party." (Oddly, Stalin's hand-colored portrait in this profusely illustrated issue was only half the size of those afforded such figures as Nadezhda Krupskaya, Lenin's widow, and Kliment Voroshilov, commissar of the Russian armies and navies—perhaps a bit of payback by the magazine for his uncooperativeness.)

Although it would be another year before the U.S. government recognized the Soviet Union, *Fortune*'s massive undertaking was clearly intended for the benefit of the American business community, its primary readership. (Who else was going to pay a buck per issue for a magazine at the height of the Depression?) An appendix listed dozens of U.S. businesses that had sold more than a million dollars worth of goods to the Soviet Union in 1930, including RCA, Ford Motor Co., Westinghouse, Caterpillar Tractor, John Deere, General Electric, and American Express. It was also noted that, in 1931, such companies as Macy's, Marshall Field, Standard Oil, and U.S. Steel had imported goods from Russia, although the balance of trade was nearly three-to-one in favor of the U.S.

In subsequent years, *Fortune* would even begin running advertisements for the Soviet Union's tourist bureau, Intourist, Inc., which had offices in Chicago, San Francisco, and New York—on Fifth Avenue, if you please. "The Soviet Union commands attention. People abreast of world affairs are more and more

☆ This Summer, travel trends from the United States point to a new travel land . . . the Soviet Union . . . A land that offers the fascination of travel off the beaten track . . . the most talked about country and the one country abroad in which the deflation of the dollar has literally been ignored. How? By making the moderate all-inclusive travel rates in force last year effective in 1934 without consideration for the fact that the U. S. dollar is not what it used to be. First Class is $15 a day; Second Class is $8 a day; Third Class is $5 a day. These rates include: Soviet visas, meals, hotels, guide-interpreters, sightseeing, boat, train and motor transportation on tour in the U.S.S.R. Many groups are going if you want to join . . . or go it alone. Write for illustrated booklet14 a graphic swing around a sixth of the earth. All travel agents have rates, schedules and itineraries.

INTOURIST
INCORPORATED

U. S. Representative of the State Travel Co. of the U. S. S. R., 545 Fifth Avenue, New York. • Offices in Boston and Chicago. • Or see your own travel agent.

realizing the great importance of its history-making advances in industry and agriculture, with their attendant social improvements. Inclusive rates of $15 per day first class, $8 tourist," one ad beckons. "These rates cover all transportation in the Soviet Union, fine hotels, meals, sightseeing by car, and the services of trained guide-interpreters." (Presumably, tours of the labor camps were not part of the package.)

In 1934, a landmark of a very different sort saw publication. Elizabeth Dilling, of Kenilworth, Illinois, who earlier had produced a pamphlet entitled *Red Revolution,* self-published a tome entitled *The Red Network: "A 'Who's Who' and Handbook of Radicalism for Patriots."* The book denotes many hundreds of Red organizations, ranging from the A.C.L.U. and the Amtorg Trading Co. ("The official Soviet government trading organization in the U.S.") to the Young Pioneers of America ("Communist organization for boys and girls 8 to 15 years of age, who may graduate from it into the Young Communist League and then at 23 into the Communist Party proper; modeled on the Boy Scout movement but passionately antagonistic to it") and the YMCA and YWCA ("advocating mixture of colored and whites in social affairs and swimming pools"). It also offers an extensive section entitled "Who Is Who in Radicalism?" along with a glossary of Communist terminology. *The Red Network* must have struck a chord of some sort, because it went through six printings over the next two years. (Critic Stefan Kanfer has noted that the book was widely referred to at the time as "The Red Nutwork.")

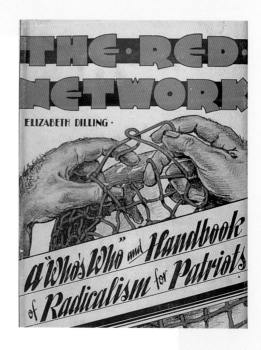

It was followed in 1936 by Mrs. Dilling's equally ambitious *The Roosevelt Red Record and Its Background.* As with its predecessor, this volume covers the "Fruits of American Innoculation with Communist Poison," as one of her chapters is titled, to an almost maniacal degree. The book offers facsimiles of various pamphlets, posters for meetings and rallies, as well as the official Socialist Party song sheet, "Songs for Socialists"; photographs of Communist

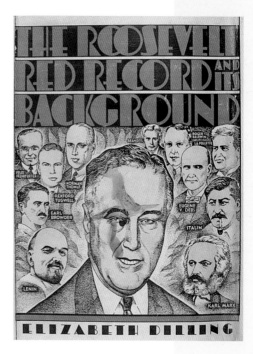

rallies held "to plan downfall of U.S. Government"; membership lists of hundreds of committees and Communist front organizations; admiring comments about FDR by a number of prominent Communists; descriptions of Public Works Art Projects and Federal Theatre productions; exposés of "Mrs. Roosevelt's Vote-Getting Poses with Negroes"; and updates of Stalin's latest outrages against humanity. All marinated in a

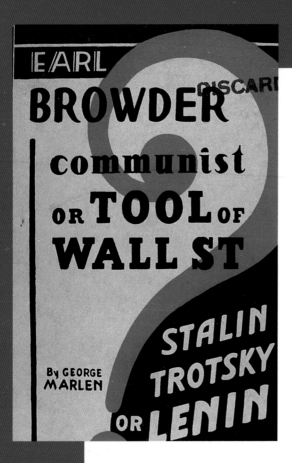

By GEORGE MARLEN

EARL BROWDER communist or TOOL OF WALL ST?

STALIN TROTSKY OR LENIN

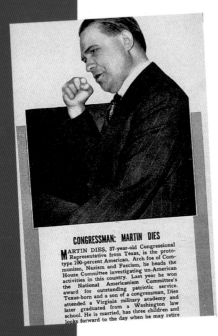

CONGRESSMAN: MARTIN DIES

MARTIN DIES, 37-year-old Congressional Representative from Texas, is the prototype 100-percent American. Arch foe of Communism, Nazism and Fascism, he heads the House Committee investigating un-American activities in this country. Last year he won the National Americanism Committee's award for outstanding patriotic service. Texas-born and a son of a congressman, Dies attended a Virginia military academy and later graduated from a Washington law school. He is married, has three children and looks forward to the day when he may retire

rich broth of quotations lifted from *The Daily Worker*.

Only after the Great Terror of 1936–1938, when Stalin's show trials and subsequent purges led to the exile or execution of much of Russia's military leadership, did the Western media begin to convey his more horrific side. Now left-leaning Americans were obliged to at least reexamine their romance with communism, and some supporters decided to sever their ties permanently (although, to their sorrow, many in this group would be reminded of, and punished for, their past affiliations in decades to come). Critical volumes like the exiled Leon Trotsky's *The Revolution Betrayed: What Is the Soviet Union and Where Is It Going?* and George Marlen's self-published tract *Earl Browder: Communist or Tool of Wall St?* were published in 1937.

The times were uneasy enough for Martin Dies (R-Texas) to get his pet project, the House Un-American Activities Committee (HUAC), approved and funded in May of 1938 (the 1930 incarnation of that committee had lasted only a year). Charged with the task of investigating subversive activities by organizations posing the threat of overthrow of the U.S. government, including (but not limited to) the Nazi Bunds and the Communist Party of the USA, Dies's HUAC made some noise—though not nearly as much as it would make nine years later under the aegis of J. Parnell Thomas (R-N.J.).

WHATEVER the tenor of the debates being conducted on the floor of the House, in the pages of America's magazines and newspapers the issues were being swatted around like so many badminton birdies on a windy day. Here is a selection of some of the day's Red readings:

"THE BRAND OF RED RUSSIA" by Dorothy Donnell, in *Motion Picture,* February 1928. "Russian refugees have come to us with horror in their eyes . . . The Russian colony in Hollywood come to the movies from every class of society. Practically all of them are refugees who have fled from their native country to escape the Red regime. There is not one who cannot remember scenes of violence and blood, not one who has not suffered personally from the revolution."

"THE WEB OF THE RED SPIDER: THE TRUTH ABOUT COMMUNISM AT LAST"
by George Sylvester Viereck, in *Liberty,* June 17, 1933. "Beginning: A Sensational Expose, Based on Authentic Documents, of the Secret Schemes by Which Communism Reaches Out to Entangle the World," slugs the article, which goes on to describe the 1933 Union Square May Day rally in New York City. There, Viereck interviews an enthusiastic lad, who tells him, "All's fair in war. We Communists are instructed to utilize every available means that will advance our purpose. We don't believe in your Constitution. Nevertheless we use it to shield our right to free speech. We don't believe in the parliaments, but that does not prevent us from running for office!" "To bore from within?" Viereck asks. "Exactly. From within and without." Viereck notes that "the moment [the boy] receives his directions and his pay from an alien land, hostile to our civilization and our form of government, he becomes a menace to the state." In Part II, in the June 24 issue, Viereck promises to explore the ins and outs of the Communist International, and its timetable for world conquest.

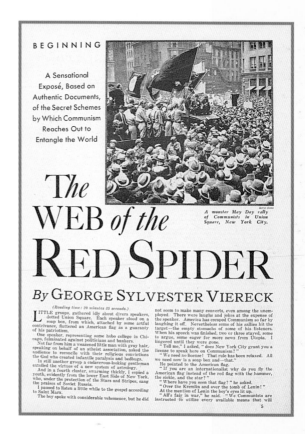

"WHY SOVIET RUSSIA HAD TO WAIT FOR RECOGNITION" by Joseph Z. Dalinda, in *Liberty,* November 11, 1933. "The man who nearly achieved American action [toward recognizing Russia] in 1921 tells at last of the Moscow blunder that ditched it."

"WILL THERE BE ANYTHING ELSE, COMRADE?" in *Reader's Digest,* July 1936. "Even mail carriers [in Russia] are beginning to expect tips," the uncredited author is amused to find during a recent visit.

"ARE WE GOING COMMUNIST?" – Everett Dean Martin, director of the Cooper Union, and Earl Browder, general secretary of the Communist Party, conduct a debate in the pages of *Forum,* November 1936. In Part I, "America Rejects Communism," Martin argues that the tenets of communism rest on the original philosophy as set down by Karl Marx, part of which states, "The arming of the whole proletariat with muskets, rifles, cannon, and munitions must be carried on immediately . . . The liberation of the oppressed class is impossible without violent revolution." But Browder states in Part II of the debate, "Communism Is on the Way," that "Communists in America are completely on the side of democracy . . . Communists advocate the widest democracy: universal suffrage; unconditional freedom of worship, speech, press, and assemblage; equality of representation; and governmental guarantee of work, education, and leisure to every citizen . . . That change from capitalism to socialism is what is known as the revolution."

Government Heads

On these pages are pictured the Chairman of the Council of Ministers of the USSR and the Chairmen of the Councils of Ministers of the 16 constituent Union Republics.*

The functions of the bodies which they head are executive and administrative. Under the Soviet Constitution, the ministers who make up these Councils are appointed by and are responsible to the appropriate Supreme Soviet, which is an elected body chosen by the people as a whole.

The Councils of Ministers of the Union Republics, in matters of administration, exercise authority under the provision of the Soviet Constitution which limits sovereignty of Union Republics only in specific matters enumerated in Article 14 of the Constitution.

* As of 1946.

JOSEPH V. STALIN
Chairman of the Council of Ministers of the USSR

| M. RODIONOV Russian SFSR | N. KHRUSHCHEV Ukrainian SSR | P. PONOMARENKO Byelorussian SSR | T. KULIYEV Azerbaijan SSR |

16

"THE END OF SOCIALISM IN RUSSIA" by Max Eastman, in *Harper's,* February 1937. The longtime radical bemoans the path followed by the USSR since the mid-Twenties, which he labels "a 12-year period of counterrevolution." He confesses, "It is a strange and sad experience, for one who has lived through these 25 years as a Marxian Socialist, to see the Soviet regime drop overboard one by one every vestige of socialism, until now there is no hope left for a classless society in present-day Russia."

"IT CAN HAPPEN HERE" by George E. Sokolosky, in *The New York Herald Tribune,* March 29, 1937. The author, a Russian émigré who attended meetings of the Constituent Assembly during the early days of the Revolution, recalls his own "anguish in the face of futility" at the time. "A minority had conquered Russia by organized minority pressure. They had seized the means of production and distribution. First they destroyed private property. Then they destroyed human rights. It was the end of Russia's chance for democracy. The majority was destroyed because it could not believe that it had to organize and fight to live . . . The American people do not yet realize that they are in the first stage of a revolution. Yet all experience with revolution shows that the seizure of private property by lawless bands before whom government stands impotent is the first major battle in the destruction of any government."

"THE D.A.R. SEES RED" by Margaret Payne, in *Forum,* April 1937. Payne is so alarmed at the Daughters of the American Revolution's hyperpatriotism and "heresy hunting" that she decides not to become a member.

"RUSSIA GROWS UP" by Maurice Hindus, in *Harper's,* May 1937. "Still holding to the core of its economic doctrine, Russia is nevertheless following more and more foreign, and especially American, social patterns."

"SELECTIONS FROM OUR FALL LIST" by International Publishers (381 Fourth Avenue, New York), in *Publishers Weekly,* September 18, 1937 (advertisement). Includes *Fascism: Made in the U.S.A.* by A. B. Magil and H. Stevens; *Letters to Americans* by Karl Marx and Friedrich Engels; *The Russian Revolution* by V. I. Lenin and Josef Stalin; and *From Bryan to Stalin* by William Z. Foster.

"SOVIET RUSSIA'S WARS OF CONQUESTS" by William Henry Chamberlin, in *The American Mercury,* April 1938. The former Russia correspondent for the *Christian Science Monitor* notes that the USSR has been waging wars of aggression as far

back as its attack on Finland in 1918, and that its current complaints about "aggressor nations" are thus quite ironic.

"THE REAL COMMUNIST MENACE" by Lawrence Dennis, in *The American Mercury,* June 1938. Dennis argues that the primary danger of communism is its ability to co-opt liberals, forming a united front that "furthers class warfare."

"COMMUNISM TWENTY YEARS AFTER" by Lillian Symes, in *Harper's,* June 1938. A good news/bad news scenario: Symes maintains that many American liberals have been lured into organizations which further Russia's foreign policy; on the other hand, the American Communist Party's middle-of-the-road'ing has lost them some of their earlier supporters.

"U.S.S.R. ATHLETES MARCH FOR STALIN," in *Life,* August 22, 1938. "Moscow's Red Square Rings with 'Smash 'Em!'"

"WAR-MONGERING ON THE LEFT" by Eugene Lyons, in *The American Mercury,* November 1938. The author of *Stalin, Czar of All the Russias* and (three years hence) *The Red Decade: The Stalinist Penetration of America* suggests that it is more important for Americans to help strengthen Russia so it can repel Nazi Germany's presumed attack upon it than to worry about the growing forces of communism on American shores.

"WHY STALIN SHOT HIS GENERALS" by W. G. Krivitsky, former general in the Red Army, in *The Saturday Evening Post,* April 22, 1939. "The first officer of the Red Army to give his story to the world, General Krivitsky, the one leading survivor of the great purge in the Red Army . . . broke with Stalin at the end of November, 1937, after the wholesale executions of the top-ranking generals of the Red Army. Escaping from Stalin's vengeance, Krivitsky recently came to the United States as a refugee . . . He is still a believer in the true Communism of Lenin."

"WHAT'S GOING ON WITH RUSSIA?" by Walter Duranty, Russia correspondent for *The New York Times,* in *Look,* August 15, 1939. "Today, 22 years after the Revolution, Russia is just beginning to recapture her place among the great powers. The world still wonders what kind of place this huge socialist country is."

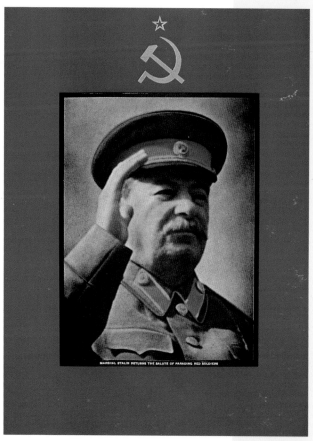

MARSHAL STALIN RETURNS THE SALUTE OF PARADING RED SOLDIERS

THE HITLER-STALIN PACT FOMENTS A NEW RED SCARE

PREDICTABLY, American sentiments towards Russia became a bit less balanced after Hitler and Stalin agreed to their nonaggression pact in the fall of 1939. Since the USSR was now an overt enemy of America for the first time, a number of magazine articles were rushed into print to help sound a loud alarm. Two of the first were *Click* magazine's September 1939 piece "The 'Trojan-Horse' Policy of Communism in America," and Eugene Lyons's *Cosmopolitan* article of November 1939, "Stalin—Hitler's New Ally." Lyons also made one of the strongest calls for proactive anti-communism in his 1941 book *The Red Decade: The Stalinist Penetration of America.* The introduction is entitled "In Defense of Red-Baiting"; the book concludes, "In taking action against the communist penetration of American life there are clearly dangers involved . . . Innocent bystanders may get hurt. But the danger of letting Nazi or Stalinist agents function freely in this time of world-wide crisis is infinitely greater."

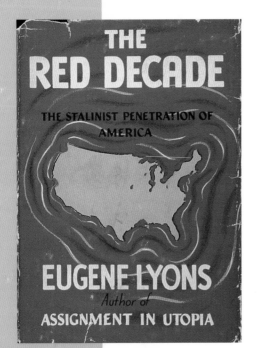

But just as typical as these five-alarm fires was the largely benign portrait of Stalin rendered by Joseph E. Davies in his 1941 memoir *Mission to Moscow,* which was serialized in *Reader's Digest* just on the heels of Hitler's June 22, 1941, attack on Russia. Davies was FDR's man in Moscow, the American ambassador attached to the USSR between 1936 and 1938, the very years of Stalin's Great Purge and the show trials. In his book, Davies offers an eyewitness account of his time in Russia, largely an admiring apology for Stalin's means, methods, and motivation.

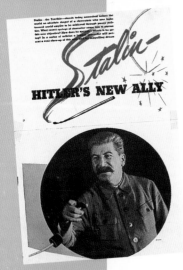

The fact that communism was only occasionally a focal point of American popular culture during this period is a tip-off that it was perceived rather ambiguously by much of the nation. Ten years later, communism would be so universally taken for granted as a menace that its presence in the popular arts, as well as in the news, would be virtually ubiquitous (as a large portion of this volume will shortly illustrate). But while the Thirties had been a time of polarized positions and philosophies, that decade also was one of the rare periods in the modern era that at least permitted a fairly rational dialogue on such a potentially divisive, hot-button issue as communism. Now heated debates over the merits of that philosophy could be found in the pages of even so quintessentially a middle-of-the-road publication as *Liberty.* The following is a sampling of some of the day's popular journalism.

"STALIN—HITLER'S NEW ALLY" by Eugene Lyons ("The first reporter to interview Stalin"), in *Cosmopolitan,* November 1939. "Stalin—The Terrible—stands today unmasked before the world as an absolute despot of a slave-state who now looks toward world empire to be achieved through power politics."

"JOSEPH STALIN" by Leon Trotsky, in *Life,* October 2, 1939. "Hitler's New Friend is Sized Up by an Old Foe." Less than a year later, Trotsky, who wired this story from his home in exile in Mexico, would be dead from an ice pick–wielding assassin's brutal attack.

"THE 'TROJAN HORSE' Policy of Communism in America," in *Click,* September 1939. Probably an adaptation of HUAC Chairman Martin Dies's about-to-be-published book by the same name, the piece begins, "Communism is the greatest menace to the domestic peace of the United States today . . . The virus of its democracy-wrecking disease is not easily recognizable by laymen who often mistake it for liberalism."

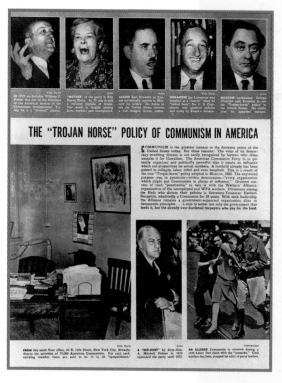

"STALIN'S NO. 1 U.S. STOOGE FINDS OUT THAT U.S. LAWS HAVE TEETH," in *Life,* November 6, 1939. Pictured: "Wrapped in the American flag, boss Earl Browder of the U.S. Communist Party defends Stalin's deal with Hitler at a New York mass meeting."

"MORE SNAKES THAN I CAN KILL" by Martin Dies, Chairman of the House Un-American Activities Committee, in *Liberty,* February 10, 1940. "Most people fail to appreciate the communist menace to America because they are under the erroneous impression that a country can only be communized by violent revolution, and they argue that we are in no danger of revolution . . . The Communists and Marxists in the United States are seeking to sabotage by degrees the political and educational system of America . . . All such proposals as the attempts to socialize medicine, law, etc., constitute steps in this program to accomplish gradually what they are unable to do by violent revolution."

"IF THE COMMUNISTS SEIZED AMERICA IN 1942: A FORMER PARTY LEADER REVEALS THE RED PROGRAM FOR FOMENTING REVOLUTION IN THE UNITED STATES—A FANTASY" by Ben Gitlow (recently expelled by the CPUSA), in *Click,* March 1940. "President of Soviet America would be stern-faced Earl Browder. But he would be the figurehead of the Comintern in Moscow. He would make effective use of the great radio networks, built by American capital, to preach propaganda asking the masses to crush out the remnants of capitalism."

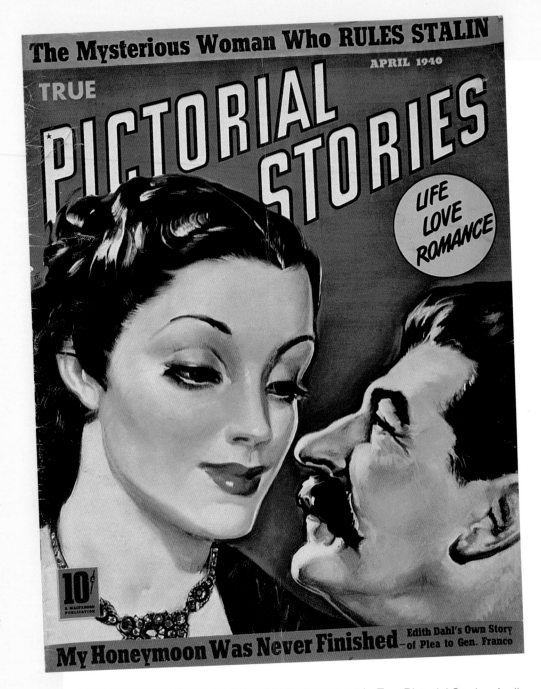

"THE MYSTERIOUS WOMAN WHO RULES STALIN" in *True Pictorial Stories,* April 1940. You know you've made it as a crossover star in American popular culture when you're depicted as the love object on the cover of a romance magazine.

"WHAT MOLOTOV WANTS," cover story in *Time,* July 15, 1940. "Though Russia might like to run the world, for a long time to come she will settle for simple security. But so long as capitalist countries fear Communism, they will suspect Russia of sinister intentions. And so long as the U.S.S.R. fears Capitalism, she will remain hostile, suspicious, Communist."

THE SOVIET PAVILION AT THE NEW YORK WORLD'S FAIR

FROM THE 1939 New York World's Fair flyer, "The Soviet Pavilion of the Arctic." "Nearly two hundred years ago, the Russian scientist and poet, Lomonosov, wrote: 'Russian Columbuses . . . will open a gate through ice and link our mighty nation with America.' This has been realized in the Soviet era. Soviet explorers, scientists, seamen, aviators, and workers have converted the Arctic into a navigable seaway, and are making immense areas within the Arctic Circle habitable.

"The story of this modern epic of exploration and pioneering is told in the displays in the Pavilion of the Arctic. Before the pavilion stands the plane in which Valery Chkalov made the first transpolar flight from Moscow to the United States; inside is the actual hut and equipment used by the Papanin Expedition, which made scientific observations for nine months on a North Pole ice flow. On the ceiling, on an illuminated map, the routes of the historic transpolar flights of Chkalov and Gromov, the recent flight of Kokkinaki from Moscow to America, and the route of the Papanin drift are shown. Additional exhibits record other heroic episodes and the vast scientific, industrial, and cultural progress in the Soviet Arctic."

From *The Official Guidebook to the 1939 World's Fair, Second Edition*. "The two extended wings of the semi-circular pavilion situated on Congress Street embrace a spacious courtyard paved with vari-colored flagstones. The facades of the [Union of Soviet Socialist Republics] building are decorated with eleven large panels representing the eleven Union Republics. Sculpted into the front of one wing is a bas-relief portrait of Lenin; on the front side of the other wing a bas-relief portrait of Stalin.

"Exhibits show the daily life and work and achievements of 170 million people living in the first Socialist country in the world. Feature exhibits include a reproduction of one of the new stations in Moscow's 'palace subway'; a replica of the Palace of Soviets in semi-precious stones; a huge map of the Soviet Union worked out in precious and semi-precious stones . . . Entertainment features include performances by the Red Army Ensemble of Singers, Dancers and Musicians. In a handsome restaurant and bar, Soviet foods and wines are served."

One wonders, did the exhibits remain in place after Hitler and Stalin signed their nonaggression pact in September 1939?

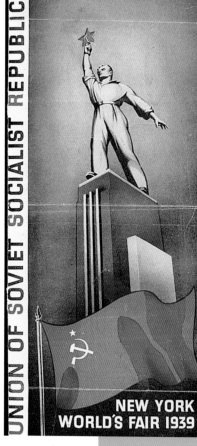

UNION OF SOVIET SOCIALIST REPUBLICS

NEW YORK WORLD'S FAIR 1939

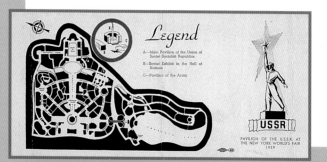

Legend

A—Main Pavilion of the Union of Soviet Socialist Republics
B—Soviet Exhibit in the Hall of Nations
C—Pavilion of the Arctic

USSR

PAVILION OF THE U.S.S.R. AT THE NEW YORK WORLD'S FAIR 1939

HOLLYWOOD KIDS THE COMMISSARS

WHILE TRAVELOGUES and newsreels about the mysterious Soviet Union were erratically produced for the big screen since the days of John Reed, American moviemakers really didn't have much data to work with for the longest time. MGM's series "Fitzpatrick Traveltalks" was promoted in the early Thirties as a trailblazing look behind the veil. The first about the USSR, *Moscow, the Heart of Soviet Russia,* came out in October of 1932 ("Answering America's curiosity about that strange land!"). *Leningrad, Gateway to Soviet Russia* ("Take off your whiskers! Russia is Recognized!") followed in November 1933, showing (the ads claimed) "Inside facts! How they live! How they work!" *The March of Time* series, which debuted in 1935, occasionally also would devote a reel or two to that distant land.

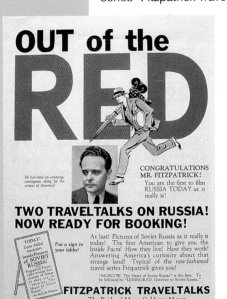

But the average Hollywood film wasn't likely even to attempt to bridge the vast dearth of information about what was actually transpiring in Stalinist Russia. And so a handful of commercial features relied on the romantic (or, more accurately, the highly romanticized) setting of the recently deposed czarist Russia for their stories. MGM heartthrob John Gilbert teamed with Reneé Adoreé in a 1928 adventure called *The Cossacks,* based on a tale by Tolstoy. In 1931, Fox released *The Yellow Ticket,* a drama set in the "heartless Russia" of 1913, heyday of the czar; it starred Elissa Landi as a woman "caught in the avid clutch of ignoble nobles," who is willing to do anything to acquire a police-issued "yellow ticket" permitting her to travel so that she may visit her ailing parents. One of the policemen in that film was played by a young actor named Laurence Olivier, who in 1935 would star in the British spy thriller *Moscow Nights.* That picture was released in the U.S. under the title *I Stand Condemned*—a sign, perhaps, that (at least for American audiences) Moscow's mythos as an epicenter of romantic adventure was beginning to fade. Even the lush Marlene Dietrich vehicle *The Scarlet*

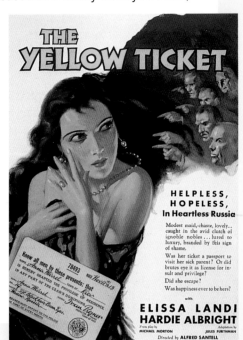

Empress (1934), in which she starred as Catherine the Great, bombed at the U.S. box office.

A great deal of fan magazine hubbub accompanied the 1934 Hollywood debut of Russian screen actress (*The Lash of the Czar, The Yellow Ticket*) and Moscow Art Theatre graduate Anna Sten. She was given starring roles that year in *Nana,* as Zola's Parisian streetwalker, and in *We Live Again* opposite Fredric March as the Russian peasant Katusha, the latter a tepid version of Tolstoy's *Resurrection.* But all that attention failed to convince American moviegoers to embrace her as the Soviet Garbo, as studio boss Sam Goldwyn had hoped—indeed, she was tagged as "Goldwyn's folly."

Less weighty, though arguably more topical, was the 1935 United Artists release *Red Salute,* which somehow managed to combine the conventions of romantic comedy (*It Happened One Night* had just swept the Oscars a few months before) with a subplot involving Red campus agitators. It starred Barbara Stanwyck as a spoiled rich girl whose dad yanks her out of college and exiles her to the far provinces when he learns she's spending most of her time with Red activist Hardie Albright. Down Mexico way she runs into handsome border patrolman Robert Young, who sets about both wooing her and reforming her of her lefty politics. Convinced she's now all-American, Young takes Stanwyck back north to her old college campus, where he beats the bejesus out of Albright and his fellow radicals. Needless to say, her dad is thrilled when he gets a gander at her new, uniformed suitor.

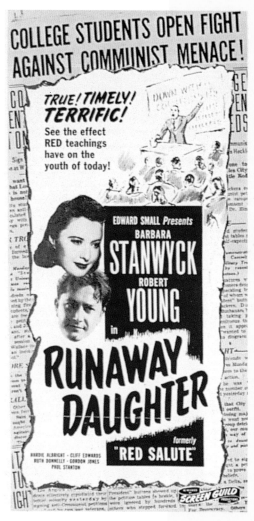

(By way of footnote, let the record show that *Red Salute* was rereleased in 1953 under the title *Runaway Daughter.* Now this innocuous romantic comedy bore ad copy that trilled, "Communist Activities Uncovered in American Colleges!" "From today's headlines comes a startling story of the RED MENACE at work in our schools . . . planting seeds of treason among the men and women of tomorrow!" And, in a masterpiece of wishful thinking, the ads summarized the picture as "True! Timely! Terrific!")

It would be four years before Hollywood bothered again with either the subject of communism, or the setting of what was now called the USSR. The most memorable effort in this area would come in 1939, when MGM had top producer/director Ernst Lubitsch film one of its top entries for that greatest of all motion picture years. *Ninotchka* presented Greta Garbo, still one of the studio's most important and commercially successful stars, as comrade Yakushova, a no-nonsense Party official who has been dispatched to Paris to

retrieve three colleagues who, while on a mission, have fallen prey to the wiles of the West. There the icy–though beautiful–apparatchik meets the decadent–but handsome!–playboy Count Dolga, who (as played by mustachioed Melvyn Douglas) represents all that she despises about capitalism and capitalists.

Or so she believes. Soon enough, Douglas's urbane charm, love of champagne, white dinner jackets, and relentless pursuit–all set against the charms of Paris–take their inevitable toll. To her horror, Ninotchka (as Dolga affectionately has nicknamed her) falls in love. Now she must figure a way to placate her dour Party bosses (one of whom is played by Bela Lugosi) while trying to remain in Paris with her new love. This being 1939, of course she finds that way.

Although *Ninotchka* was released on November 10, six weeks after Stalin and Hitler agreed to their nonaggression pact, American audiences didn't seem put off by the film's playful jabs at communism and Party politics. "The Picture That Kids the Commissars!" trumpeted its ad campaign (along with the come-on, "Garbo laughs!"). Indeed, the film was not only a commercial success, but was also nominated for several Academy Awards, and remains one of the high points of Garbo's illustrious career.

Its success spawned a virtual remake by MGM the following year. *Comrade X* starred Hedy Lamarr as a frigid Soviet streetcar conductor in Moscow who is about to get purged for heretical deviation from the Party line; MGM's top-dog, Clark Gable, plays the cocky American correspondent who generously marries her to save her from the gulag. (Somewhat after the fact, his all-American ardor actually does thaw her out.) Gable pretends to be an American Communist who needs Lamarr to help spread propaganda in the States. But the secret police arrest the pair and condemn them to death, a fate they avert when Gable steals a tank that Hedy drives to freedom. This bizarre combination of screwball comedy and topical, two-fisted adventure won an Oscar nomination for screenwriter Walter Reisch, who had cowritten the story on which *Ninotchka* was based, and who in 1956 would spin yet another version of the yarn with *The Iron Petticoat*. (*Ninotchka* would later be adapted into a Broadway musical called *Silk Stockings* by George S. Kaufman and Cole Porter, which itself became the basis for a movie in 1957, starring Fred Astaire and Cyd Charisse, now suffused with much dancing and singing.)

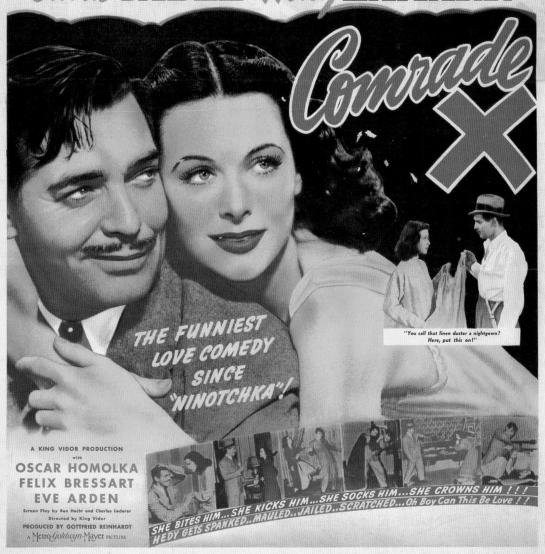

TIMELINE:

1944: Film director Sam Wood founds the Motion Picture Alliance for the Preservation of American Ideals, an ultra-conservative antidote to what Wood and his fellow members felt was an incipient Communist takeover of Hollywood. **DECEMBER 9, 1944:** Moscow's Party newspaper *Pravda* issues an attack on William H. White's about-to-be published book *About Russians,* based on an advance look from the *Reader's Digest* serialization. The book argues that Russian workers have no freedom, and that Russian industry simply copies American techniques. **JANUARY 3, 1945:** HUAC, from which Martin Dies stepped down in 1944, is voted a permanent subcommittee of the House of Representatives. **FEBRUARY 3–11, 1945:** The Yalta conference among Stalin, Roosevelt, and Churchill is held in far-flung Crimea at the insistence of Stalin. After gaining concessions that would haunt the U.S. for decades to come—FDR basically signed over control of Poland, Romania, Czechoslovakia, Hungary, and Bulgaria—Stalin agrees to enter the war against Japan once the fighting in Europe has concluded. **APRIL 12, 1945:** President Roosevelt dies, leaving the incipient Cold War to be managed by his successor, Harry Truman. Just before his death, FDR wrote to Churchill, "We can't do business with Stalin. He has broken every one of the promises he made at Yalta." **APRIL 25, 1945:** The founding conference of the United Nations begins in San Francisco. Attendees include all twenty-six states that banded together in 1942 against the Axis, including the USSR. **JUNE 4, 1945:** *The Daily Worker* reports the National Board of the Communist Political Association officially has repudiated CPA president Earl Browder's wartime policy of cooperation with capitalism to the end of defeating the Nazi menace, labeling his approach as one rife with "revisionist errors." **JULY 16, 1945:** The first A-bomb is tested at Alamogordo in the New Mexico desert, under the code name Trinity. **JUNE 26, 1945:** The U.N. charter is signed on the final day of the founding conference. **JULY 17—AUGUST 2, 1945:** With Truman taking the place of FDR, the Big Three convene at Potsdam. Midway through the conference, Churchill is voted out of office, and is replaced on July 25 by new Prime Minister Clement Attlee. **SEPTEMBER 1945:** Igor Gouzenko, a code clerk at the Russian Embassy in Ottawa, Canada, who, as part of a spy ring, has been acquiring atomic secrets and funneling them back to Moscow, defects with 109 pages of classified documents. When he spills the beans to Canadian and American authorities, several spies are flushed out, including atomic scientist Alan Nunn May and Canadian Parliament member Fred Rose. **OCTOBER 16, 1945:** J. Robert Oppenheimer, who headed up the Manhattan Project that led to the development of the A-bomb, resigns as director at Los Alamos. He later became quite vocal in his

1944–1947

opposition to the development of the H-bomb. In the late 1990s, the archives of the Russian Republic reveal that at least twenty-nine Soviet agents penetrated the Manhattan Project. **OCTOBER 24, 1945:** The United Nations charter is ratified by fifty-one founding nations at the San Francisco Conference. Its first secretary-general is a U.S. State Department official named Alger Hiss, who had also attended the "Big Three" Yalta conference. **NOVEMBER 14, 1945:** The "U.S.A./U.S.S.R. Allies for Peace" rally, sponsored by the National Council of American Soviet Friendship, is held at Madison Square Garden in New York. Among those sending good wishes for the event: General Dwight D. Eisenhower and screen stars Katharine Hepburn and Orson Welles. **NOVEMBER 16, 1945:** General Dwight D. Eisenhower testifies before the House Military Affairs Committee that "Nothing guides Russian policy so much as a desire for friendship with the United States." **JANUARY 10, 1946:** The first meeting of the United Nations convenes in London. **FEBRUARY 1946:** Stalin publicly announces the inception of a new kind of five-year plan: an arms buildup specifically in anticipation of a military conflict with the Western powers. It was interpreted by many as, in effect, a declaration of World War III. **FEBRUARY 1946:** Earl Browder, acting head of the CPUSA since 1930, is expelled from the Party for deviationism (actually, for having been too much of a moderate in supporting the policies of FDR). **FEBRUARY 22, 1946:** George F. Kennan of the State Department, known only as "X" for reasons of security, sends his famous "long telegram," a nineteen-page, eight-thousand-word essay that explains the Soviet predilection for expansion—all due, he argues, to their "traditional and instinctive sense of insecurity." Kennan advocates a proactive policy of containment, and warns that the notion of "peaceful coexistence" with the USSR is purely a pipe dream. **MARCH 5, 1946:** As a guest of Harry Truman, Churchill delivers his famous speech at Westminster College in Fulton, Missouri: "From Stettin in the Baltic to Trieste in the Adriatic, an iron curtain has descended across the Continent…" **MARCH 21, 1946:** The Strategic Air Command (SAC), the Tactical Air Command (TAC), and the Air Defense Command (ADC) are established by General Carl Spaatz. **1946:** England's Alan Nunn May becomes the first "atom spy" tried and convicted of giving atomic secrets to the Russians. He is sentenced to ten years in prison, of which he serves approximately two-thirds. **MARCH 12, 1947:** President Truman delivers his address before a joint session of Congress calling for $400 million in aid to Greece and Turkey to help them beat back the encroachment of Communism and resist "attempted subjugation." The Truman Doctrine, as it came to be known, was resoundingly passed.

JUST A GUY NAMED IVAN

WORLD WAR II MAKES US COMRADES IN ARMS

After Hitler's invasion of the Soviet Union on June 22, 1941, sundered the uneasy alliance of the past twenty months between Germany and Russia, one of America's first orders of business was reconditioning its citizenry to react positively to the concept of the USSR as an ally. Thinking of Russia as a threat to the American way of life was no longer a productive option. Better that the Russians be perceived as imperiled comrades, deserving of immediate action, commitment and, yes, even sacrifice on America's part.

What follows is a selection of readings from this pre-Cold War honeymoon with the USSR, illustrating how pro-Russia propaganda worked in the popular press.

"CAN THE RED ARMY SMASH THE NAZIS?" by Captain Sergei N. Kournakoff, in *Click,* March 1941. "Why *Click* prints this timely article: Joe Stalin is no lily, but he's more valuable to us as a friend than as an enemy." (Published three months before Hitler attacked Russia.)

"RED GUERRILLAS: TOUGH RUSSIANS FIGHT NAZIS FAR BEHIND THE FRONT LINES" by A. Polyakov, in *Life,* November 10, 1941.

"STALIN: DEVIL OR GENIUS?" by Emil Ludwig, in *Liberty,* January 17, 1942. Part Two of an in-depth series about the early life and rise to power of our newest ally, with special attention paid to the Russian Revolution. "Stalin's jealousy of Trotsky" is promised to be the focus of Part Three in the next week's issue.

"MEET THE REAL STALIN" by Joseph E. Davies, Chairman of the President's Committee on War Relief Agencies (and former ambassador to the USSR), in *Look,* April 7, 1942. "What sort of a human being is Joseph Stalin? He impressed me as quiet and kindly . . . He is definitely of the 'easy boss' type. Personal generosity and

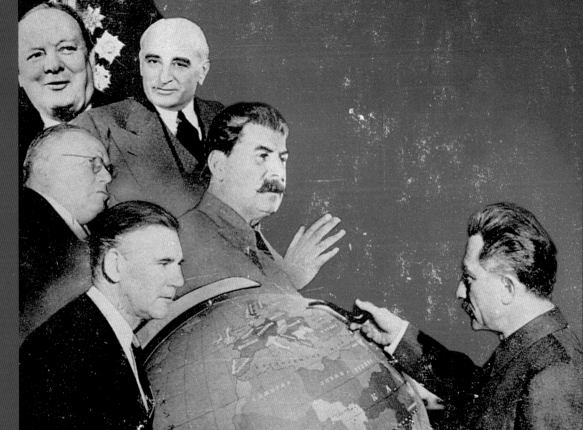

MISSION TO MOSCOW

BY THE FORMER
UNITED STATES AMBASSADOR TO THE SOVIET UNION

JOSEPH E. DAVIES

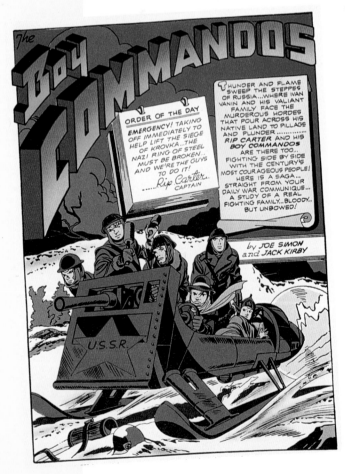

Meet the Real Stalin

By Joseph E. Davies

Former United States Ambassador to the Soviet Union, author of the best-selling book, "Mission to Moscow"

EDITOR'S NOTE: *Joseph Stalin, the man who turned back the Nazi tide in Russia, has long been an enigma to Americans, a subject of wild conjecture and of countless half-truths.*

LOOK asked Mr. Davies to give his personal estimate of Stalin, based on observation and face-to-face impressions during his stay in Russia. Mr. Davies, a man of wealth and a distinguished attorney, has been counsel for many important American corporations, was chairman of the Federal Trade Commission under Wilson.

He was U.S. Ambassador to Russia for two years, is now chairman of the President's Committee on War Relief Agencies. His book, "Mission to Moscow," published by Simon & Schuster last December, sold 50,000 copies within six weeks of publication.

Mr. Davies here appraises Stalin from six angles: his personality, private life, work, position in Russia, attitude on trends in government and measure as a world figure.

STALIN'S PERSONALITY:
The "easy boss" type

What sort of a human being is Joseph Stalin? He impressed me as quiet and kindly. Above all, he has great native dignity and gives one a strong sense of reserve power. Of course, Stalin has shown strength in his relations with other men, but he is definitely of the "easy boss" type. Personal generosity and forbearance also seemed to me to mark his character.

In private conversation, Stalin is low-voiced and earnest, but there's always a gleam of humor in his kindly brown eyes. Occasionally, his eyes will flash and turn hard on angle.

A few days after I talked with him in the Kremlin for more than two hours, I wrote the following to my daughter:

"It was really an intellectual feast which we all seemed to enjoy. He has a sly humor, and we joked and laughed at times. He has a very great mentality—it is sharp, shrewd and wise."

Although Stalin and I conversed through an interpreter, I came away with a feeling of strong personal liking for him as a human being. And, from what I could learn, Stalin himself has a real affection for people as individuals.

In appearance, Stalin is neither so robust nor so tall as he is commonly depicted in posters. He is a rather short man who gives the impression of gentle, almost shy, kindliness.

Although you would never think of Stalin in connection with "social graces," he is not the kind of man to be ill at ease in any company. If he were to be plunked down in the midst of a society function on Park Avenue, Stalin would be his simple, natural self. His personality radiates a sense of power that would command the respect of those around him.

What struck me most decidedly about Stalin was his extreme modesty. That, to me, was one of the secret indications of his size. Really great men are simple.

"Stalin's personality," says Mr. Davies, "is exactly the opposite of what rabid anti-Stalinists conceive."

CONTINUED ON NEXT PAGE 13

forbearance also seemed to me to mark his character. In private conversation, Stalin is low-voiced and earnest, but there's always a gleam of humor in his kindly brown eyes. . . From what I could learn, Stalin himself has a real affection for people as individuals. . . His personality is exactly the opposite of what rabid anti-Stalinists conceive."

"FROM JOHN DOE TO THE RUSSIAN FRONT" by Lois Mattox Miller in *Reader's Digest,* May 1942. "Last March former Governor Alfred E. Smith, outstanding Catholic Layman, joined the board of directors of Russian War Relief (RWR). 'No American can fail to recognize that aid for our allies is the quickest and cheapest means available for striking at Hitler,' he said. 'The Russian army and people are serving magnificently as the spearhead of our fight and I have joined RWR to do what I can to aid them.'"

"THE SIEGE OF KROVKA" *FROM THE* ***"BOY COMMANDOS"*** comic strip in *Detective Comics #69* (November 1942). "Thunder and Flame sweep the steppes of Russia . . . where Ivan Vanin and his valiant family face the murderous hordes that pour across his native land to pillage and plunder . . . Rip Carter and his Boy Commandos are there too, fighting side by side with the century's most courageous people! Here is a saga straight from your daily war communique. . . a study of a real fighting family. . . bloody but unbowed!"

"THE SOVIETS AND THE POST-WAR" – A Q&A with former Ambassador Joseph E. Davies, in *Life,* March 29, 1943. *"Can we assume that the rulers of Russia are men of goodwill toward other nations and that they desire a peaceful, stable world?"* "Yes. Their public statements of policy and their deeds in the past decade establish that. . . . It is, also, to their practical best interest to have

peace with, and in, the world." *"Even if Russia is not interested in promoting world rev-olution for its own sake, may she . . . promote communist revolutions in Europe? In Asia?"* "The Soviet Union has an enviable record as a nation for keeping its obliga-tions. Except as an instrument of military necessity, the Soviet Union will not promote dissension in the internal affairs of other nations."

"THE PRICE THAT RUSSIA IS PAYING" by Maurice Hindus, in *Reader's Digest,* April 1943 (condensed from the *New York Herald Tribune,* February 7–12, 1943). "With so many millions already sacrificed, Russians feel their losses too deeply to derive conso-lation from the praise which people of the United Nations accord them for their magnif-icent courage. 'Tell America,' said a Russian colonel on my recent departure from the Soviet Union, 'not to pat us so much on the back.' 'But,' I said, America appreciates the heroism of the Red Army.' 'Yes,' he replied, 'but think of the price we are paying.' *Russia has already lost a total of 10,000,000 lives."*

"WHAT EVERY AMERICAN SHOULD KNOW ABOUT RUSSIA" by Former Ambassador Joseph E. Davies, in *Click,* March 1943. *"Q: What are Russia's leaders like?"* "A: To my mind Joseph Stalin is one of the world's great altruistic leaders." *"Q: Has Communism worked in Russia?"* "A: In point of fact, true Communism no longer exists in Russia . . . Russia today, no matter whatever Russians may say, is a socialistic democracy." (Accompanies a feature on the new Warner Bros. film version of *Mission to Moscow,* in which Davies is played by Walter Huston.)

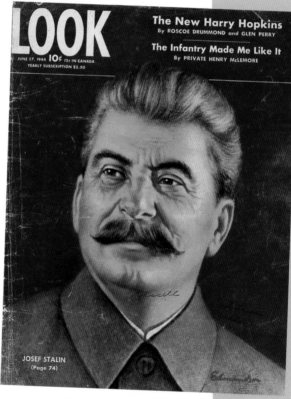

"RUSSIAN BATTLE PAINTINGS SHOW VALOR AND SUFFERING," in *Click,* August 1943. "Frontline Artists Record the Grim Fight for Soviet Freedom."

"HOW DID THE RUSSIANS DO IT? TACTICS, PRODUCTION BEAT NAZIS" by Paul Schubert, in *Look,* June 21, 1944.

"A GUY NAMED JOE," in *Look* magazine, June 27, 1944 (cover story). According to writer Ralph Parker, a Moscow-based corre-spondent who authored *The Last Days of Sevastopol,* Stalin spends half his time writing poetry and the other half reading it to the schoolchildren who flock to sit on his knee. (Former U.S. Ambassador Joseph Davies also remarked on Stalin's kindly way with children, in his book *Mission to Moscow.*) Noting that "Stalin is undoubtedly among the best-dressed of all world leaders, [making] Churchill in his siren suit look positively shabby," Parker goes on to sketch the literary interests of Russia's fearsome —yet sensitive–leader:

"Perhaps there is a clue to this all-around knowledge in Stalin's school certificate on exhibit in the Tiflis Museum. It establishes that Josif Vissarionovich Dzhugashvili [Stalin's given name] made top marks in all subjects except Greek.

"In addition to this man of trenchant speech, indomitable will and extraordinary mental capacity, there is another Stalin—the lover of literature. Stalin who will suddenly ask an engineer if he read Fenimore Cooper as a boy—Stalin did. A Stalin who at age 16 was writing poetry; who—even during the war—is deeply concerned with the work of younger poets, playwrights, novelists, eager that they should express the new Russia's soul."

"A Guy Named Joe" also makes the point that, before the war, Marshal Stalin handled problems on the level of choosing the "most suitable" wrapping for a bar of soap. The implication is clear: as soon as this damned war is over, Stalin will return to reading *The Deerslayer* and polishing his verse. Somehow it never happened. Perhaps embarrassed by its longtime pro-Joe stance, *Look* would soon emerge as one of the most tireless Stalin-bashers in the American press. And presumably Ralph Parker was placed under house arrest as a Stalin apologist.

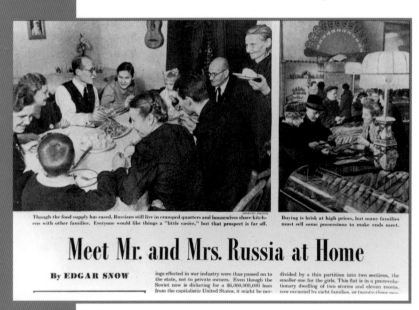

Though the food supply has eased, Russians still live in cramped quarters and housewives share kitchens with other families. Everyone would like things a "little easier," but that prospect is far off.

Buying is brisk at high prices, but many families must sell some possessions to make ends meet.

Meet Mr. and Mrs. Russia at Home

By EDGAR SNOW

ings effected in war industry were thus passed on to the state, not to private owners. Even though the Soviet now is dickering for a $6,000,000,000 loan from the capitalistic United States, it might be per-

divided by a thin partition into two sections, the smaller one for the girls. This flat is in a prerevolutionary dwelling of two stories and eleven rooms, now occupied by eight families, or twenty-three peo-

"CAN WE LIVE WITH RUSSIA?" by Demaree Bess, in *The Saturday Evening Post,* July 7, 1945. "A *Post* editor presents the most important problem of the peace—and points the way toward a solution."

"AN OPEN LETTER TO THE RUSSIANS" by Stanley High, in *Reader's Digest,* July 1945. "The Soviet government has been badly informed, indeed, if it is unaware how great is the measure of good will and friendliness in the United States toward the Soviet Union. There is not the slightest basis in fact for Russian mistrust of the United States. By every device of modern communication—newspapers, magazines, books, lectures, radio and movies—the American people have been intensively and with the utmost sympathy informed about Soviet Russia."

"MEET MR. AND MRS. RUSSIA AT HOME" by Edgar Snow, in *The Saturday Evening Post,* December 22, 1945. "What's life really like for a 'middle-class' family in the Soviet today? A *Post* editor gives the answers, based on firsthand observations."

COMRADES IN ARMS

HOLLYWOOD WARMS UP TO RUSSIA

EVEN DURING the years of the Hitler-Stalin Pact, when a good part of the print media in America was dusting off its old Red Scare files, Hollywood remained fairly sanguine about our relationship with the Soviet Union. MGM's *Ninotchka* ("The Picture That Kids the Commissars!") went into pro-duction before the nonaggression pact changed the world alignment, but it still charmed audiences when it was released on November 10, 1939. Directed by the master of romantic comedy, Ernst Lubitsch, *Ninotchka* was nominated for seven Academy Awards, including Best Picture, Best Actress, Best Original Story, and Best Screenplay. Hardly the sort of recep-tion one might have expected during a time when Red-baiting was in bloom. (Interestingly, the film was rereleased in 1948 and again in 1962, both periods of intense Cold-War activity.)

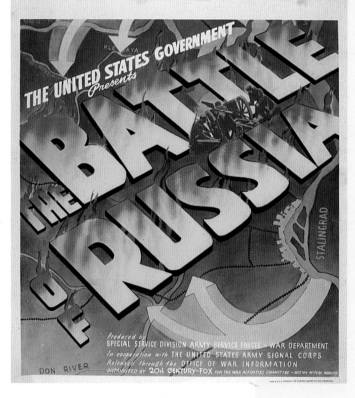

One of the most noticeable effects of Hitler's strike against the Soviet Union was how quickly the U.S. government managed to rev up its propaganda machine to help inspire homefront support for their belea-guered new ally. The army sponsored an ambitious film series called "Why We Fight"; initiated in 1942 under the direction of Frank Capra, it numbered among its 1943 entries The *Battle of Russia,* which revealed the heroism of the Red Army through documentary footage of the battles of Moscow, Leningrad, and Stalingrad.

"Distributed by 20th Century-Fox for the War Activities Committee – Motion Picture Industry," the poster informs us, along with this elaborate credit: "Produced by the Special Service Division, Army Service Forces, War Department, in Cooperation with the United States Army Signal Corps, Released through the Office of War Information."

One import early in the game was *Our Russian Front* ("SEE the heroism of men and women fighting on our side!"), a Russian film customized in 1942 for American

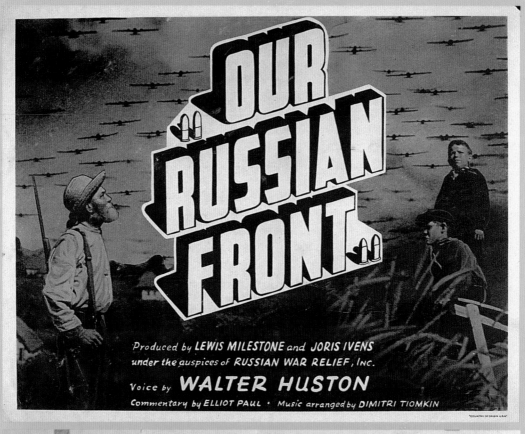

OUR RUSSIAN FRONT

Produced by LEWIS MILESTONE and JORIS IVENS
under the auspices of RUSSIAN WAR RELIEF, Inc.

Voice by WALTER HUSTON

Commentary by ELLIOT PAUL · Music arranged by DIMITRI TIOMKIN

"COUNTRY OF ORIGIN U.S.A."

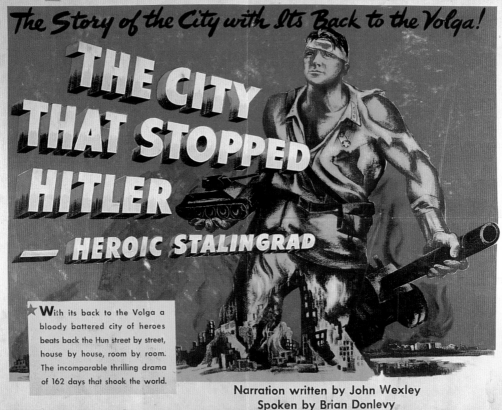

The Story of the City with Its Back to the Volga!

THE CITY THAT STOPPED HITLER

— HEROIC STALINGRAD

★ With its back to the Volga a bloody battered city of heroes beats back the Hun street by street, house by house, room by room. The incomparable thrilling drama of 162 days that shook the world.

Narration written by John Wexley
Spoken by Brian Donlevy

audiences by Oscar-winning director Lewis Milestone "under the auspices of Russian War Relief, Inc." It offered battle footage shot by Soviet cameramen, embroidered with narration by the great Walter Huston. More importantly, by dint of its very title, the film made the case that our erstwhile foes were now our brethren.

A number of other Soviet motion pictures, both documentaries and dramas, would be exported to England and America after being customized with English-language narration and, at times, Hollywood-style titles. *The Defeat of the Germans Near Moscow* and *Leningrad in Combat* both were imported in 1942; one of them might have been repackaged as the film advertised at the Allerton Theatre in the Bronx for October 8 and 9 of that year, *Guerrilla Brigade*. The advertising for that picture read, "I, a Red guerrilla, swear to my comrades-in-arms that I shall be brave, disciplined and merciless to the enemy. To the ends of my days I shall remain faithful to my country, my party, and my leader Stalin." (Its co-feature was *Sweetheart of the Fleet,* with Jinx Falkenburg.)

Paramount imported the film *Stalingrad* in 1943 and released it as *The City That Stopped Hitler—Heroic Stalingrad,* adding narration by Brian Donlevy and the clever tag line, "162 Days That Shook the World." Other Soviet dramas exported to the West include *Heroes Are Made, Mashenka,* and *Red Flyer* ("The True Story of Russia's Greatest Flyer CHKALOV")—all from 1942—while 1943 offered such patriotic Soviet dramas as *Natasha* ("The Dramatic Adventures of Three

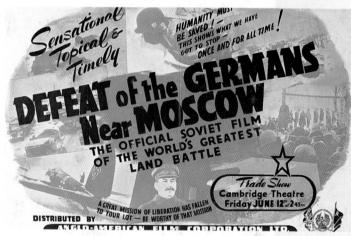

Red Cross Workers," starring Zoya Fererova), *No Greater Love (She Defends Her Country)* ("A Great Story of Undaunted Russia," starring Vera Maretskaya) and *In the Rear of the Enemy* ("For Stalin – For Freedom – For Victory"). In 1944, *Moscow Sky, Zoya, The Great Earth, Girl No. 217,* and *Jubilee* were all exported to the West. Presumably, all of these had been made with the Soviet audience in mind (though what Russian would have been free to go to the cinema in the midst of World War II?). But each film also was selected for its ability to inculcate in Western eyes sympathy for the Russian plight, along with admiration for the doughtiness and hardy spirit of the Soviet people, thereby helping to sell the British and American publics on the Russian

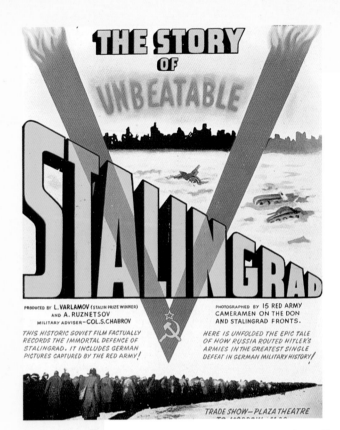

War Relief program, and its ilk.

And why not? The Russians were fighting for their lives against Hitler, and now, so were we. For far less compelling reasons, alliances have been forged. While FDR was pledging a billion dollars of Lend-Lease support to the Soviet Union, Hollywood enthusiastically leapt into the fray with its own array of contributions to the cause. Many were quickly (and cheaply) produced B-pictures, like PRC's *Miss V from Moscow* (1942), which starred Lola Lane as a Soviet agent stationed in occupied Paris who helps a downed Allied flier. Columbia's *The Boy from Stalingrad* (1943) featured a ragtag group of village youths who successfully defeat the cream of the invading German army. *Three Russian Girls* (1943), adapted from the Russian film *The Girl from Leningrad,* starred erstwhile Russian export Anna Sten and used the war as a backdrop for formulaic romance, dusted with a tribute to Soviet valor under fire. "They're the glory girls of today," the ad copy blared, "writing their own matchless story in the annals of gallantry . . . Side-by-side with their fighting men!"

Some pictures were based on more specific historical situations. Fox's 1943 production *Chetniks* dramatized the struggle of a brave group of Yugoslav partisans who

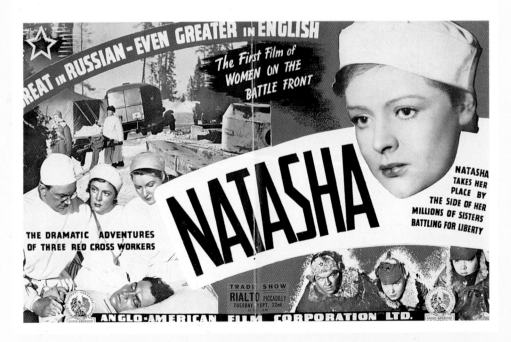

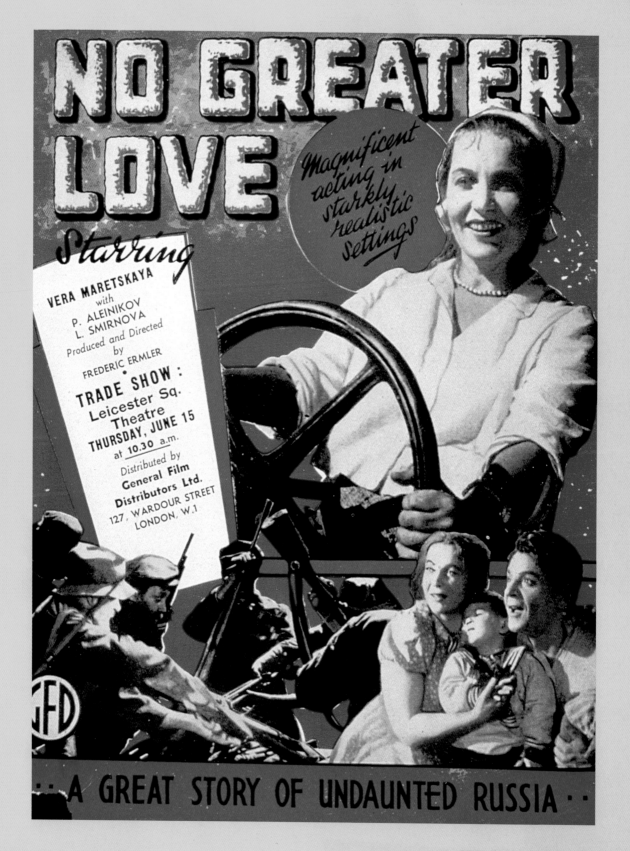

THRILLING AS TODAY'S FLAMING HEADLINES!

CHETNIKS!
The Fighting Guerrillas

with
PHILIP DORN
ANNA STEN
JOHN SHEPPERD
VIRGINIA GILMORE
MARTIN KOSLECK

Directed by LOUIS KING · Produced by SOL M. WURTZEL
Screen Play by Jack Andrews and Edward E. Paramore

A 20th CENTURY-FOX PICTURE

BOXOFFICE TIMED TO YOUR PLAYDATE

battle, and ultimately outwit, their Nazi occupiers. Inspiring stuff—except that in reality, General Mihajlovic's Chetniks often collaborated with the Nazis, the better to wage their own war against Tito's Communist guerrillas.

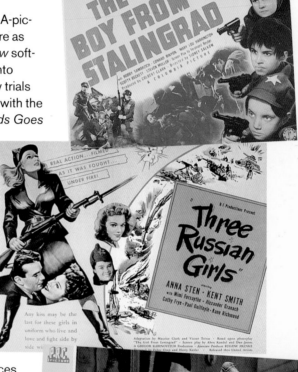

And then there was *Mission to Moscow.* Published in 1941, former Ambassador Joseph Davies's popular account of his many adventures while stationed in Moscow from 1936 to 1938 was brought to the screen by Warner Bros. in 1943, and given the full A-picture treatment. Described by film historian Nora Sayre as "a gigantic mashnote to our ally," *Mission to Moscow* softened the book's already tolerant portrait of Stalin into something approaching hagiography. The Moscow trials of 1937 and 1938 are shown as being conducted with the genial goodwill of the courtroom scene in *Mr. Deeds Goes to Town,* and Stalin is portrayed as a visionary who was driven into Hitler's arms by the dimwittedness of the British and French (which, in fact, was at least partly the case). At one point, the Davies character, played by the estimable Walter Huston, tells Stalin, "I believe, sir, that history will record you as a great benefactor of mankind"—a line that does not appear in the book. But Davies himself appears in the film's prologue praising "those fine and patriotic citizens," thus indicating he wasn't too upset by the liberties taken in adapting his book. *Mission to Moscow* ends with a heavenly apparition asking, "Am I my brother's keeper?" as disembodied voices answer, "Yes, you are—now and forever more!"

Forever didn't last too long, though. By 1947 the House Un-American Activities Committee was asking Jack Warner to explain how such shamefully pro-Soviet propaganda could have come from his studio. Had FDR made a personal appeal? Had the government helped subsidize the production? Warner answered in the negative, though he changed his story in his 1965 autobiography: there he says yes, FDR had made just such a request, "and I considered FDR's request an order." Unfortunately, this

revelation came far too late to save the career of screenwriter Howard Koch, who was blacklisted in large part because of his work on *Mission to Moscow.* As film critic James Agee noted at the time, "the film is almost describable as the first Soviet production to come from a major American studio."

Perhaps the most commercially successful of these valentines to the USSR was the 1943 *Song of Russia,* a typically glitzy production from MGM. Robert Taylor plays a famous American conductor who is touring the Soviet Union, just before the war breaks out. After meeting him, Russian fan Susan Peters manages to wrangle a fancy dinner out of him. Taylor falls for her when he realizes that she's "just like an American girl." Amid the strains of Tchaikovsky, the young lovers visit her parents' dacha,

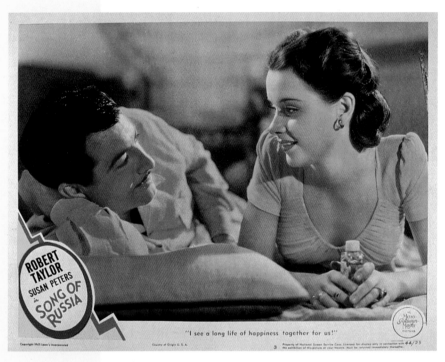

"I see a long life of happiness together for us!"

where Peters wows the conductor by repairing tools and driving a tractor. Smitten, Taylor marries her in a local church, but their honeymoon is interrupted by the Nazi invasion. Peters sets about making Molotov cocktails, and (true to the film's source) helps set the town ablaze so the invaders cannot use its resources. *Song of Russia* ends with Taylor and Peters being sent to America to tell us, "We are soldiers, side by side, in this fight for all humanity."

The film's screenwriter, Richard Collins, testified before HUAC in April 1951 that *Song of Russia* had seemed "pretty innocuous" to him and cowriter Paul Jarrico, both of whom admitted having had Communist leanings at the time. But he went on to note that star Robert Taylor, one of Hollywood's premier archconservatives, had objected to the script's pro-Russian slant, and successfully pushed for the deletion of all references to collective farms and the like. Producer David Selznick refused to lend Ingrid Bergman to the project because the script he saw was too favorable to Russia, which mystified MGM head Louis B. Mayer, who had "just wanted to make a picture about Russia, not Communists."

Collins, who had been subpoenaed by HUAC in 1947 as one of the original nineteen witnesses without ever being called to the stand, ultimately furnished HUAC with twenty-three names—but he maintained to the end that *Song of Russia* "was actually

pretty lukewarm" in relation to American popular support of the USSR at that time. But writer Ayn Rand, a virulent anti-Communist, told HUAC in those same sessions that the film made her "sick," and that the smiling of the war-ravaged peasants throughout was totally unrealistic. (Point taken.) Robert Taylor, another friendly witness, testified that he only agreed to appear in the movie because the Office of War Information had pressured MGM to make it. (He must have been unfamiliar with the slogan of the Communist Party of the USA: "Communism Is Twentieth-Century Americanism.")

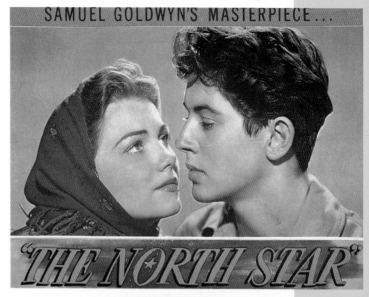

Equally rich in political overtones was the Samuel Goldwyn production *The North Star,* which was released in November 1943 with major publicity hoopla, including a *Look* magazine cover. Set in June 1941, this rousing yarn, written by Lillian Hellman, was also about the heroism of workers on a Russian collective farm (Walter Huston, Dana Andrews, Anne Baxter, Farley Granger) who suddenly must resist the onslaught of Nazi invaders, led here by the peerless Eric von Stroheim. (Hellman reportedly burst into tears when she viewed Goldwyn's final cut of the film at a screening.) The last of Hollywood's pro-Soviet epics was probably *Days of Glory* (1944), which introduced dashing young Gregory Peck

to the screen. Peck plays a heroic Russian guerrilla battling the vile Nazis, aided by the lovely and exotic (and married-to-the-producer) Tamara Toumanova, former prima ballerina of the Ballets Russes de Monte Carlo. In the end, she and Peck both die heroically—not that there was any other way in those days for Russian characters to expire in a Hollywood movie.

TIMELINE:

APRIL 9, 1947: Demonstrations take place in Bogata, Colombia, at the Conference of American States. Among the activists: a young Cuban radical by the name of Fidel Castro. **APRIL 16, 1947:** Financier Bernard Baruch, in his address to the legislature of South Carolina, warns, "Let us not be deceived—today we are in the midst of a Cold War." In short order, that term would enter the lexicon of Americans. **MAY 13, 1947:** The Senate approves the Taft-Hartley Labor Act, and votes on June 20 to override the veto registered that same day by President Truman. The Act requires that labor leaders take an oath stating that they are not Communists. **JUNE 5, 1947:** Recently appointed Secretary of State George Marshall gives a speech at Harvard advocating major economic aid for struggling European countries so that communism could not gain a foothold. The $12 billion Marshall Plan would dovetail with the Truman Doctrine to implement the policy of containment advocated by George Kennan. For his vision, Marshall would later be named *Time* magazine's Man of the Year. **1947:** The first issue of the anti-Communist periodical Plain Talk is published under the editorial direction of Isaac Don Levine, financed by San Francisco businessman Alfred Kohlberg. A weekly called *Counterattack* follows shortly, the fruit of the American Business Consultants—a group founded by a trio of ex-FBI agents, dedicated to unearthing Reds who have infiltrated company unions. **OCTOBER 1947:** The Comintern, now called the Cominform, is revived. **OCTOBER 20, 1947:** HUAC's Hollywood hearings commence under the stewardship of J. Parnell Thomas. Gary Cooper, Robert Taylor, Ronald Reagan, and Robert Montgomery will testify as cooperative witnesses, along with studio executive heads Jack Warner, Walt Disney, and Dore Schary. Ginger Rogers's mother is another particularly cooperative witness. **OCTOBER 21-23, 1947:** The Hollywood Ten—Alvah Bessie, Herbert Biberman, Lester Cole, Edward Dmytryk, Ring Lardner Jr., John Howard Lawson, Albert Maltz, Samuel Ornitz, Adrian Scott, and Dalton Trumbo—testify before HUAC. They repeatedly and, usually, belligerently cite the Fifth Amendment as they refuse to answer the question, "Are you now, or have you ever been, a member of the Communist Party?" On November 24, all of them are indicted for contempt of Congress, and are fired from their jobs the next day. **OCTOBER 24, 1947:** Humphrey Bogart, Lauren Bacall, Spencer Tracy, Katharine Hepburn, Groucho Marx, Frank Sinatra, Ava Gardner, Ronald Reagan, John Huston, Danny Kaye, and dozens of other Hollywood actors, directors, and screenwriters band together under the name Committee for the First Amendment in protest of HUAC's manhandling of the Hollywood Ten. Several of the stars charter a plane—which they foolishly dub *Star of the Red Sea*—and fly to St. Louis,

1947-1950

Kansas City, Chicago, and, ultimately, Washington, D.C., giving a press conference at each stop along the way. **DECEMBER 27, 1947:** The Civil Service Loyalty Review Board sets about the business of testing the loyalty of federal employees. **MARCH 31-APRIL 1, 1948:** The Russians give the first orders forbidding the entrance of military trains into and the exporting of freight out of Berlin without their approval. **MAY 19, 1948:** Congressmen Richard M. Nixon's and Karl Mundt's bill to "protect the United States against un-American and subversive activities"—the Mundt-Nixon Bill—is passed in the House by a vote of 319 to 58. The bill, also known as the Internal Security Act, makes it a crime to attempt to establish a totalitarian dictatorship, by any means. In effect, this makes the existence of the Communist Party itself a violation of the law. **JUNE 1948:** *Washington Witch Hunt* by Bert Andrews, which decries the recent abuses of civil liberties by Red hunters, is published by Random House. **JUNE 28, 1948:** Yugoslavia's Communist Party, under Marshal Tito, is expelled from the Cominform, becoming the first Soviet satellite nation to break free of Moscow rule. **JUNE 28, 1948:** The total blockade of West Berlin begins. Over the next eleven months, Americans and Brits airlift food, medicine, and fuel to help maintain the city and the well-being of its occupants. **JULY 20, 1948:** After a thirteen-month investigation, a New York grand jury returns indictments against twelve members of the National Board of the Communist Party, who are charged with conspiracy to overthrow the government of the United States. **JULY 28, 1948:** Elizabeth Bentley, dubbed "the Red Spy Queen" by the press, testifies before a Senate subcommittee and, three days later, to HUAC, that she had been the courier to a Washington-based Soviet spy ring during the war. She also implicates the man she replaced in that capacity, Whittaker Chambers. **AUGUST 25, 1948:** In what has since become known as "Confrontation Day," Whittaker Chambers testifies before HUAC regarding his earlier acquaintance with Alger Hiss, as Hiss looks on. **DECEMBER 15, 1948:** Former State Department official Alger Hiss is indicted on two counts of perjury for denying his role in passing classified documents to the Russians, but his first trial ends on July 8, 1949, with a hung jury. **JANUARY 1949:** Chinese Communist forces enter Beijing. **APRIL 1949:** The North Atlantic Treaty Organization (NATO) is formed. **MAY 12, 1949:** The Berlin blockade is lifted. Great Britain and the U.S. have flown 272,000 missions, airlifting 2,325 million tons of supplies to West Berliners. **JUNE 13, 1949:** The Hollywood Ten, cited for contempt of Congress, learn their convictions have been upheld by the U.S. Circuit Court of Appeals. Eight of them serve one year in prison; Herbert Biberman and Edward Dmytryk serve six months. Each of

the Ten is assessed a fine of $1,000. All are blacklisted upon their release. JULY 1, 1949: Judith Coplon is sentenced to prison on charges of espionage. JULY 18, 1949: Baseball star Jackie Robinson testifies before HUAC, addressing the question of whether the Negroes of the U.S. would be willing to fight against Russia, if war were to be declared. (He didn't think it would pose a problem.) AUGUST 6, 1949: Secretary of State Dean Acheson announces that the U.S. is withdrawing support of Chiang Kai-shek's Nationalist Chinese government. AUGUST 27, 1949: Famed singer, actor, and Soviet supporter Paul Robeson is but one of the left-leaning entertainers to participate in a concert in Peekskill, New York, which is disrupted when a riot breaks out. Unperturbed, Robeson and Pete Seeger, among other stars, return a week later to give a second concert. But that one also ends in disarray when another ugly riot ensues. AUGUST 29, 1949: Russia detonates its first atomic bomb, although Americans do not learn of it until President Truman announces the fact at a September 23 press conference. SEPTEMBER 21, 1949: Federal Republic of Germany (West Germany) is founded. OCTOBER 1, 1949: Standing before the Great Tiananmen Gate, Mao Zedong announces the formation of the People's Republic of China. OCTOBER 7, 1949: The German Democratic Republic (East Germany) is founded. OCTOBER 14, 1949: Eleven leaders of the American Communist Party are convicted of advocating the violent overthrow of the U.S. government, a violation of the 1940 Smith Act. Their nine-month trial, which generates 21,157 pages of testimony and costs the government a million dollars to prosecute, is held in New York City under Judge Harold R. Medina. After sentencing the Red Eleven to five-year prison terms, Medina is feted on the cover of *Time* magazine (Oct. 24, 1949). Among those who testify: FBI counterspy Herbert A. Philbrick, a Boston-based agent who had spent the past nine years infiltrating Communist organizations, and Matt Cvetic, whose undercover activities took place in Pittsburgh. (Their escapades would soon be dramatized in autobiographical books, radio shows, a television series, and a movie.) DECEMBER 7, 1949: China officially becomes a Communist country after Chiang Kai-shek and his Nationalist army flee to Formosa (Taiwan), leaving Beijing to the forces of Mao Zedong. DECEMBER 16, 1949: Mao Zedong and Josef Stalin meet for the first time, in Moscow. They would meet only once more, on January 22, 1950. DECEMBER 18, 1949: Nikita Khrushchev relocates from the Ukraine to Moscow, where he is appointed a secretary of the All-Union Central Committee. JANUARY 21, 1950: The second trial of Alger Hiss ends with his being convicted of perjury. He is sentenced to five years in a federal prison. MARCH 1, 1950: Klaus Fuchs, German-born atomic research physicist who worked at Los Alamos before relocating to England, pleads guilty to violating the Official Secrets Act in giving the Russians atomic secrets dating back to 1942. He is sentenced to fourteen years in prison.

THE NATIONAL POLICE GAZETTE

MAY, 25¢ ANC

AMERICA'S FIRST PICTORIAL — SPORTS — TRUE ADVENTURE — PEOPLE

HITLER IS ALIVE!
Secret Report of his Latest Activities

THE TRUTH ABOUT STALIN'S A-BOMB!

PLUS:— EXCLUSIVE COLOR PHOTOS

The REAL LOWDOWN on "MR. LUCILLE BALL" TV's outstanding star

JIMMY CARTER BOXING'S MYSTERY CHAMPION

KOREA'S GREATEST TRUE ADVENTURE STORY

THE IRON CURTAIN DESCENDS

4

THE BEAR GROWS AND GROWS

resented as the centerfold of the Sunday magazine section of *The New York Daily News of January 6, 1946, "The Bear Grows and Grows"* illustrates America's dawning perception that the postwar Soviet Union was not only a mighty nation and a very large one, but was also quite hungry, with borders that were constantly expanding. The Yalta agreement of February 1945 had already given the signal that the Soviets were in an acquisitive frame of mind, now that the German threat had been laid to rest. Stalin's appetite for expansion was already a matter of record; after all, it had been his bold (some would say foolhardy) annexation of Bessarabia from Romania in June of 1940 that had effectively forced Hitler to terminate the nonaggression pact, leading to his invasion of Russia.

For the caption-writer of *"The Bear Grows and Grows,"* the direction the postwar Soviet Union was taking was clear as a Daily News headline: *"Stalin is determined to buttress his sprawling colossus on all sides with territorial cushions. . . . In addition, Russia continues to spread, by 'zones of influence,' a modern double-talk expression meaning anything from fields of strong political pressure to absolute political domination."* A few months later, Churchill would make his "Iron Curtain" speech at tiny Westminster College in Missouri, and the Cold War would become part of America's daily fabric.

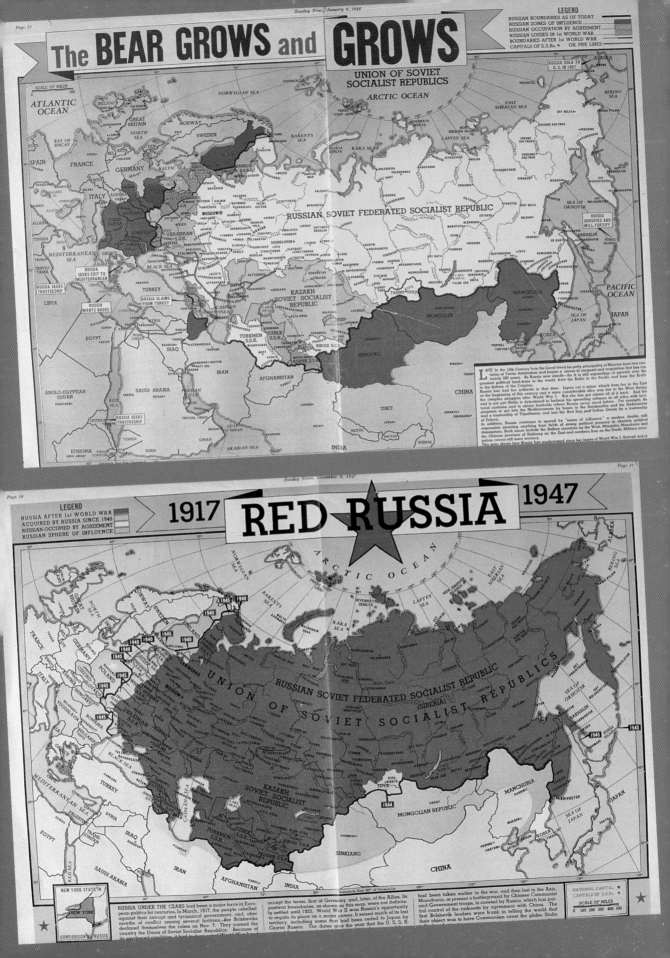

COULD THE REDS SEIZE DETROIT?

AMERICA'S WEEKLY MAGAZINES COVER THE POSTWAR STALIN YEARS

TO KEEP up with the constantly evolving saga of the Cold War, most Americans were obliged to rely on information provided by a combination of the day's mass media: newspapers, magazines, radio broadcasts, and movie newsreels, along with the occasional book. This section gathers a representative selection of news and feature stories that appeared in some of the most popular weekly magazines of the postwar years, including *Life, Look, The Saturday Evening Post, Colliers, Click,* and *Liberty,* which had a combined weekly circulation in the millions. By the fall of 1945, magazine pieces like William Hard's "Eight Things to *Do* About the Soviet Union," published in *Reader's Digest* for September 1945, were already appearing; the piece is permeated with such cautionary advice as, "Let us have friendly relations with the Soviet Union but let us not lose our own self-respect." It would not be long before mere caution would give way to outright fear and trembling. The following list of articles, drawn from just the weekly magazines, is arranged chronologically to illustrate the evolving Cold War *zeitgeist.*

"THE RUSSIAN NAVY IS REBORN," in *Life,* December 17, 1945. "Stalin demands a mighty Red navy and a great literature to inspire it to great deeds."

"THOUGHTS ON SOVIET FOREIGN POLICY AND WHAT TO DO ABOUT IT, PART II," by John Foster Dulles, in *Life,* June 10, 1946. "The Soviet program is a danger to peace. In this article we consider what policies will enable the American people to avert that danger."

"THE U.S. COMMUNIST PARTY," by Arthur Schlesinger Jr., in *Life,* July 29, 1946. "Small but tightly disciplined, it strives with fanatic zeal to promote the aims of Russia."

"MOLOTOV AND VISHINSKY," by John Osborne, in *Life,* September 9, 1946: "A hard-headed old Bolshevik and a supple ex-Menshevik dispense the Kremlin's foreign policy at Paris."

"THREE OLD LADIES: THEY BOUGHT THE DAILY WORKER," by Lilian Rixey, in *Life,* October 14, 1946. (Reports that the new owners of the paper, circulation 22,701, are eight active Party members.)

"DOES WASHINGTON THINK WAR WITH RUSSIA IS INEVITABLE?," by Mrs. Raymond Clapper, in *Look,* November 12, 1946. "Our world faces a desperate crisis. But we can still win an honorable and lasting peace if we act boldly."

"WHAT STALIN TELLS THE RUSSIANS ABOUT US," in *Look,* January 21, 1947. "Compiled from Soviet Government domestic [radio] broadcasts [and newspaper reports], with marginal notes by William B. Arthur."

"A PERSONAL INTERVIEW WITH STALIN," by Elliot Roosevelt, in *Look,* February 4, 1947. (Stalin's first interview with an American reporter in more than ten years.) "I interviewed Josef Stalin in his office in the Kremlin on the night of December 21, 1946. It was Stalin's 67th birthday."

"WHY RUSSIA GOT THE DROP ON US." by Martin Sommers, in *The Saturday Evening Post,* February 8, 1947. "The hitherto unpublished story of a secret wartime White House conference which deferred a planned 1943 invasion of Europe—perhaps changing the history of the world for keeps—and a recommendation as to how we must deal with the situation the conference created."

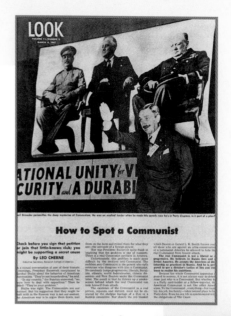

"WHY WE DON'T UNDERSTAND RUSSIA," by Edgar Snow in *The Saturday Evening Post,* February 15, 1947; and "Stalin Must Have Peace" by Edgar Snow, in *The Saturday Evening Post,* March 1, 1947. 'Russia today is incapable of fighting a major aggressive war against the United States,' an authority flatly states. 'The men in the Kremlin know such a conflict would mean complete disaster for the Soviet.'

"HOW TO SPOT A COMMUNIST," by Leo Cherne, in *Look,* March 4, 1947. "Check before you sign that petition or join that little-known club; you might be supporting a secret cause."

"MAY DAY IN MOSCOW," in *Life,* May 19, 1947. (Pictorial on Moscow's May Day parade.)

"I DON'T WANT MY CHILDREN TO GROW UP IN SOVIET RUSSIA," by Nina I. Alexeiev, in *Liberty,* June 7, 1947. "When Kiril Alexeiev, Soviet Embassy attache in Mexico, refused to return to Russia, Americans wondered why. His wife here reveals the shocking reasons in an article that cuts deep behind the Iron Curtain."

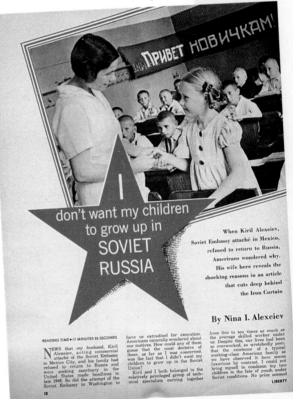

"HOW MY VIEWS ON THE RUSSIANS CHANGED," by Arthur Rothstein, in *Look,* June 24, 1947: "A *Look* photo-reporter finds the Russians unfriendly."

"WE CAN LOSE THE NEXT WAR IN SEVEN DAYS," by Nat S. Finney, in *Look,* July 8, 1947. "[This article] outlines the staggering problems of defense America would face. The report confirms what most Americans suspect—that another war might bring down the curtain on civilized society."

HOW TO IDENTIFY AN AMERICAN COMMUNIST

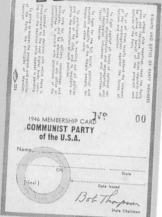

Adapted from material prepared by Friends of Democracy, Inc.

There is no simple definition of an American Communist. However, certain general classifications can be set up. And if either a person or an organization falls within most of these classifications, that person or organization can be said to be following the Communists' lead.

These identifying classifications include:

1) The belief that the war waged by Great Britain and her allies during the period from August 1939 to June 1941 (the period of the war before Russia was invaded), was an "imperialistic" war and a game of power politics.

2) The support of foreign policy, which agrees always with that followed by Soviet Russia, and which changes as the USSR policy changes.

3) The argument that any foreign or domestic policy, which does not fit the Communist plan, is advanced for ulterior motives and is not in the best interests of either the people or of world peace.

4) The practice of criticizing only American, British, and Chinese policies, and never criticizing Soviet policies.

5) Continually receiving favorable publicity in such Communist publications as the *Daily Worker* and the *New Masses.*

6) Continually appearing as sponsor or co-worker of such known Communist-front groups as the Committee to Win the Peace, the Civil Rights Congress, the National Negro Congress, and the groups which can be described as Communist inspired because they fall within the classification set forth here.

7) Continually charging critics with being "Fascists," no matter whether the criticism comes from liberals, conservatives, reactionaries, or those who really are Fascists.

8) Arguing for a class society by pitting one group against another; and putting special privileges ahead of community needs as, for example, claiming that labor had privileges but had no responsibilities in dealing with management.

9) Declaring that capitalism and democracy are "decadent" because some injustices exist under those systems.

Of course, actual membership in the Communist Party is 100 percent proof, but this kind of proof is difficult to obtain.

(From Look *magazine, March 4, 1947)*

"THE SOURCES OF SOVIET CONDUCT," by "X" [George Kennan], in *Life,* July 28, 1947 [reprints article in July issue of *Foreign Affairs*]. "Magazine article is causing a sensation because it is believed that it expresses the official U.S. view of why the Russians act as they do."

"HOW THE GARMENT UNIONS LICKED THE COMMUNISTS," by J. C. Rich, in *The Saturday Evening Post,* August 9, 1947. "Nowhere else in this country are there as many commies per square foot as in New York's garment district. Yet the Reds have been licked time after time in their campaign to gain control of the clothing workers' unions. A man who had a ringside seat at these battles tells of the shrewd tactics which have kept leadership in moderate hands."

"NEGATIVE NEANDERTHALER," cover story in *Time,* August 18, 1947. "But [Russia's permanent representative on the U.N. Security Council Andrei] Gromyko behaves in chancelleries and council chambers with all the charm of a misanthropic robot. He is blunt, aloof, without imagination, without the right (or apparently the will) to independent thought. He refers every decision to Moscow."

"RED STAR OVER THE MIDDLE EAST," by Joseph and Stuart Alsop, in *The Saturday Evening Post,* September 20, 1947. "The authors offer some hitherto undisclosed facts about the cunning and ruthless Soviet offensive in an area vital to us. What to do? They offer an aggressive strategic program."

"WHAT THE TRUMAN DOCTRINE REALLY MEANS," by Major George Fielding Eliot, in *See,* September 1947. "President's new foreign policy, if adhered to, promises to prevent third World War."

"THE VISHINSKY APPROACH," cover story in *Time,* September 29, 1947. "If [Soviet Deputy Minister for Foreign Affairs Andrei] Vishinsky had meant to sow dissension in the U.N., he had chiefly succeeded in sandbagging the peace-loving nations. If he had meant to sow dissension in the U.S., he had a lot to learn about Americans. The amplifications, and the fury of his delivery were the mouthings of a bully whose number has been called. Cracked one wag: 'I guess Uncle Joe has not got The Bomb.'"

"THE STRANGE CASE OF THE TAFT-HARTLEY LAW," by Claude Robinson, President, Opinion Research Center, in *Look,* September 30, 1947. (One provision of this law is that Communists are not permitted to hold office in unions.)

LOOK
VOLUME 11, NUMBER 14
JULY 8, 1947

1. FIRST BLOW An atomic bomb attack will come with no more warning than Texas City had. After the first blast, the armed forces (right) will move in. For General Eisenhower's views on the new blast, and the threat of an atomic war, read this story. Follow the pictures to see what could happen to a city in an atomic-bomb attack.

We Can Lose the Next War in Seven Days
By NAT S. FINNEY
of LOOK's Washington Bureau

EDITOR'S NOTE
LOOK here reports on what military experts think another war will be like. It outlines the staggering problems of defense America would face. The report confirms what most Americans suspect—that another war might bring down the curtain on civilized society.
LOOK feels that no stronger argument can be offered to encourage Americans to do everything they can to help prevent another war.

In the next war the first seven days will be decisive. Victory or defeat will depend upon the nation's readiness to withstand an enemy's first assault without demoralization and collapse, and upon its ability to strike back instantly....

The ingratiating smile was absent from General of the Army Dwight D. Eisenhower's face when he spoke those words to a group of congressmen at a Washington dinner. The U. S. Army's Chief of Staff became sterner as he went on to spell out the new facts of military life. His blunt words let his listeners understand it is no pleasant job to be responsible for planning America's defense in the next war—an atomic war in which the United States must, because of its constitutional democracy, await an enemy's first blow before it can strike.

(Continued on next page)

"J. EDGAR HOOVER: COMMUNIST HUNTER NO. 1," in *Look,* October 14, 1947. "His FBI is charged with keeping the government's payrolls free from any subversive or disloyal employees."

"THE TRUTH ABOUT RUSSIA'S 12,000,000 SLAVE LABORERS," by David J. Dallin and Boris I. Nicolaevsky, in *Look,* October 28, 1947. Also in this issue: "We're a Third-rate Power in the Air" by Richard Tregakis, author of *Guadalcanal Diary.* "Today, two years after V-J Day, America is heedlessly repeating a mistake first made at the end of World War I: We are letting our air power crumble. At our present rate, we are producing only a third of our required air strength. Should a third World War come, our money may not buy us the time that is needed to build an air arm."

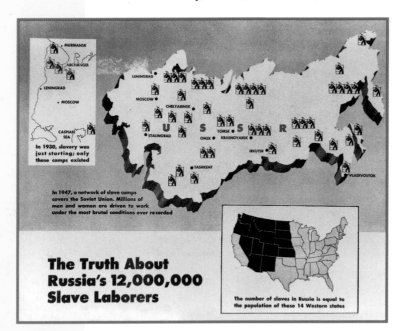

The Truth About Russia's 12,000,000 Slave Laborers

The number of slaves in Russia is equal to the population of these 14 Western states

In 1930, slavery was just starting; only these camps existed

In 1947, a network of slave camps covers the Soviet Union. Millions of men and women are driven to work under the most brutal conditions ever recorded

"WE'RE PREPARING FOR THE WRONG WAR," by Major Alexander P. de Seversky, in *Look,* December 9, 1947. "But real air power is still not a reality. In this article, Major Seversky describes what we must do—while there is still time."

"PORTRAIT OF AN AMERICAN COMMUNIST," by John McPartland, in *Life,* January 5, 1948. "After 12 years of hard work, boredom, and grim discipline, a member of the party now waits for a crisis—and power." (The story of "Kelly," CPA member since 1935.)

"COMMUNISTS IN LABOR WILL LOSE GROUND IN 1948," by Victor Riesel, in *Look,* January 6, 1948. "Both the AFL and the CIO will actively support the Marshall Plan, while cleaning out left-wingers who refuse to sign loyalty oaths. Under the Taft-Hartley Act, unions will sue unions . . . "

"IS THERE A 'WITCH HUNT'?," Editorial in *Life,* January 12, 1948. "No—although the hunt for real enemies has been partly bungled. Let's keep our heads."

"STALIN THINKS I'M DEAD," by Vasili Kotov, in *The Saturday Evening Post,* January 17, 1948. (Part I of III. The byline is a pseudonym.) "In the Soviet Union, I am a dead man."

"DOES COMMUNISM THREATEN CHRISTIANITY?," by Dorothy Thompson in *Look,* January 20, 1948. "Here are the candid views of an expert who tackles a question vital to the spiritual welfare of mankind."

"COMMUNISM–HEIR OF FASCISM," by William Henry Chamberlin, in *Look,* February 3, 1948. "While the Soviets claim to despise fascism, they have actually adopted the worst features of it."

"U.S. FOREIGN POLICY TAKES A LICKING," in *Life,* March 8, 1948. "Russia pushes a new salient into Western Europe as the Communists seize total power in Czechoslovakia."

"THE HUNTER," cover story in *Time,* March 22, 1948. "Most Soviet citizens go to bed at night without fearing that Beria's MVD will pound on their doors. This security, however, is bought at a terrible price... More and more power gravitates toward Beria, not merely because he is an ambitious intriguer, but because power brings more power. How many million spies and informers he has, no one outside the Kremlin can say."

"THE REDS HAVE A STANDARD PLAN FOR TAKING OVER A NEW COUNTRY," in *Life,* June 7, 1948. An illustrated, cautionary feature that depicts each step of the Communists' "technique" for seizing control of a country.

"LIFE STORY OF STALIN," by Louis Fischer in *Look,* June 8, 1948. "This small man with drooping shoulders tyrannizes one-fifth of the world. The story of his rise to absolute power over millions of lives is told in a two-part biography by a veteran reporter who spent 14 years in Russia."

"WE NEED NOT FIGHT RUSSIA," by Barbara Ward (Foreign Affairs Editor of *The Economist*), in *Look,* July 20, 1948.

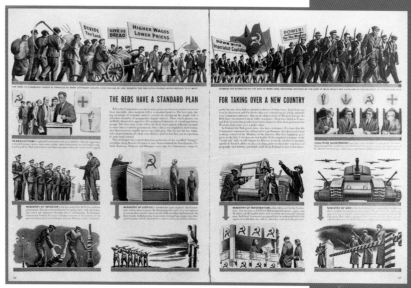

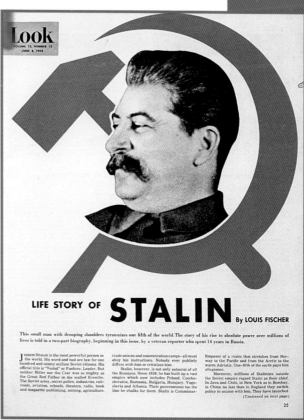

"COULD THE REDS SEIZE DETROIT?," by James Metcalfe, in *Look,* August 3, 1948. (Pictorial dramatization) "Many factors make Detroit a focal point of Communist activity. Not the least of these is its geographical location. Only a narrow river separates the city from Canada, a foreign country. Ignoring the formalities of legal entrance, Red agents can shuttle back and forth, as rum-runners did during Prohibition days." The piece goes on to note that there are between three to six thousand "sinister" Communists currently believed to inhabit Detroit—modest numbers, it would seem, for implementing a citywide takeover. But their ranks would quickly be augmented, it is suggested, by the prisoners of the Wayne County Jail, who would be freed, recruited, and armed within minutes of the "blitzkrieg-style" attack. And then, "for at least one night, Detroit could know the chaos and horror that Bogota, Colombia knew this spring when a Red inspired revolt unleashed a reign of terror and destruction."

Dramatized with the cooperation of formidable Detroit police commissioner Harry Toy and his legion of four thousand officers, along with the help of the Wayne County Road Patrol and Detroit Mayor Eugene I. Van Antwerp, "Could the Reds Seize Detroit?" is a paean to paramilitary passion and paranoia.

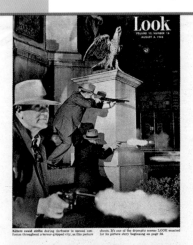

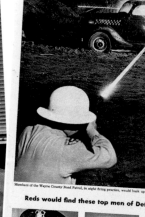

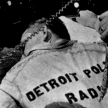

Members of the Wayne County Road Patrol, in night firing practice, would back up the Detroit Police Department's riot squads in counterattacks on the Reds.

Reds would find these top men of Detroit Police Department tough foes

"A REPORT ON RUSSIA'S STRENGTH: THE SOVIET UNION IS BUILDING A GREAT MACHINE FOR WAR," in *Life,* August 9, 1948: "Everyone knows that Russia is a closed country: how, then, do we know? The result is not complete . . . but it adds up to the best available answers to questions that all the world is asking." Also in this issue: "The Great Airlift Sustains Berlin."

"HOW WE WON THE WAR AND LOST THE PEACE," by William C. Bullitt, in *Life,* August 30, 1948. "Former Ambassador Bullitt looks back on 15 years of U.S. foreign policy, explains America's dangerous position in the world today, and lists the errors in judgment that got us there." (Bullitt negotiated a treaty with Lenin in 1919, and became FDR's first Ambassador to the USSR in 1933.)

"HOW RED A HERRING?," Editorial in *Life,* September 6, 1948. "The spy revelations are credible if we remember the past two decades." Also in this issue: "The Thomas Committee Censures Alger Hiss," and "How We Won the War and Lost the Peace, Part Two" by William C. Bullitt. ("Former Ambassador Bullitt reveals the sad inside history of Teheran, Yalta, and Potsdam, where two American presidents gave away the fruits of victory for Stalin's empty promises.")

"HOW CLOSE ARE WE TO WAR WITH RUSSIA?," by Cecil Brown, in *See,* September 1948. "The world is the prisoner of patterns that produced conflicts in the past." Also in this issue: "Berlin—Spy Center of the World" by John Lewis Carver ("Shrewd men and beautiful women scramble to learn and sell secrets of all nations").

"KARL MARX," by Hubert Kay, in *Life,* October 18, 1948. "Beset by creditors, carbuncles, and a houseful of romping children, he wrote the bible of communism on which Russia's policy is based."

"JOHN GUNTHER REPORTS FROM BEHIND THE IRON CURTAIN," in *Look,* November 9, 1948.

"REVOLT IN KOREA: A NEW COMMUNIST UPRISING TURNS MEN INTO BUTCHERS," in *Life,* November 15, 1948.

"HOW WE CAN WIN THE COLD WAR WITH RUSSIA," by Eric Johnston, President, Motion Picture Association of America, in *Look,* February 15, 1949. "A well-known observer of the workings of the Soviet shows where we have failed in the struggle against world communism. He proposes a new program— expensive, yes, but cheaper than another war."

"THE RUSSIANS ARE AFRAID OF US," by John Gunther, in *Look,* March 1, 1949. "Because they are afraid, they get tough . . . They're confident we won't call their bluff . . . They think friction works to their advantage . . . They think our rearmament may bankrupt us."

"HERE'S WHERE OUR YOUNG COMMIES ARE TRAINED," by Craig Thompson, in *The Saturday Evening Post,* March 12, 1949. "Do you imagine that all the youthful dupes of United States Reds are embittered misfits from underprivileged families? Then this

article, telling how and where American youngsters are taught contempt for their country, will enlighten—and shock you."

"RUSSIA IS LOSING THE BATTLE OF BERLIN—BUT CAN WE WIN IT?," by John Gunther, in *Look,* March 15, 1949. "Red prestige is at its lowest ebb, but we don't know what to do next."

A Post Double-Length Article Complete in This Issue

"WHY I TURNED AGAINST RUSSIA," by Louis Fischer, in *Look,* March 29, 1949 (excerpted from the book *Why I Changed My Mind about Communism* edited by R. H. Crossman). "The dream of equality for all men has vanished in the dictatorship of one, and communism's promise of a better world has become a threat to the freedom of men everywhere."

"I LEARNED ABOUT COMMUNISM THE HARD WAY," by Paul Ruedemann, in *The Saturday Evening Post,* May 28, 1949. "The unique and dramatic step-by-step account of how a Russian puppet state stole a Standard Oil subsidiary, imprisoned the American manager—the author—in a dungeon, and forced him to sign a 'confession' before permitting him to escape."

"NOW THE RUSSIANS ARE FLEEING RUSSIA," by Marguerite Higgins, in *The Saturday Evening Post,* June 4, 1949. "Thousands of Red Army deserters, discovering their leaders lied to them about life outside, find refuge in the American Zone of Germany today. Here's what they tell us about their homeland and its war aims."

"I SAW RUSSIA PREPARING FOR WORLD WAR III," by Nicholas Nyaradi (former finance minister of Hungary), in *The Saturday Evening Post,* July 2, 1949. "The author tells how the Soviet, in violation of treaties, is forging satellite armies which will be ready to fight by 1951. Compelling evidence of the Kremlin's plan."

"TITO DEFIES THE KREMLIN," cover story in *Life,* September 12, 1949. "Exclusive pictures show a nation under pressure."

"RUSSIA THROUGH RUSSIAN EYES," by John Scott, in *Life,* September 26, 1949. "Nine former Soviet citizens tell the story of their old life and why they won't return. . . The first-hand stories which are reported here [by a scientist, an artist, a soldier, a doctor, a math teacher, a colonel in the army, a journalist, an aircraft designer and a reservist captain] comprise the most comprehensive close look at conditions in the Soviet Union in recent years."

"I SAW THE RUSSIANS SNOOPING," by Jack Roberts in *The Saturday Evening Post,* October 1, 1949.

"RUSSIANS EXPLAIN ATOM BLAST," in *Life,* October 10, 1949. "They say they set off bomb to reverse rivers and make desert blossom."

"THE COMMIES DON'T EVEN SAY 'THANKS,'" by James Burke, in *The Saturday Evening Post,* October 22, 1949. "A first-person account of one of today's most remarkable foul-ups. How our planes, tires, tractors, and clothing—meant for the Nationalists—actually wind up in the hands of China's communist forces."

"WHAT KIND OF MAN IS STALIN?," by Lt. General Walter Bedell Smith (former U.S. ambassador to Russia), in *The Saturday Evening Post,* November 12, 1949. "Is Stalin an absolute dictator or, as some observers have said, is he a prisoner of the Politburo? Does he keep promises made across the conference table? The former American ambassador gives you his answers and tells a fascinating story of one historic face-to-face session with the Generalissimo." Followed by Bedell's "Why the Russian People Don't Rebel," in the issue of November 26, 1949: "From the cradle to the grave the Soviet citizen is taught to believe that he is the luckiest man alive. And for skeptics, there are the secret police—who already have some 15,000,000 Russians doing 'involuntary labor.'"

"SCIENTIFIC WEAPONS AND A FUTURE WAR," by Dr. Vannevar Bush (President, The Carnegie Institution of Washington), in *Life,* November 14, 1949. "Intercontinental Missiles? High bomber fleets? Carriers? A great scientist tells the facts about new weapons and explains how war can be averted or, if necessary, won."

"IRON CURTAIN COUNTRIES," in *Life,* December 5, 1949. "A sensitive photographer [Werner Bischof] shows their somber mood."

"HOW PREPARED ARE WE IF RUSSIA SHOULD ATTACK?," by George Fielding Eliot, in *Look,* June 20, 1950. "A leading military expert analyzes our defenses and finds America vulnerable at almost every point."

"IS FORMOSA NEXT?" by John Osborne, in *Life,* August 7, 1950. "It probably can be defended, but Reds plan to take it—and all of Asia—eventually."

Look
VOLUME 14, NUMBER 13
JUNE 20, 1950

HOW
PREPARED
ARE WE
IF
RUSSIA
SHOULD
ATTACK?

A leading military expert
analyzes our defenses and
finds America vulnerable
at almost every point

Bombs like these we dropped on enemy target in last war could hit us

By GEORGE FIELDING ELIOT

Could we repel a Soviet attack against America and its outlying bases? The way our defenses are today, the answer is no. Our state of preparedness at almost every point falls far below

sending our forces to defend Western Europe. Besid offensive against Atlantic shipping, the Russians leash attacks against every point they could rea

"THE ORDEAL OF JUDGE MEDINA," by Jack Alexander, in *The Saturday Evening Post,* August 12, 1950. "Every day of the nine-month trial fanatics screamed 'Rat!'—and worse—at Harold Medina. They threatened him, abused him, fought vainly to make him lose his temper and even his mind. This is how he survived the communist trial…"

"NOW THEY KNOW WHAT RED CONQUEST MEANS," by William W. Worden, in *The Saturday Evening Post,* November 25, 1950. "For three months this middle-class family lived like hunted animals in the ruins of Seoul. That's what Red terror meant to

Communist Leader Foster and five of the defendants in the trial before Judge Medina: Stachel, Winston, Davis, Dennis and Williamson.

How Will Our Law Against Traitors Work?

By BEVERLY SMITH
Washington Editor of The Saturday Evening Post

Why did rugged Sen. Douglas weep during the debate on the anticommunist act? How could the President say it makes "a mockery of our Bill of Rights" – while such men as Saltonstall, Vandenberg and Connally voted for it? What's the truth about the least understood law in U. S. history?

THE Internal Security Act of 1950, sometimes called the McCarran Act or the anticommunist law, is one of the most controversial and least-understood laws in the history of the republic. Yet it is of high importance that Americans understand it, since it involves (1) our national safety and (2) our individual liberties.

Its advocates say this law helps protect our safety and does not endanger our liberties. Its critics say that it does not protect our safety, and does endanger our liberties. There are wise and patriotic men on both sides of the argument. The law is there for all to read. Yet one side says "Good," the other says "Bad." Public understanding of the law was further obscured by an accident of timing. The final debates on the bill and the split between Congress and the President, which would normally have held top billing in the newspapers and on the radio, were overshadowed by the news from Korea. That was the week of the Inchon landing and the battle for Seoul. Arguments about the anticommunist bill were drowned out, for the public, by anticommunist gunfire.

On September twentieth the law was passed over-whelmingly by the House and the Senate. Two days later President Truman vetoed it. His veto message, 5,000 words long, detailed and fervent, was one of the most emphatic ever written by a President. He said the law "would not hurt the communists. Instead, it would help them . . . it would actually weaken our existing internal security measures . . . It would make a mockery of our Bill of Rights and of our claims to stand for freedom in the world . . . give aid and comfort to those who would destroy us . . . this legislation would be a terrible mistake." And he gave his reasons at length.

His veto was applauded by many influential newspapers, by numerous churchmen and distinguished liberals, and by the heads of the AFL and CIO—who usually swing great weight with Congress. Nevertheless the House and Senate promptly overrode Mr. Truman by massive majorities. The Democratic President, in a Democratically controlled Congress, was able to muster only two senators and forty-eight representatives—a bit over 10 per cent of each house—to support his veto.

How explain this vast rift, this astounding divergence? Critics of the law say: "Congress had the election jitters. In its hysteria it was willing to vote

them—and would mean to any other family engulfed by a wave of communism."

"HOW U.S. CITIES CAN PREPARE FOR ATOMIC WAR," by Prof. Norbert Wiener, M.I.T. (inventor of cybernetics), in *Life,* December 18, 1950. "M.I.T. professors suggest a bold plan to prevent panic and limit destruction." Also in this issue: "Berlin Voters Defy Reds"; "Trouble in Red China" by Rodney Gilbert; "The Situation in Korea: 'Bug Out'" by Hugh Moffet.

"HOW WILL OUR LAW AGAINST TRAITORS WORK?," by Beverly Smith, in *The Saturday Evening Post,* January 13, 1951. "Why did rugged Sen. Douglas weep during the debate on the anti-Communist act? How could the president say it 'makes a mockery of our Bill of Rights'—while such men as Saltonstall, Vandenberg and Connally voted for it? What's the truth about the least understood law in U.S. history?" The article discusses the implications of the recently passed McCarran Act, aka the Internal Security Act.

"HOW THE POLITBURO THINKS," by Leo Rosten, in *Look,* March 13, 1951.

"THE HISS CASE ENDS AT LAST," in *Life,* April 2, 1951. A photo shows Alger Hiss being led off in handcuffs for the ride to the House of Detention, where he will begin serving his five-year sentence for perjury.

"DEMAGOGUE MCCARTHY: DOES HE DESERVE WELL OF THE REPUBLIC?," Cover story in *Time,* October 22, 1951. "He comes up to you with tail wagging and all the appeal of a tramp dog—and [is] just about as trustworthy."

"SATELLITES IN ARMS," by Leland Stone, in *Life,* December 17, 1951 (excerpted from his forthcoming book *Conquest by Terror*). "Soviet Russia has been secretly mobilizing

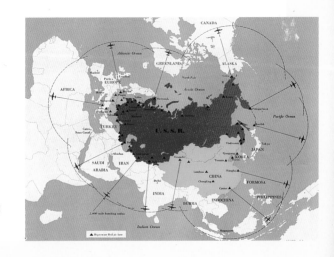

the Iron Curtain nations and with one order can send a million extra soldiers to war."

"THE HOLE IN THE IRON CURTAIN," by Richard Thruelsen, in *The Saturday Evening Post,* January 26, 1952. "We still have one direct channel of communication into the Soviet world—the 46-language Voice of America. Only part of its daily barrage of truth gets through to Red countries, but the Voice sometimes hits where it hurts. Else why does it make Moscow so mad?"

"WHAT THE LOYALTY OATH DID TO THE UNIVERSITY OF CALIFORNIA," by Dan Fowler, in *Look,* January 29, 1952. "It labored like a mountain to produce two tiny mice, a Communist piano player and a part-time teaching assistant." Also in this issue: "Is Stalin in Trouble?" by Edward Crankshaw: "His gamble for world domination has strained the Russian people to the limit—if not beyond—and disrupted the Soviet's vaunted planned economy."

"THE MCCARRAN CURTAIN," editorial in *Life,* March 10, 1952. "The McCarran curtain . . . cannot exclude Communism. Rather it isolates us from the full knowledge of Communism. It protects us from knowing what we are up against."

"THE PEOPLE IN RUSSIA," by Admiral Alan G. Kirk, in *Look,* April 22, 1952. "Admiral Kirk, who, as U.S. ambassador, lived and traveled in the Soviet Union, frankly answers the questions which most Americans would like to ask of the Russian workers and farmers."

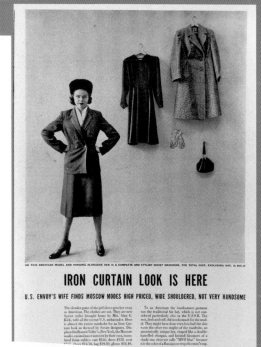

IRON CURTAIN LOOK IS HERE

U.S. ENVOY'S WIFE FINDS MOSCOW MODES HIGH PRICED, WIDE SHOULDERED, NOT VERY HANDSOME

Stalin's Secret War Plans

By GEN. ALEXEI MARKOFF

The author, a former confidant of Stalin's marshals, warned us, in 1950, of the coming Korean invasion. Now he tells us where and

"IRON CURTAIN LOOK IS HERE," in *Life,* March 10, 1952 (fashion article). "U.S. envoy's wife finds Moscow modes high priced, wide shouldered, not very handsome."

"STALIN'S SECRET WAR PLANS," by Gen. Alexi Markoff, in *The Saturday Evening Post,* September 20, 1952. "The author, a former confidant of Stalin's marshals, warned us, in 1950, of the coming Korean invasion. Now he tells us where and how the Reds will strike, if war begins in Europe or the Middle East."

"I WENT TO SCHOOL BEHIND THE IRON CURTAIN," by Ivan Pluhar, in *Quick,* November 17, 1952. "Mr. Pluhar, a Czech student, fled in 1951 from forced labor in the uranium mines of his Communist-run homeland."

THE COLD WAR HITS THE SILVER SCREEN

THREE FOR THE SHOW: "THE IRON CURTAIN," "THE RED MENACE," AND "I MARRIED A COMMUNIST"

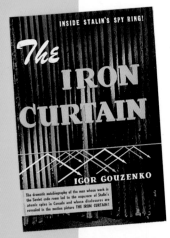

THE IRON CURTAIN, based on the 1947 book of the same name, was the first Cold War film drawn from the headlines. It dramatized the much-ballyhooed case of Igor Gouzenko, a code clerk at the Soviet embassy in Ottawa, Canada, who in 1945 turned over to Canadian authorities 109 documents proving that his embassy coworkers had been stealing atomic secrets from the Allies. Eleven Soviet agents were convicted as a result of Gouzenko's efforts–most shockingly, Fred Rose of the Canadian Parliament and British scientist Alan Nunn May.

Making good use of the phrase coined by Winston Churchill in his legendary 1946 speech ("From Stettin in the Baltic to Trieste in the Adriatic, an iron curtain has descended across the Continent . . ."), 20th Century-Fox gave *The Iron Curtain* the full A-picture treatment for its 1948 release. Studio stars Dana Andrews and Gene Tierney were cast as Gouzenko and his wife, Svetlana, and top director William Wellman was put in charge of the production. The result was a dark, almost

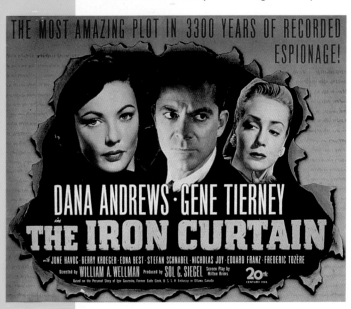

dull account of Gouzenko's adventure, notable primarily for Andrews's perpetual pout. But *The Iron Curtain* did launch the cycle of Red Menace and atomic-spy films that would roll into theaters like a Red tide over the next few years, most of which were considerably more fun.

As for Gouzenko and his family, the Mounties put them into the Canadian version of the Witness Protection Program as a hedge against retaliation by the NKVD, the Soviet Union's secret police force. (They were still very much on Gouzenko's mind, even after the death of Stalin, as his 1954 confession in *Look,* "I'm Still in Hiding for Life," indicated.) But at least the film ended with a bucolic vision: the Gouzenkos walking along a sunny country road as two dour government bodyguards follow behind, lugging the family's picnic basket.

"See . . . How a Psychopathic Love-Starved Woman Defies the Law!"

"See . . . How a Man Is Driven to Suicide Rather Than Bend to the Yoke of Tyranny!"

"See . . . How a Man Is Brutally Murdered Because He Challenges Gangster Rule!"

That ad from Republic Pictures's marvelously sensationalistic 1949 campaign neatly conveys the flavor of *The Red Menace,* the studio's overheated exposé of Communist Party treachery. Narrated by Los Angeles city councilman Lloyd G. Douglas, *The Red Menace* may stand as the only movie ever made in which every bit of dialogue is a position paper.

The plot: When angry vet Bill Jones

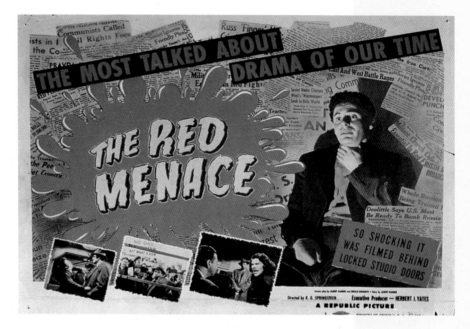

finds the folks at Veteran's Aid unresponsive to his complaints, he is targeted by Red agents as a disillusioned sap ripe for recruitment into the Party. Seduced by B-girl Molly, a very poor man's Mata Hari, the easily manipulated lug starts attending adult education courses in Communist thought. There he falls for his attractive teacher, Nina Petrovka, who dispenses the Party line even as she becomes increasingly aware that her cell is run by a collection of thugs and lunatics. When a sensitive Jewish poet named Solomon is driven to commit suicide after the Party has excommunicated him for deviationism—he wrote a poem about Marx that credited Hegel (what rhymes with Hegel?)—Bill and Nina flee. Even Molly, the lapsed Catholic, will return to the Church and the arms of her forgiving mother, as the local padre beams. No wonder the Communist newspaper the *Daily People's World* called the film "stupid but dangerous." Given that review, it's hard to see why, as the poster boasts, the picture had to be "filmed behind locked studio doors!" (Maybe they were afraid the actors would escape.)

A valentine to the packs of HUAC investigators nipping at Hollywood's heels, *The Red Menace* won a commendation for Republic studio boss Herbert J. Yates. The "world wide Marxist racket," as one character refers to communism, never seemed so pathetically inept.

I Married a Communist, inspired in large part by the case of Harry Bridges, the leader of the West Coast longshoremen whom the government spent some thirteen years and millions of dollars futilely trying to convict of having allowed Reds to infiltrate

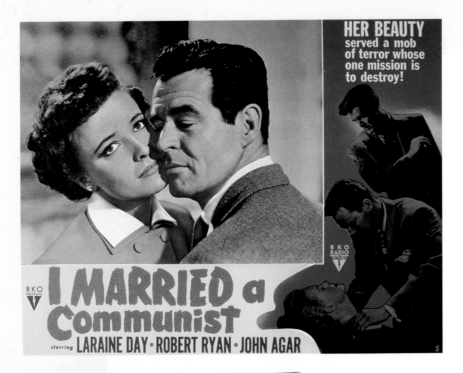

HER BEAUTY served a mob of terror whose one mission is to destroy!

RKO PRESENTS

I MARRIED a Communist

starring LARAINE DAY · ROBERT RYAN · JOHN AGAR

Her Beauty served a mob of terror whose one mission is to destroy!

RKO presents

I MARRIED a Communist

starring
LARAINE DAY · ROBERT RYAN · JOHN AGAR
with THOMAS GOMEZ · JANIS CARTER
Executive Producer SID ROGELL · Produced by JACK J. GROSS · Directed by ROBERT STEVENSON
Screen Play by CHARLES GRAYSON and ROBERT HARDY ANDREWS

his union, opened in New York in the fall of 1949. That must have seemed a timely choice; Bridges's final trial (after endless appeals) and the Foley Square trial of eleven leaders of the CPA had been in the headlines for months. But the fortuitous publicity tie-ins must not have helped, as RKO studio boss Howard Hughes had the film yanked before it went into national distribution. He rereleased it months later under the less polarizing title *The Woman on Pier 13,* but to no avail. Audiences still didn't want to see this film noir fable of dumb Americans being outsmarted by thuggish, gun-toting Communists, whose insidious plan is to take over New York's waterfront (and then, of course, the rest of the world).

Robert Ryan and Laraine Day play the newlyweds whose bliss is obliterated when union leader Ryan's past as a Lefty comes back to haunt him. It seems that Ryan once was a member of the Party, like so many other well-meaning liberal Americans in years past. But now they are blackmailing him with the threat of exposure, which—given the climate of 1949—would surely cost him his job. So he plays along, helping them infiltrate his organization, and keeping the dark secret from his puzzled wife. But by the time the dust has settled, poor dupe John Agar (playing Day's cocky younger brother) has become the prey of Red seductress Janis Carter, and gets run over by a car driven by the Commie hoodlums. Then Carter, who had fallen for Agar, gets defenestrated for going soft on the Party. In the end, Ryan

gets shot to death in a warehouse donnybrook with Red cell leader Thomas Gomez. By then, paying customers were probably running for the exits and straight to their local FBI office.

Still, the film had its moments. This excerpt from the screenplay features a Party official named (irony of ironies!) Nixon blackmailing Ryan/Brad with his past history (as erstwhile Party member "Frank Johnson") to force him to turn over control of the longshoremen's union to the Reds:

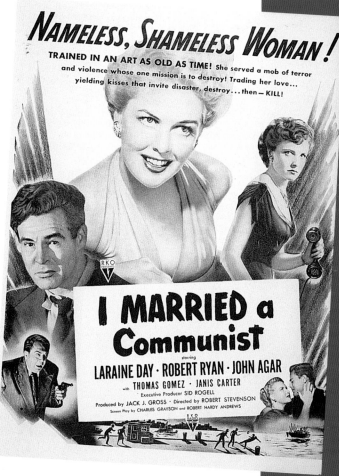

NIXON: All right, Johnson.
(Brad advances to him grimly.)
BRAD: I came down here to get something settled . . .
NIXON: (interrupts) I sent for you—Johnson—because I wanted to refresh your memory about what can happen to Party members who betray their Party oath. In your case, you're going to be given the opportunity to redeem yourself . . .
BRAD: Look—I'm out of the Party. I've been out for years. You've got nothing I want. . . . What do you want from me?
(As he speaks, Nixon dons spectacles—writes on slip of paper. Brad's half-plea, half-challenge means nothing.)
NIXON: (interrupting again) Beginning immediately, two fifths of your salary will be deposited in this bank, to the account of this organization. (hands slip across table) The organization is listed as a charity. Therefore, your contributions are tax-deductible. That's very important to some of our higher-bracket members. Incidentally, Johnson, we know the exact amount of your income from all sources.
BRAD: I bet you do! Just like the good old days.
NIXON: Not quite. Frank Johnson could make speeches at meetings—pass out handbills—brawl in the streets. Mr. Bradley Collins can't. Your present position qualifies you for much more important service to the Party.
BRAD: Now, look . . .
NIXON: (interrupts) You'll be notified when I have orders for you. That's all.

HOW HOLLYWOOD TOLD THE TALE OF THE COLD WAR

CONSPIRATOR (MGM, 1949) – Elizabeth Taylor (here still in her teens) is shocked to learn that husband Robert Taylor, a British officer, is in fact a murderous Communist agent.

PROJECT X (Film Classics, 1949) – This low-budget obscurity has physicist Keith Andes, a former member of the Party, being blackmailed by Red college chum Jack Lord, who wants Andes's atomic secrets. Is nightclub siren Rita Colton another Party lure, or just an innocent dupe? And who is the mysterious Commie ringleader "Radik"? The fate of the postwar world hangs in the balance.

GUILTY OF TREASON (Eagle-Lion, 1950) – The story of Cardinal Mindzenty of Hungary, whom the Reds framed as an anti-Semite and imprisoned in 1949. The persecuted prelate, played here by Charles Bickford, was released from prison in 1956.

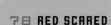

THE WHIP HAND (RKO, 1951) – The northwoods of Wisconsin is the setting of this paranoia-drenched melodrama, which finds Nazi scientists working for the Reds (!), who plan to unleash a worldwide plague of fatal bacteria from their secret lab. Raymond Burr, still in his hulking villain mode, plays the pitiless Commie ringleader.

ASSIGNMENT–PARIS (Columbia, 1952) – Dana Andrews, yet again, this time as a reporter trying to undercover a plot by two Communist nations to destroy the West.

INVASION, U.S.A. (Columbia, 1952) – Barflies watch a live television broadcast that shows the U.S. being overrun by armed Reds after an A-bomb attack. Fortunately, it was only a mass hallucination . . . Or was it?!?

WALK EAST ON BEACON (Columbia, 1952) – Based on the writings of the great man himself, J. Edgar Hoover, this story about the Reds blackmailing an atomic scientist was shot on location in Boston, the former stomping grounds of counterspy Herb Philbrick. (Nice of Herb to leave a few Reds behind for someone else in the Bureau to mop up!)

BIG JIM MCLAIN (Warner Bros., 1952) – John Wayne finally faces off against the Commies in (of all places) Hawaii, as (of all things!) an investigator for HUAC. His HUAC partner in arms here is Jim Arness, better known for his television role of Marshal Matt Dillon on television's long-running series *Gunsmoke*.

RED PLANET MARS (United Artists, 1952) – Those devious Commies are transmitting messages that they want us to believe originate from outer space. And then, all of a sudden, the messages begin to be genuine. Food for deep thought.

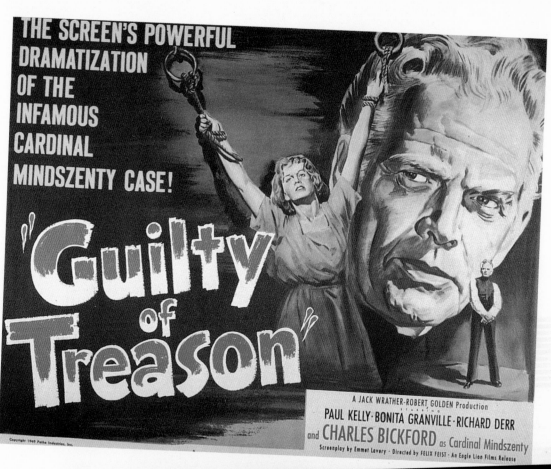

THE SCREEN'S POWERFUL DRAMATIZATION OF THE INFAMOUS CARDINAL MINDSZENTY CASE!

"Guilty of Treason"

Copyright 1949 Pathe Industries, Inc.

A JACK WRATHER-ROBERT GOLDEN Production

STARRING

PAUL KELLY · BONITA GRANVILLE · RICHARD DERR

and CHARLES BICKFORD as Cardinal Mindszenty

Screenplay by Emmet Lavery · Directed by FELIX FEIST · An Eagle Lion Films Release

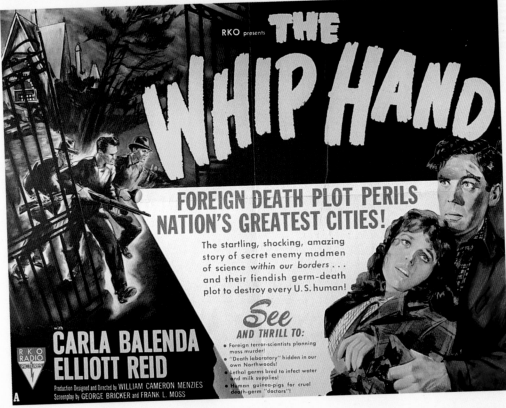

RKO presents THE

WHIP HAND

FOREIGN DEATH PLOT PERILS NATION'S GREATEST CITIES!

The startling, shocking, amazing story of secret enemy madmen of science within our borders . . . and their fiendish germ-death plot to destroy every U.S. human!

See
AND THRILL TO:
- Foreign terror-scientists planning mass murder!
- "Death laboratory" hidden in our own Northwoods!
- Lethal germs bred to infect water and milk supplies!
- Human guinea-pigs for cruel death-germ "doctors"!

with

CARLA BALENDA
ELLIOTT REID

RKO RADIO PICTURES

Production Designed and Directed by WILLIAM CAMERON MENZIES
Screenplay by GEORGE BRICKER and FRANK L. MOSS

A

MY SON JOHN (Paramount, 1952) – Leo McCarey's over-the-top yarn about a college educated lad (Robert Walker, fresh from his role as the psycho in Hitchcock's *Strangers on a Train*) who falls for the Party line, to the horror of his straight-arrow parents (Helen Hayes and Dean Jagger).

PICKUP ON SOUTH STREET (Fox, 1953) – Pickpocket Richard Widmark embroils himself in the Cold War when he unwittingly lifts a roll of microfilm from the pocket of Soviet agent Richard Kyle, who is not amused. Luscious Jean Peters and cantankerous Thelma Ritter help him avoid assassination until, irony of ironies, the Feds step in to save his bacon. One of the best of the period, directed by Sam Fuller.

SECURITY RISK (Allied Artists, 1954) – Fed John Ireland enlists sensuous Dorothy Malone to help him battle the Reds.

TRIAL (MGM, 1955) – University law professor Glenn Ford thinks he's defending an innocent young Mexican boy on charges of murder. But then the Communists who raised money for the boy's defense decide he would be worth more to the Party as a dead martyr, sell him out at the trial, and incite a crowd to lynch him.

THE IRON PETTICOAT (MGM, 1956) – Bob Hope and Katharine Hepburn take a page from *Ninotchka* in this comedy—you guess who is the wisecracking American and who the frosty Soviet official. Not much as a comedy, but we love that title.

ANASTASIA (Fox, 1956) – A bit of nostalgia for czarist days of yore. Ingrid Bergman says she is the long-lost grand duchess of Russia in exile, daughter of the last czar. But can she convince the old, skeptical empress (Helen Hayes)? While this was in theaters (later earning Bergman an Oscar), Khrushchev was busy denouncing the legacy of the Stalin Terror at the Twentieth Party Congress in Moscow and suppressing the uprising in Hungary with Soviet tanks and soldiers.

JET PILOT (RKO, 1957) – Originally filmed in 1950, but tinkered with for the next seven years by RKO studio boss Howard Hughes, this half-serious adventure pits curvaceous Russian jet flier Janet Leigh against American ace John Wayne (fewer curves, more heft). After wooing her with sexy lingerie, a weekend in Palm Springs, and a luscious steak dinner, Wayne convinces his "silly Siberian cupcake" to defect—and marry him! In the bargain, he also inherits her state-of-the-art MIG. (Withheld from distribution for many years thereafter by Hughes, it is now out on video.)

THE GIRL IN THE KREMLIN (Universal, 1957) – "Is Stalin Alive?" Somehow the answer involves Zsa Zsa Gabor, but we don't pretend to know why or how. It's good to see Uncle Joe's visage on a poster again, though, since by this point Khrushchev had branded him an enemy of the Party while exposing the thousands of evil acts he committed while in power.

SILK STOCKINGS (MGM, 1957) – The musical remake of the 1939 classic *Ninotchka*. Cyd Charisse takes on Garbo's role as the no-nonsense Party official sent to retrieve three colleagues who have been seduced by the charms of Paris, and dapper Fred Astaire replaces Melvyn Douglas as the American (this time, a film producer) who tries to thaw out her indoctrinated heart. Cole Porter adds the tunes ("All of You," "Fated to be mated"), and Cyd Charisse contributes those fabulous legs. But Garbo and Douglas, in the nonmusical staging of this East/West fable about communism vs. capitalism, still win out.

FIVE STEPS TO DANGER (United Artists, 1957) – Ruth Roman knows that the Russians have planted one of their agents inside a nuclear facility, but before she can notify the authorities, they mount a campaign to prove she's mentally ill.

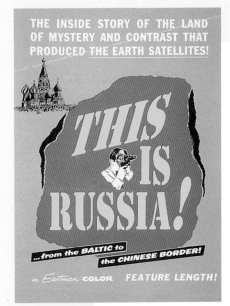

THIS IS RUSSIA! (Universal, 1958) – Documentary about "The Land of Contrast and Mystery That Brought You the Earth Satellites!" Promises to reveal "What Soviet teen-agers are *forced* to learn!"

SPY IN THE SKY (Allied Artists, 1958) – "The Enemy That Watches–Behind the Veil of Space!" After the impact of the Sputnik launch, it came as no surprise that low-budget films were rushed into production to exploit those front-page headlines. Starring Steve Brodie, this was based on a book called *Counterspy Express.*

WAR OF THE SATELLITES (AIP, 1958) – Just days after the U.S. managed to join the USSR in space by launching its Explorer satellite, B-movie king Roger Corman promised that he could get a movie ready for the drive-ins in just two months. And he did–although here America faces off in space against aliens, rather than Russians. Then again, what's the difference?

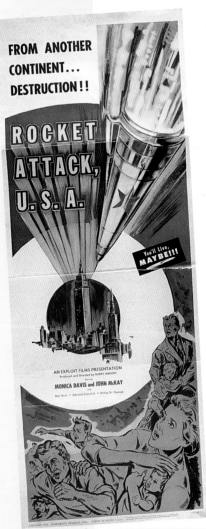

ROCKET ATTACK, U.S.A. (TransAmerica, 1959) – Ultra low-budget anxiety about the Reds' plan to nuke New York City has American spies racing against time to steal their missile plans. Appears to have been made on a budget underwritten with Green Stamps.

MAN ON A STRING (Columbia, 1960) – Ernest Borgnine as real-life counterspy Boris Morros, in a somewhat exaggerated version of Morros's memoir, *My Ten Years as a Counterspy.*

THE SECRET WAYS (Universal, 1961) – Based on the Alistair MacLean novel, Richard Widmark plays a hard-boiled American who penetrates Red-controlled Hungary to help a refugee escape. Shot on location.

WE'LL BURY YOU! (Columbia, 1962) – "The shocking, uncen-sored story of Communist terror that brought half the world to its knees!" The poster's central image is a shot of a raging Premier Khrushchev ("World Enemy #1!" if you're keeping score) that would give King Kong pause. Also features Stalin, Mao, Castro ("Bearded Betrayer!"), Malenkov, Lenin, and poor Trotsky–"The most infamous cast of characters ever assembled in one film!"

THE MANCHURIAN CANDIDATE (United Artists, 1962) – Laurence Harvey, in the best role of his career, plays a former Korean War POW who has been brainwashed so he can be used, years later, to assassinate the presidential nominee. Frank Sinatra is equally memorable as Harvey's commanding officer, who overcomes his own brainwashing to figure out the plot. And the Communist ringleader who devised this

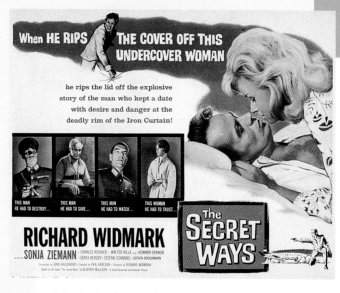

diabolical scheme? Harvey's own mother, played here with chilling precision by Angela Lansbury. From the Richard Condon novel.

RED NIGHTMARE (Warner Bros., 1962) – An oddity, this twenty-five-minute short film shows a small town in the American heartland suddenly taken over by Communist forces. Narrated by America's voice of authority, *Dragnet*'s Jack Webb.

ESCAPE FROM EAST BERLIN (MGM, 1962) – Inspired by the true-life case of an East German chauffeur Erwin Becker (Don Murray) who, in January 1962, tunneled to West Berlin with his girlfriend (Christine Kaufman) and twenty-six other friends and family members. Shot on location in West Berlin, with Becker serving as a technical adviser, the film was advertised as being "Torn from today's headlines," which for once wasn't far from the truth.

FAIL-SAFE (Columbia, 1964) – A B-52 bomber is accidentally green-lighted to nuke Moscow, and President Henry Fonda and his cabinet must parlay with the Russkies to stop the bomber before it can deliver its lethal payload. Originally serialized in *The Saturday Evening Post*, it was remade in the Spring of 2000 as a live (black-and-white) television movie, starring George Clooney as the pilot with the deadly payload, and Richard Dreyfuss as the frantic president.

DR. STRANGELOVE; OR, HOW I LEARNED TO STOP WORRYING AND LOVE THE BOMB
(Columbia, 1964) – *Fail-Safe* played for laughs, but this one came first. This classic black comedy by Stanley Kubrick is based on a cautionary novel, *Red Alert,* by Peter George—but Kubrick marinates the yarn in his own special brand of perversity. The stellar cast features Peter Sellers in three roles, including the title one. Sterling Hayden, one of the Fifties film stars who sang for HUAC, is great here as General Jack D. Ripper; George C. Scott (as Gen. "Buck" Turgidson), Keenan Wynn (Col. "Bat" Guano), and Slim Pickens (Major "King" Kong) also submit classic performances. A fitting sendoff for Nikita Khrushchev, who would be forced into retirement a few months later.

FROM RUSSIA WITH LOVE (United Artists, 1964) – The second of the James Bond films starring Sean Connery, and, for some tastes, the best. Agent 007 faces off against a plethora of villains, per usual, but this time the spycraft is atypically straight-forward: Bond is sent to Istanbul to steal a state-of-the-art Russian decoding machine. He is obliged to seduce a lovely clerk from the Soviet embassy (Daniela Bianchi), who proves quite helpful in the end, and battles unto the death with assassins Robert Shaw and Lotte Lenya.

THE SPY WHO CAME IN FROM THE COLD (Paramount, 1965) – John Le Carré's seminal bestseller gets top-notch treatment here, with Richard Burton splendid as the burned-out agent who's asked to carry out just one more impossible mission for queen and country.

THE IPCRESS FILE (Universal, 1965) – Almost as good as the above entry, based on Len Deighton's almost-as-good best-seller. Michael Caine is terrific as Harry Palmer, a crook converted into a secret agent. *Funeral in Berlin* (1966) and *The Billion Dollar Brain* (1967) continued the series on screen.

DR. ZHIVAGO (MGM, 1965) – A rare foray into pre–Cold War nostalgia, this 197-minute epic by David Lean, adapted from the Boris Pasternak novel, was presented onscreen as the *Gone with the Wind* of the Russian Revolution. Julie Christie as the suffering Lara is all right, but stolid Omar Sharif is no Clark Gable. Truth to tell, he's not even Leslie Howard.

THE RUSSIANS ARE COMING! THE RUSSIANS ARE COMING! (United Artists, 1966) – Nathaniel Benchley's novel *The Off-Islanders* becomes the basis of this popular farce, in which a Russian sub lands off the coast of New England, leading to a culture clash of titanic proportions. Alan Arkin, Carl Reiner, and Jonathan Winters lead the tomfoolery. One of the first tip-offs that America was no longer quaking in its boots over the prospect of a Red invasion.

REDS (Paramount, 1981) – Warren Beatty produced, directed, and cowrote this popular epic about radical American journalist John Reed. Set during the days just prior to, and the onset of, the October Revolution of 1917, it stars Diane Keaton as Reed's lover, feminist Louise Bryant, Maureen Stapleton as the ultra-radical Emma Goldman (for which Stapleton won an Oscar), Jack Nicholson as Eugene O'Neill, Edward Hermann as the erstwhile radical Max Eastman, and Jerzy Kozinski as Communist

Clint Eastwood in

FIREFOX

Tom Clancy

The Hunt for RED OCTOBER

A NOVEL

Party chief Grigory Zinoviev. One of the "witnesses" who reminisces during the documentary interludes is Hamilton Fish, one of the founders of HUAC back in 1930.

FIREFOX (Warner Bros., 1982) – Clint Eastwood is a cranky Vietnam vet and ace pilot recruited to infiltrate Russia, steal its top-secret prototype warplane, and fly it home. Clint being Clint, he just squints a little harder and gets it done.

RED DAWN (MGM/UA, 1984) – Director/writer John Milius's paranoid fantasy about a takeover of the U.S. by Commie mercenaries feels more like 1954 than 1984, but that's the sort of thing that happens when Reagan's "Star Wars" program gets everyone all het up. Patrick Swayze leads the guerrilla counterattack in the Rockies, aided by Jennifer Gray, Charlie Sheen, and the good Lord above.

RAMBO: FIRST BLOOD, PART II (Tri-Star, 1985) – Sly Stallone battles the Russkies, among others, deep in the heart of Cambodia, as he searches for a hidden nest of Vietnam War POWs. An enormous hit, *Rambo* must be taken as part of the woof and weave that made Reagan's hard-line policy towards the Soviet Union so popular at the time.

ROCKY IV (MGM/UA, 1985) – Soviet superboxer Dolph Lundgren kills Rocky's old foe/friend Apollo Creed during a match, and Rocky comes out of retirement to avenge him. Wouldn't you know it, he learns that the sadistic blond giant has been snacking on steroids—but ultimately Rocky is able to obliterate him using good ol' American know-how.

INVASION, U.S.A. (Cannon, 1985) – It's action star Chuck Norris trying to repel an attack by Russians, Cubans, and Arab terrorists who are attempting a takeover of—Florida?!? Well, it probably beats the heck out of the Caspian Sea resorts. Leonard Maltin's grade: "Bomb."

RAMBO III (Tri-Star, 1988) – Now it's off to Afghanistan for John Rambo (Stallone, as if you didn't know), who has to liquidate several thousand Soviet troops in order to save his former commander (Richard Crenna) from prison.

THE HOUSE ON CARROLL STREET (Orion, 1988) – The Rosenberg case looms large in this espionage thriller set in the early Fifties. Kelly McGillis stars as a onetime radical who teams up with FBI agent Jeff Daniels to uncover a plot worthy of McCarthy himself.

RED HEAT (Tri-Star, 1988) – Arnold Schwarzenegger as a tough Soviet cop tracking Russian drug dealers all the way to Chicago, we can buy. But Jim Belushi as his hard-boiled American counterpart? Where's our national pride?? Gorbachev must have been wired into central casting. Else how to explain that this was the first American flick permitted to film scenes in Moscow's Red Square?

THE HUNT FOR RED OCTOBER (Paramount, 1990) – Tom Clancy's trailblazing techno-thriller centers on a cat-and-mouse game between U.S. and Russian nuclear subs. Crafty Russian officer Sean Connery seems to be defecting to the U.S., offering his top-secret submarine as his visa. Or is he just trying to get close enough to U.S. shores to launch his nuclear missiles? It's up to American Intelligence ace Jack Ryan (Alec Baldwin) to figure out the true mission before either Connery or the U.S. is nuked.

THE RUSSIA HOUSE (MGM/UA, 1990) – The John Le Carré bestseller is well served by this spy thriller set largely in and around Moscow, with Sean Connery as a British publisher recruited by British Intelligence to track down the source of a provocative manuscript, and Michelle Pfeiffer the idealistic Russian, Katya. The film spends rather more time showing off its impressive location footage and gorgeous stars than worrying over the spycraft, but we like the casting of the "good guy" spies: director Ken Russell, James Fox, and Roy Scheider.

TIMELINE:

FEBRUARY 9, 1950: Senator Joseph McCarthy (R-Wisconsin), a former Marine tail-gunner, gives his now infamous speech before the Women's Republican Club of Wheeling, West Virginia. There he charges that the State Department "is thoroughly infested with Communists," brandishing a piece of paper that he claims (in some reports) bears the names of 205 employees in the State Department who are either "card-carrying members or certainly loyal to the Communist Party." The following day he delivers a similar speech in Salt Lake City, but now the number has been lowered to 57, which he later maintains is the number he meant all along. **APRIL 10, 1950:** The U.S. Supreme Court upholds the power of congressional committees to compel witnesses to state whether or not they are now, or have ever been, Communists. **JUNE 1950:** *Red Channels: The Report of Communist Influence in Radio and Television,* a 213-page pamphlet that lists 151 names, 130 organizations, and 17 publications with suspicious ties to the Communist doctrine, is published by the team of ex-FBI agents who published the newsletter *Counterattack.* **JUNE 25, 1950:** The People's Democratic Republic of North Korea invades the Republic of South Korea. **AUGUST 1950:** Senator Pat McCarran of Nevada sees his Internal Security Act passed into law. It requires any "Communist-action" or "Communist-front" organization to register with the attorney general, as must the officers of such a subversive organization. President Truman, alarmed by the broad powers of the law, calls the bill "unnecessary, ineffective, and dangerous," but his veto is overridden by both Houses. In effect, this made the act of registration an admission of guilt in belonging to an illegal organization, while the failure to register was also a crime. **DECEMBER 1950:** The Senate creates their own version of the McCarran Act: the Internal Security Subcommittee of the Senate Judiciary Committee. **JANUARY 1951:** Arthur Koestler's anti-totalitarian novel *Darkness at Noon* is adapted for Broadway. It would later win the Drama Critics Circle Award as the year's best play. **MARCH 22, 1951:** His appeal denied, Alger Hiss begins serving his five-year sentence at the penitentiary in Lewisburg, Pennsylvania. He continues to maintain his innocence. **MARCH 22, 1951:** Larry Parks, called before HUAC in its second round of Hollywood investigations, becomes the first screen star to admit to having been a Communist in past years. "Was Red But Not Now, Parks Says" is the headline in that week's issue of the trade journal *The Showman's Trade Review.* Other actors and directors who testify before HUAC over the next few months include Elia Kazan, Mel Ferrer, Sterling Hayden, John Garfield, Edward G. Robinson, and Budd Schulberg. **MARCH 29, 1951:** "Atom spies" Julius and Ethel Rosenberg, who, along with fellow spy Martin Sobell passed

on secret documents from the Manhattan Project to their Soviet "handlers," are found guilty of conspiracy to commit wartime sabotage and sentenced to death. State witness David Greenglass, Ethel's brother, receives a fifteen-year prison sentence. APRIL 1951: Truman's Loyalty Oath for government employees has its penalties stiffened. Now anyone who inspires "reasonable doubt as to the loyalty of the person involved" can be terminated. (In 1947, one could be fired only if "the person involved [has been] disloyal to the government.") JUNE 1951: The Supreme Court upholds the conviction of the eleven Communist Party leaders tried by Judge Harold Medina in New York. Seven surrender to authorities, but four become fugitives. Later, two of them are captured. Author Dashiell Hammett, as trustee of the Civil Rights Congress, had posted their bail. 1951: Senator Joseph McCarthy's *America's Retreat from Victory: The Story of George Catlett Marshall* is published by the Devin-Adair Press. OCTOBER 22, 1951: *Time* magazine runs a cover story on Senator McCarthy titled "Demagogue McCarthy," in which he is credited with a "sweat-stained, shirt-sleeved earnestness." But Tail-Gunner Joe is also taken to task for having "no regard for fair play, no scruple for exact truth." JANUARY 1952: The McCarran-Walter Act is passed by Congress. It empowers the Department of Justice to deport any alien or naturalized citizen who is found to have engaged in subversive activities. MAY 21, 1952: Whittaker Chambers's 799-page memoir, *Witness,* is published by Random House. It was chosen as a Book-of-the-Month Club Main Selection, and had an unprecedented ten-part serialization (Cover slug: "One of the Great Books of Our Time") in *The Saturday Evening Post.* The book was #1 on the best-seller list of *The New York Times* through most of the summer, and went on to become the ninth best-selling nonfiction book of 1952. JULY 9, 1952: Senator McCarthy addresses the Republican National Convention in Chicago. Following several references to the ongoing Korean conflict, his speech ends with these words: "I say one Communist in a defense plant is one too many. One Communist on the faculty of one university is one Communist too many. One Communist among the American advisers at Yalta was one Communist too many. And even if there were only one Communist in the State Department, that would still be one Communist too many." DECEMBER 24, 1952: On Christmas Eve, President Truman pardons J. Parnell Thomas, former head of HUAC, who had served nine months of his eighteen-month sentence in the Danbury Correctional Institute, convicted of taking more than $8,000 in kickbacks while placing nonworking employees on his government payroll from 1940 to 1945. 1953: The FBI conducts an "internal security" investigation of Groucho Marx, the beloved host of the popular quiz show *You Bet Your Life.*

"I'M NO COMMUNIST"

⭐ 5

THE LONG, STRANGE SAGA OF HUAC

t was in June of 1930 that the House of Representatives first created a special committee to police Communist activities in the U.S. By a vote of 210 to 18, the House approved a prototypical version of what would become, eight years later, the House Un-American Activities Committee (HUAC). Charged with the task of being on the lookout for "all entities, groups or individuals who are alleged to advise, teach or advocate the overthrow by force or violence of the Government of the United States" (in essence, the language of the Sedition Act of 1918), this committee's first chairman was Hamilton (Ham) Fish of New York. He had once declared, "It is not the purpose of this resolution to interfere with any group except the Communists in the United States, and we propose to deport all alien Communists." Following its six-month investigation, the Fish Committee tendered a report early in 1931 that, in part, called for the deportation of alien Communists, established an embargo on all articles imported from Russia, and made the Communist Party itself illegal.

After a lengthy period of relative quietude, Congress roused itself in 1938 to again confront the Bolshevik menace head-on. On May 26, 1938, Congressman Martin Dies of Texas was given the opportunity to plead his case for the establishment of his committee to investigate subversives, radicals, and other euphemisms for Communists. "I am not inclined to look under every bed for a Communist," he assured his interlocutors, and he was granted a seven-month charter to investigate "the extent, character, and object of propaganda activities in the United States." Of course, Dies had no intention of stepping down, or aside, after so short a term—not with so much evil abroad in the land. And so he resubmitted his plea to Congress, first in January of 1939, and thereafter on a semi-regular basis, to get refunded so the Committee's activities could continue. Finally, in 1944, suffering from ill health and the cumulative effect of years of criticism lodged by those appalled by his Committee's reckless charges, Dies stepped down from the House. The Dies Committee was officially in the history books.

But HUAC would not remain dormant for long. On January 3, 1945, the opening day of the seventy-ninth Congress, John E. Rankin (D-Mississippi), the chairman of the powerful Veterans Committee, stood and proposed that the House Un-American

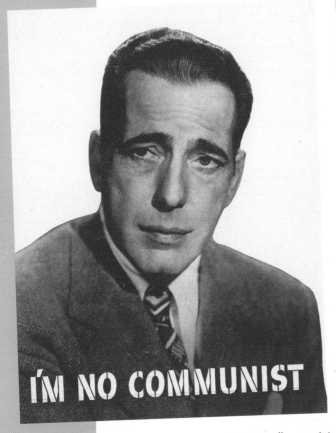

I'M NO COMMUNIST

Activities Committee not only be reactivated, but made a permanent standing committee of the House. To the surprise of many, the motion was passed, 207 for versus 186 against. HUAC was reborn, funded with $50,000, and a new latitude to investigate in any direction it saw fit.

Under the aegis of Chairman J. Parnell Thomas, HUAC's Hollywood hearings open for business on October 20, 1947. Among the first to be called are megastar Gary Cooper, erstwhile MGM glamorpuss Robert Taylor, B-list leading man Ronald Reagan, and British transplant Robert Montgomery. All testify as friendly witnesses, and all disavow any congress with un-American persons, places, or things while toiling in the capital of screen dreams. Taylor, though, does allow that he was a mite piqued when his enlistment in the Navy was held up in 1943 until he had finished filming the pro-Soviet romance *Song of Russia.*

But the next few days would tell a much different story. On October 24, Humphrey Bogart joined a contingent of fifty Hollywood directors, writers, and actors—all part of the group that called itself the Committee for the First Amendment—on a cross-country flight bound for Washington, D.C. Rather foolishly, they had christened their chartered plane "Star of the Red Sea," to express their displeasure with HUAC's investigation into Communist infiltration of Hollywood. Bogart in particular must have felt nigh-invincible. At the peak of his popularity with the movie-going public, Bogart had starred in as many patriotic films during WWII as any actor in the land, including *Sahara, Action in the North Atlantic, To Have and Have Not,* and, of course, *Casablanca.* What better icon of all-Americanism could the 300-member Committee for the First Amendment have chosen to lead the charge against HUAC's high-handed inquisition, spearheaded by the haughty J. Parnell Thomas?

And so, on October 24, 1947, a bow-tied Bogie and a dazzling crew of film and entertainment luminaries that included Lauren Bacall, Groucho Marx, Frank Sinatra, John Huston, Ira Gershwin, Gene Kelly, and Danny Kaye flew East. Their goal: to help protect the rights of the "Hollywood Ten"—Alvah Bessie, Dalton Trumbo, Edward Dmytryk, Ring Lardner Jr., John Howard Lawson, Lester Cole, Herbert Biberman, Albert

HUAC'S SO-CALLED COMMUNIST FRONT ORGANIZATIONS TO WHICH DASHIELL HAMMETT WAS LINKED

The American Committee for Democracy and Intellectual Freedom
The American Committee for the Protection of the Foreign Born
The American Committee to Save Refugees
The American Continental Congress for World Peace
The American Council on Soviet Relations
The American Labor Party
The American Peace Crusade
The American Peace Mobilization
The American Relief Ship for Spain
The American Writers Congress
The Citizens' Committee for Harry Bridges
The Citizens Committee to Free Earl Browder
The Committee for a Boycott Against Japanese Aggression
The Conference for Legislation in the National Interest
The Conference on Constitutional Liberties in America
The Congress of American Revolutionary Writers
Consumers Union
The Coordinating Committee to Lift the [Spanish] Embargo
The Council for the Advancement of the Americas
The Cultural and Scientific Conference for World Peace
Film Audiences for Democracy/Films for Democracy
Friends of the Abraham Lincoln Brigade
The Golden Book of American Friendship with the Soviet Union In Defense of the Bill of Rights
The Joint Anti-Fascist Refugee Committee
Motion Picture Artists [Spanish Aid] Committee
The National Committee to Repeal the McCarran Act
The National Committee to Secure Justice in the Rosenberg Case
The National Committee to Win Amnesty for Smith Act Victims
The National Council of the Arts, Sciences, and Professions
The National Emergency Conference for Democratic Rights
The National Federation for Constitutional Liberties
The North American Spanish Aid Committee
An Open Letter for Closer Cooperation with the Soviet Union
A Statement by American Progressives on the Moscow Trials
The Stockholm Peace Appeal
United Labor and Citizens' Committee for Jobs and Recovery
Veterans of the Abraham Lincoln Brigade

Maltz, Adrian Scott, and Sam Ornitz. After stops and press conferences in Kansas City, St. Louis, and Chicago, Bogart's gang of fifty landed in Washington and held a press conference outside HUAC's very doors. They also broadcast a nationwide radio show called "Hollywood Fights Back," which decried HUAC's high-handed methods.

But those efforts proved to be in vain. Not only would the uncooperative Hollywood Ten be cited for contempt of Congress and sent to prison (where, ironically, they were shortly joined by J. Parnell Thomas himself, who had been padding his payroll), but Bogart's own heroic image was tarnished by his high-profile defense of those impertinent subversives. Some hasty spin-control was called for, and Bogart rose—or descended—to the occasion by issuing a press release in which he described himself as "a foolish and impetuous American" who detested communism "just as any other decent American does." An expanded version of the statement appeared in the March 1948 issue of *Photoplay* magazine, concluding with Bogart's assessment of himself as "a dope." Years later, Bogart would deny that he had ever made a retraction of his stance against HUAC. But Paul Henreid, Bogart's costar in *Casablanca,* labeled the 1948 statement "a form of betrayal," and renounced his friendship with Bogart. The "non-retraction" must have worked, though, because Bogart went on to win the 1952 Academy Award for Best Actor, while the Hollywood Ten had to work undercover for the next decade, when they could find work at all.

In 1951, the games began again. HUAC summoned a new array of Hollywood figures to testify about the infiltration of Communists into the film industry. The names weren't quite as grandiose this time around—Larry Parks, he of *The Jolson Story* fame, was one of their bigger fish from the acting ranks—but significant testimony did emerge. Actor Sterling Hayden named names, an act for which, to his dying day, he never forgave himself, and screenwriter Richard Collins, who collaborated with Paul Jarrico on the now-infamous *Song of Russia* back in 1943, tried to explain why the movie's pro-Soviet message wasn't an act of subversion. The 1951–52 hearings were also the showcase of Oscar-winning director Elia Kazan's controversial testimony, which haunted him for almost a half century—including the night of his honorary Lifetime Achievement Academy Award in 1999.

THE LOVE SONG OF J. EDGAR HOOVER

HE BESTRODE the twentieth century like a petty colossus—if a colossus can be said to resemble a fireplug with jowls, exhibit a surfeit of both hubris and vindictiveness, and be absolutely bereft of humor. But John Edgar Hoover, director of the Federal Bureau of Investigation and lifelong foe of the Communist menace, could claim a degree of influence exceeding that of many heads of state. Yes, he had power to spare, along with an innate cunning and a diamond-hard single-mindedness of purpose, that being the greater glory of J. Edgar Hoover. But once Hoover was appointed head of the Bureau of Investigation (as it was initially called) in 1924, he never had to look back—only around corners, under mat-

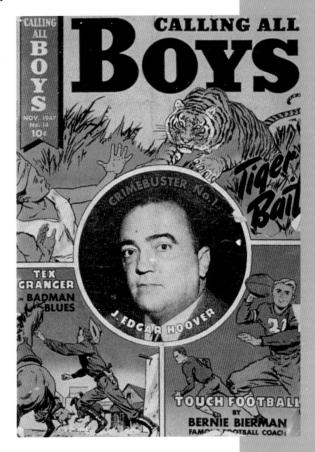

tresses, and behind mirrors. It was Hoover whom *Look* magazine deemed "Communist Hunter No.1" in a typically fawning 1947 article. That was followed a few months later by issue #14 of the comic book monthly *Calling All Boys,* the cover of which proclaimed Hoover to be "Crimebuster No. 1"—not a bad perfecta.

True, in many ways Hoover was a typical government bureaucrat, abhorring the notion of giving credit to, or sharing it with, anyone else when he could claim it all for himself. And yet, through a combi- nation of circumstance and his own bull- doggedness, Hoover at times had an impact on events nearly as great as even a giant such as Josef Stalin. Both men took power in 1924, and while Stalin's was absolute and Hoover's was (at least in theory!) circumscribed, they both freely lived above the very laws they helped for- mulate and impose on others. Like Stalin, Hoover and the power he represented inspired fear and loathing, even while he was being feted by the American media as a national icon. (It was Hoover who was able to reap all those photo opportunities with the likes of Joe DiMaggio and Marilyn Monroe; poor Joe Stalin had no such glamour available to him.) And, like Stalin, Hoover didn't relinquish that power until his last day on earth—for the indomitable G-man, that would be on May 2, 1972, just a week shy of his forty-eighth anniversary as the director of the Bureau.

Following the debacle of his term as A. Mitchell Palmer's quarterback during the first Red Scare of 1919–21, Hoover regrouped. He was made director of the newly formed Bureau of Investigation in 1924, took his initial budget of $2,250,000 and never looked back. (By 1952, at the height of the Red Scare, that budget would balloon to $90 million.) Setting his sights beyond the underwhelming threat of conquest by radical aliens, Hoover began to go after the kingpins of organized (as well as disorganized) crime. In 1934, he masterminded the bloody demise of Public Enemy No. 1, the notorious John Dillinger, at Chicago's Biograph Theater. The rigor mortis–ridden corpse was photo-op'd for an enthusiastic press corps in the Cook County morgue several hours later—but it was Bureau agent Melvin Purvis who actually executed that legendary ambush, and the press understandably gave him the lion's share of the glory for the kill. Hoover was peeved, and he would be peeved again when the notorious Ma Barker and her boys were gunned down by Bureau agents after being cornered in their cabin in Lake Weir, Florida, while Hoover sat in his office on Ninth Street and Pennsylvania Avenue in Washington. Wanting to be adored as America's real-life Dick Tracy, Hoover made sure he was in on the actual arrest of Alvin "Creepy" Karpis, the last surviving member of the Ma Barker gang, in New Orleans on May Day of 1936. (That adventure was immortalized under the dual byline of Hoover and Courtney Ryley Cooper in the November 1936 issue of *The American Mercury,* as "The Boy Who Wanted to Go Fishing"—one of many articles ostensibly written by Hoover for America's top publications.)

On August 24, 1939, Hoover supposedly "captured" the notorious Louis "Lepke" Buchalter, one of the kingpins of Murder Inc., and the reigning Public Enemy Number 1, all by himself on a New York City street corner. In actuality, Lepke had already surrendered to Hoover's pal, newspaper and radio gossipmonger Walter Winchell, who simply transferred him into Hoover's limo as more than twenty FBI agents stood by.

When the Nazi threat superceded the threats of both Communists and gangsters, J. Edgar Hoover made sure he was in the forefront of that action as well. His crowning

glory came in June of 1942. George John Dasch, the leader of a group of German saboteurs who had been dropped off the coast of Long Island by a submarine, decided to blow the whistle on himself and his compatriots, all of whom had been trained at Abwher's school of sabotage. But, in a comedy of errors, Dasch's first effort to turn himself in to the FBI was ignored as a crank call. He actually had to take a train from New York to Washington and virtually beg the Bureau agents at FBI headquarters to take his story—which included their plan to blow up the dam at Niagara Falls—seriously. After eight days of interrogation, they did. Once again Hoover smelled headlines, and a few days later he called a press conference to make sure he got them. The result: "FBI CAPTURES 8 GERMAN AGENTS LANDED BY SUBS" on the front page of *The New York Daily News* of June 28, 1942. But, true to what Hoover presented at the press conference, the accompanying story said nothing of Dasch having turned himself in, making it appear that the FBI had scooped the would-be saboteurs off their submarines before their feet had even touched the beach. He didn't come clean until 1945, not even to FDR. By then eight spies had been executed—including the unfortunate Dasch, who'd been expecting leniency, if not a full-fledged parade, for having handed the conspirators to the FBI on a silver platter. While the press speculated on whether the FBI had somehow managed to infiltrate the Gestapo itself, the FBI quietly floated a plan for Hoover to be awarded the Congressional Medal of Honor.

HOOVER STARRED as cover boy of *Newsweek*'s issue of June 9, 1947, wherein he shared his thoughts on the gamut of issues relating to the Communist threat. A masterpiece of sage counsel couched in (for Hoover) an atypical mode of moderation, "Ten 'Don'ts' by Mr. Hoover" cautions citizens whose patriotic blood had been brought to a boil (most likely by Hoover himself!) with these bywords of restraint:

"We can successfully defeat the Communist attempt to capture the United States by fighting it with truth and justice, implemented with a few 'don'ts':

"Don't label anyone a Communist unless you have the facts.

"Don't confuse liberals and progressives with Communists.

"Don't take the law into your own hands. If Communists violate the law, report such facts to your law enforcement agency.

"Don't be a party to the violation of the civil rights of anyone. When this is done, you are playing directly into the hands of the Communists.

"Don't let up on the fight against real Fascists, the KKK, and other dangerous groups.

"Don't let Communists in your organization or Labor union out-work, out-vote, or out-number you.

"Don't be hoodwinked by Communist propaganda that says one thing but means destruction of the American Way of Life (*sic*). Expose it with the truth.

"Don't give aid and comfort to the Communist cause by joining front organizations, contributing to their campaign chests, or by championing their cause in any way, shape, or form.

"Don't let Communists infiltrate into our schools, churches and moulders of public opinion, the press, radio, and screen.

"Don't fail to make democracy work with equal opportunity and the fullest enjoyment of every American's right to life, liberty, and the pursuit of happiness."

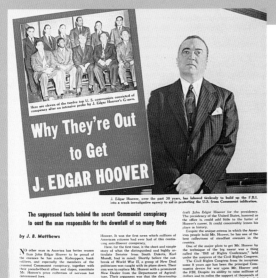

READ THE LETTER FROM THE DIRECTOR OF THE F.B.I. AT THE BEGINNING OF THIS STORY.

THE MOST EFFECTIVE WAY TO FIGHT COMMUNISM IS TO LEARN ALL YOU CAN ABOUT IT.

AND BE SURE TO FOLLOW THIS SERIES THROUGH THE YEAR. NEXT MONTH: CHAPTER II OF "THIS GODLESS COMMUNISM."

AS ALREADY mentioned, Hoover was also the subject of a laudatory profile in *Look* magazine during 1947. "J. Edgar Hoover: Communist Hunter No. 1" revealed Hoover's budget for 1948 ($35 million, with another $11.3 million allocated for investigations involving the Atomic Energy Act), what percentage of the FBI's arrests resulted in convictions (96.9), and how many investigations the Bureau had underway at the close of 1946 (13,507). Hoover's FBI won one of its most important cases in 1949, both from a legal and a public relations standpoint, when (to the confoundment of most legal experts), he managed to mount a case against America's Communist leaders based on the Smith Act of 1940, which expressly made anyone advocating the violent overthrow of the United States government subject to arrest. Eleven Party leaders were arrested and brought to trial before Judge Harold Medina in New York City. Six hard-fought months later, they were all convicted and sent to prison.

BUT HOOVER'S path wasn't always to be strewn with rose petals. In 1940, the Bureau bungled the pre-dawn arrests at the homes of Spanish Loyalist activists living in Detroit and Milwaukee. The charge: having recruited candidates for the Loyalist army back in 1936. Shades of the Red Scare roundups of 1919 and 1920, the suspects were released in short order and their indictments overturned by the attorney general, who chided Hoover in no uncertain terms for having trampled on their civil rights.

He also had been badly embarrassed during the *Amerasia* case of 1945, when what should have been a slam-dunk for the Bureau went sour. *Amerasia* was a journal devoted to covering Far Eastern affairs, and in 1945 it made the mistake of quoting verbatim a report on Thailand that had just been submitted as an internal document by an OSS agent. The agent realized there had to have been a leak at the State Department, and brought the matter to Hoover's attention. Smacking his lips in anticipation of his imminent prosecution of a spy ring that had infiltrated the government, Hoover let loose the dogs, both burglarizing and wiretapping the offices, hotel rooms, and homes of the *Amerasia* editors as well as the suspected contacts in State and other branches. When apprised of the case, President Truman told Hoover he backed him 100 percent, and urged him to proceed quickly. With that blessing, the FBI raided the *Amerasia*

offices on June 6, 1945, seizing 1,700 classified government documents and arresting six of the principal suspects. The charge: "conspiring to violate the federal Espionage Statutes through theft of highly confidential documents." But after only three of the suspects were indicted, the charge was downgraded before going to trial to "unauthorized possession of government documents."

When the defendants' lawyers protested the FBI's unlawful wiretapping and search tactics (the seizure of the documents had been executed with a legal warrant), the Justice Department quickly folded its tent, knowing it would be embarrassed in court. The suspects were allowed to plea bargain for minor fines, leaving Hoover absolutely furious—his boys had caught these Reds red-handed, and now they were skating, all because of a few lousy illegal bugs! But just over a year later, Hoover would enjoy some delayed gratification when the revelations of the *Amerasia* case proved to lay the groundwork for the institution of a federal loyalty oath. Hoover was charged with carrying out the actual investigations by Truman on March 22, 1947, and investigated some four million loyalty cases over the next five years.

Hoover would be embarrassed again following the April 1949 trial of Justice Department spy Judith Coplon. She had been caught dead to rights and convicted of passing on classified documents to Soviet agent Valentin Gubitchev, who'd been working undercover as an employee of the United Nations. There was just one niggling

problem: as had happened in the *Amerasia* case, the FBI had committed dozens of illegal wiretaps at Coplon's office, at her home, and at her parents' home—including privileged conversations with her attorney —in making their case. On top of that, she and Gubitchev had been arrested without a warrant being issued. Consequently, her conviction, handed down on June 30 with a sentence of ten years in prison, was tossed out and a second trial was scheduled. That one, too, seemed to end in a triumph for Hoover, as on March 7,

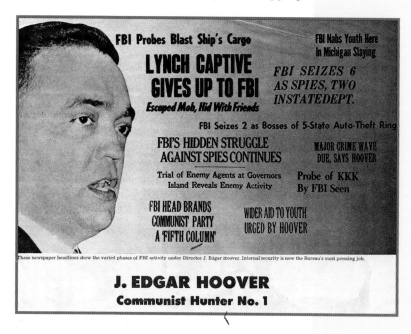

These newspaper headlines show the varied phases of FBI activity under Director J. Edgar Hoover. Internal security is now the Bureau's most pressing job.

J. EDGAR HOOVER
Communist Hunter No. 1

FBI Probes Blast Ship's Cargo
LYNCH CAPTIVE GIVES UP TO FBI
Escaped Mob, Hid With Friends
FBI Nabs Youth Here In Michigan Slaying
FBI SEIZES 6 AS SPIES, TWO INSTATEDEPT.
FBI Seizes 2 as Bosses of 5-State Auto-Theft Ring
FBI'S HIDDEN STRUGGLE AGAINST SPIES CONTINUES
MAJOR CRIME WAVE DUE, SAYS HOOVER
Trial of Enemy Agents at Governors Island Reveals Enemy Activity
Probe of KKK By FBI Seen
FBI HEAD BRANDS COMMUNIST PARTY A 'FIFTH COLUMN'
WIDER AID TO YOUTH URGED BY HOOVER

1950, both defendants were convicted of spying and given fifteen-year sentences. But later that year, Judge Learned Hand of the U.S. Circuit Court of Appeals overturned the convictions. Hoover had egg on his face once again, but managed to torment Coplon by keeping her on no-interest cash bail for seventeen years, without the ability to vote, have a driver's license, or leave the greater New York City area.

Still, on those occasions when his judgment or tactics got him into hot water,

there were many ready to rise to his defense. The August 27, 1952, issue of the pocket magazine *People Today* featured the cover story, "What Is Behind the Smear Against the FBI?" In it, the uncredited author makes the case that the wave of attacks washing over Hoover and his agency in recent days was backlash from the FBI's long having been "over-glorified and over-glamorized, the victim of its own publicity." He goes on to note, in Hoover's defense, that the FBI had solved 348 of 350 kidnapping cases, following the 1932 passage of the Lindbergh Law, and that 97 to 98 percent of the cases they brought to court ended in convictions.

The October 1954 issue of *The National Police Gazette*—long a bastion of right wing opinion—also featured Hoover in a defensive cover story called "Why They're out to Get J. Edgar Hoover," written by J. B. Matthews, the former aide to HUAC chairman Martin Dies. "The suppressed facts behind the secret communist conspiracy to oust the man responsible for the downfall of so many Reds" is the article's subhead, which goes on to state, "No other man in America has better reason than John Edgar Hoover to be proud of the enemies he has made. Kidnappers, bank robbers, and especially the members of the criminal Communist conspiracy, together with their pseudo-liberal allies and dupes . . . have labored and plotted year after year, day in and day out, with unparalleled zeal and vengeance, to get rid of the man responsible for the downfall of so many of their number." The *Gazette,* which had run several pieces recently that howled in protest over attacks on Senator Joseph McCarthy as well, also noted that there were "rumors going around" that Hoover might be drafted for the presidency, an office which the magazine felt "could add little to the luster of his illustrious career." They probably were right.

IN 1958, Hoover had the pleasure of having his first book published since *Persons in Hiding* had become a national best-seller twenty years earlier (spawning a handful of B-pictures in its aftermath). The new volume was titled *Masters of Deceit: The Story of Communism in America and How to Fight It.* It was #1 on the national best-seller list for three weeks, and remained on the list for thirty-one weeks in all, going through four printings in its first four months of release, ultimately selling 250,000 copies in hardcover and another two million in paperback. In the book, a less-than-sanguine Hoover tackles all the hard issues: "Who Is Your Enemy?," "Why Do People Become Communists?," "Mass Agitation," "Infiltration," and "Espionage and Sabotage." As he remarks in his foreword to *Masters of Deceit,* "Today, as I write these words, my conclusions of 1919 remain the same. Communism is the major menace of our time . . . International communism will never rest until the whole world, including the United States, is under the hammer and sickle. I have deep faith in the American people and in our American way of life. But I know what communism could do to us." Hoover probably collected over $70,000 for his efforts, possibly double that. The book was almost certainly ghostwritten for him by a veritable legion of FBI underlings, as were his next two literary endeavors, the 1962 opus *A Study of Communism* (with 125,000 sold in hardcover, an unqualified success) and the 1969 work *J. Edgar Hoover on Communism* (a less lofty 40,000 sold).

Another favorite Hoover bromide was served up in a less distinguished medium, the humble comic book. The September 28, 1961, issue of the biweekly comic *Treasure Chest* (Vol. 17, #2) inaugurated a faux-documentary history modestly entitled "This

Godless Communism." Stopping for a moment to admire that issue's stark cover graphic of a hammer and sickle encircling the wrist and torch of freedom borne aloft by the Statue of Liberty, we turn the page to find on the inside cover a letter, dated March 13, 1961. Reprinted in facsimile, it reveals what we must presume is Hoover's personal stationery, designating as it does "Office of the Director, United States Department of Justice, Federal Bureau of Investigation, Washington 25, D.C." After greeting the young readers of *Treasure Chest,* Hoover solemnly notes:

"Your editor has informed me that this magazine is undertaking a series of stories on communism, and I am pleased to present my views . . . Communism represents the most serious threat facing our way of life. The responsibility of protecting and preserving the freedoms we cherish will soon belong to the members of your generation. The most effective way for you to fight communism is to learn all you can about it . . . This knowledge is most essential, for it helps us recognize and detect the communists as they attempt to infiltrate the various segments of our society."

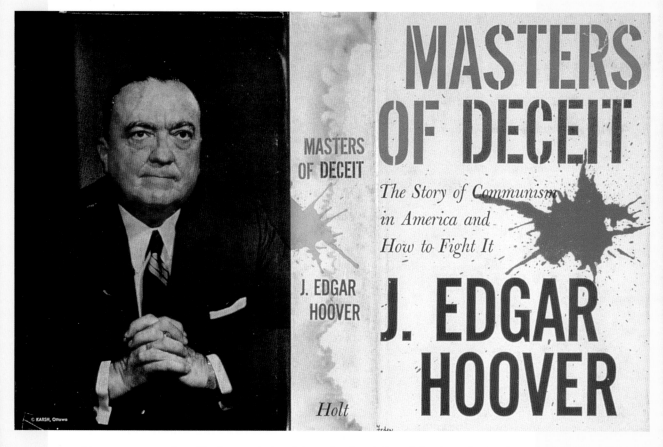

Hoover was rendered in the comic book by artist Reed Crandall, who submitted a not unflattering head-and-shoulders portrait of the director brandishing some sort of pamphlet—presumably, one given the Good Communist–Hunter Seal of Approval by HUAC.

"I LED THREE LIVES," MAYBE MORE:

THE FBI'S STAR UNDERCOVER SPIES

J. EDGAR HOOVER had so many irons in the fires of celebrity tribute—movie tie-ins, book deals, ghostwritten magazine pieces—that it seems unlikely that bounty could be left over for any Bureau underlings to snack on. And yet, at least two enterprising undercover agents for the FBI managed to eke out a modest fortune by making their derring-do public.

The first to strike paydirt was Matt Cvetic, a Pittsburgh-based undercover agent. His testimony at the 1949 Judge Medina trial in New York City, about Communist infiltration of Pittsburgh's labor unions, ultimately helped convict several highly placed members of the Communist Party of having intent to overthrow the United States government. Cvetic quickly sold the story of his drama-drenched escapades to *The Saturday Evening Post*. Serialized over three issues in 1949 as "I Posed As a Communist for the F.B.I.," ("as told to" Pete Martin), it was a smashing read. Warner Bros. snapped up the film rights, and in 1951 *I Was a Communist for the F.B.I.,* as it was now titled, celebrated its opening at Pittsburgh's Stanley Theatre. The evening—part of the official "Matt Cvetic Day" declared by the mayor of Pittsburgh—was replete with a parade (the governor, Legionnaires, Boy Scouts, and Amvets all participated), a live NBC-radio broadcast sponsored by Proctor and Gamble, and awards bestowed onstage to Cvetic by citizens' groups, all filmed by newsreel crews.

Frank Lovejoy played the intrepid Cvetic, and the ads screamed, "I was under the toughest orders a guy could get! I stood by and watched my brother slugged. . . I started a riot that ran red with terror. . . I learned every dirty rule in their book and had to use them!" While the picture turned out to be only a modest hit, it somehow ended up with an Academy Award nomination—as the year's best documentary! It went on to enjoy further

life as a radio series in 1952, with Dana Andrews voicing the escapades of Cvetic.

NOT TO BE outdone, Boston FBI agent and counterspy Herbert A. Philbrick (who had testified at the Judge Medina trial on April 6, 1949) authored a sensational account of his own adventures, published in 1952 as *I Led Three Lives.* The yarn was developed into a syndicated television

series by Ziv Productions, starring Richard Carlson as the perpetually fear-drenched, nail-biting Philbrick. The show debuted in 1953 and ran through 1956, totaling 117 episodes, with titles reeking of the paranoia of the day: "Anti-Red Squad," "Spy Ring," "Party Discipline," "Communist Extortion Racket," "Hidden Enemy," "Secret Printing Press," and (our favorite) "Sweethearts for Servicemen." Filmed in the breathless, *faux*-documentary style of the 1948 film *Naked City, I Led Three Lives* employed the oddly effective conceit of having Carlson provide a stream-of-consciousness narration consisting mostly of an endless series of pep talks marinated in bitter recrimination: "Nice going, Philbrick. . .You just may have cooked your goose for good this time. . . Better think fast, or you'll be pushing up daisies by morning!"

With his devoted wife, who knows of his double life, his two young daughters, who don't, and his cover as a pipe-smoking Boston advertising executive, Philbrick makes for one of the least convincing double agents in the annals of spydom. In one typically paranoia-soaked episode, "Comrade Herb" is asked by the boss of his local cell to

take in his daughter for a few days while he attends to out-of-town business. Philbrick obliges, but soon realizes that the girl has been sent into his home as a Trojan horse—spying on his movements, rifling through and even stealing his papers. "Never underestimate a Commie, even a baby one," Herb reflects. But he loses his cool when he finds that the boss's daughter has been testing his daughter's knowledge of Party policy and philosophy (she scores a big zero, natch), even reading Party propaganda to the girl as bedtime stories. Yet, though his young houseguest is totally on to his subterfuge and even has an incriminating document to prove it, Philbrick improbably—and clumsily—manages to talk his way out of the hot spot. As always, he retains the trust of his cell members, who remain

blissfully unaware that Herb is the pipeline through which all their precious secrets are flowing, like the Mississippi River, to the FBI.

Another episode finds Herb trying to crack a Commie dope ring—one credited with having to move the unlikely quantity of "200 tons of uncut heroin"—by filming their street corner transactions from the convenient vantage point of his office window. (To add to the suspense, a Communist agent has recently been added to his office staff under the guise of being Herb's new secretary, the better for the Reds to spy on their own spy.) In one sublimely lunatic scene, Herb is interviewed in his office by a newspaper journalist while the camera is filming behind a screen, and is obliged to shave with an electric razor in front of the reporter to cover the loud whirring. "As long as there are two Communists left in the world, one will be spying on the other one," was Herb's caustic comment on this adventure.

In an episode entitled "Policy Change," Herb finds himself at odds with the Party's local disciplinarians, who don't approve of his steadfast reluctance to embrace the cell leader's advocacy of undertaking immediate, violent action to foment "panic and unrest." Herb insists that the cell should maintain the old policy—"lulling the masses into a false sense of security"—but the other cell members are all too glad to toss bricks through department store windows and generally raise hell. It looks like curtains for Herb when he learns that a Party disciplinarian is being flown in from Moscow to review the cell's performance. But, lo and behold, upon his arrival the Muscovite coolly advises the comrades that, upon further review, the Party has again changed course, and that the old policy of "quietly sharpening the sword of revolution" has been reinstated. The cell boss is removed from his post in disgrace, and once again the feckless Herb Philbrick is home free.

MICKEY SPILLANE'S ONE LONELY NIGHT

"CHAMPION OF THE TOUGH MYSTERY WRITERS"—so his paperback publisher knighted Mickey Spillane in the 1950s, after his five Mike Hammer novels had sold upwards of thirty million copies. *One Lonely Night* was fourth in the series, and it contained all the standard elements of Spillane's work to date—treacherous females, frightful villains, and an incorruptible (if slightly dim) hero. But here there's one key innovation: private eye Mike Hammer faces off against a horde of machine gun–toting Communist thugs, whose plan is (ho hum . . .) a takeover of the United States. One of Hammer's typically passionate, if bird-brained, fulminations follows:

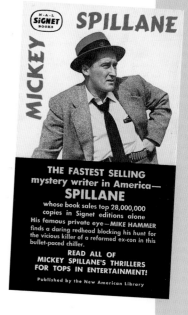

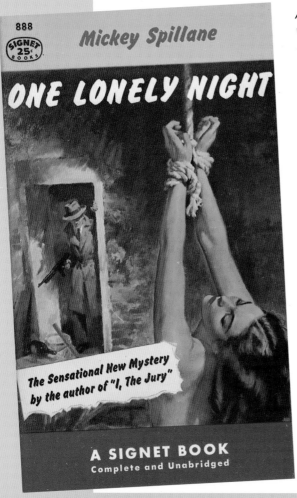

A Commie. She was a jerky Red. She owned all the trimmings and she was still a Red. What the hell was she hoping for, a government order to share it all with the masses? Yeah. A joint like this would suddenly assume a new owner under a new regime. A fat little general, a ranking secret policeman, somebody. Sure, it's great to be a Commie . . . as long as you're top dog. Who the hell was supposed to be fooled by all the crap? . . . Read the papers today. See what it says about the Red Menace. See how they play up their sneaking, conniving ways. They're supposed to be clever, bright as hell. They were dumb as horse manure as far as I was concerned. They were a pack of thugs thinking they could outsmart a world. Great.

TELEVISION AND THE RED MENACE

AS THE MOVIE industry had already discovered, the threat of the Red Menace, however much it appeared in the headlines, did not translate automatically into big box-office entertainment. Television, which did not require a paying audience, would make its own attempt to bring the Cold War into the living rooms of America; but in the end it, too, would have to admit defeat.

There had been a few attempts on radio to cash in on America's Cold War cold sweat, notably with the *American Agent* series, which in the 1950–51 season offered such adventures as "She Danced for Stalin," "The Red Danube," and "Red Impersonation." But the mass audience for television had little to gnaw on. Beyond the relatively successful *I Led Three Lives*, which ran in syndication for three years and 117 sweat-drenched episodes, there were relatively few anti-Communist television series running during the Fifties—certainly fewer than one might expect, given the climate of the times. *Foreign Intrigue, Passport to Danger,* and *Dangerous Assignment* all debuted in 1951. *Biff Baker, U.S.A.,* which ran on CBS in 1952, starred Alan Hale Jr. as an American posing as an import-export whiz who, along with his wife, happily does a bit of spying for Uncle Sam as he travels from country to country. In "Black Lead," a 1952 episode, Biff takes on a gang of Chinese Communist hoodlums. *The Man Called X, I Spy,* and *Soldiers of Fortune* all did their part to expose the Communist conspiracy during the 1955 season. *O.S.S.* ran during part of 1957, while *Behind Closed Doors* had a 1958 episode called "Assignment Prague," in which star Warren Stevens finds an American who's sunk to making propaganda films for the Reds. *Counterthrust* made a brief appearance in 1960.

The truth is, except for *I Led Three Lives* and *Foreign Intrigue*, none of those programs aired for more than a single season, obviously because their ratings weren't even remotely comparable to those earned by the top comedies, westerns, and variety shows that were then ruling the airwaves. The single exception might be the animated series *Rocky and His Friends,* which debuted in 1959 in an afternoon timeslot on ABC and ran for another thirteen years, changing its name in the process to *The Bullwinkle Show.* The endless struggles of Rocket J. Squirrel and Bullwinkle J. Moose to defeat the ridiculously convoluted schemes of evil Russian spies Boris Badenov and Natasha Fatale constituted an absurdist take on the Cold War. (Nostalgia for the series' delectable brand of whimsy inspired Universal Studios to make a big-budget, feature-film version that was released in the summer of 2000, starring Robert DeNiro as the monocled Fearless Leader, and Jason Alexander and Rene Russo as his ineffectual underlings.)

Of course, individual episodes of various TV series occasionally would devote a token evening to the pursuit of the Commie threat. "Red Tentacles," a 1952 episode of *Sky King,* found Sky and sidekick Penny exposing a nest of Red Chinese agents, while

the 1955 episode "The Camp" in *The Crusader* series had star Brian Keith infiltrating Czechoslovakia to help free a famous dissident. "Tanya Tamar," a 1955 entry in *The Man Called X,* featured star Barry Sullivan aiding a ballerina who wants to defect from the USSR. And Richard Boone's series *Medic* had a fantasy episode in 1955, "Flash of Darkness," that featured Dr. Styner's efforts to set up an emergency medical clinic after a city has been ravaged by atomic attack.

During the Fifties, a handful of television "specials" addressing, or dramatizing, the Red Menace also surfaced. The award-winning dramatization of Arthur Koestler's *Darkness at Noon* that had taken Broadway by storm in 1951 was broadcast by NBC on May 2, 1955, while NBC also showed *Nightmare in Red,* a history of Communist Russia, in December of 1955. CBS distin-guished itself with the docudrama "The Day North America Is Attacked," the debut episode of its 1956 *Air Power* series, which was narrated by Walter Cronkite and overseen by the Defense Department. This was an hour-long dramatization—filmed at defense installations and air bases—that showed exactly how our military would respond if the Russians dispatched 1,100 aircraft to attack us from all directions. A 1953 episode of Walter Cronkite's popular series *You Are There* provided a reenact-ment of the Moscow Purge trials on 1938, with CBS correspondents playing the roles of the inquisitors and inquisitees. And the *Motorola TV Hour* put together a 1954 special, "Atomic Attack," that showed a family in the New York 'burbs coping with the aftermath of a nuclear attack. That same year, for thirty-six days, the major networks broadcast live coverage of the Army-McCarthy hearings. In 1961, an hour-long docu-drama "The Spy Next Door," which illustrated the Reds' espionage techniques, was broadcast as an installment of *The Armstrong Circle Theater.* And on December 10, 1963, ABC showed *The Soviet Woman,* a documentary that included a direct appeal to the women of America from Mrs. Nikita Khrushchev.

J. Edgar Hoover's all-time favorite TV series was, obviously, ABC's long-running hit *The F.B.I.,* which was broadcast from 1965 to 1974. It starred Efrem Zimbalist Jr. as doughty Inspector Lewis Erskine. Hoover gave the show both his commendation and his cooperation, sharing carefully vetted FBI files so they could be used as the basis for various episodes. He also allowed occasional filming at FBI headquarters in Washington for some background scenes. The show often ended with a direct appeal for information on the FBI's "Most Wanted" criminal, including an April 1968 appeal for James Earl Ray, who had recently escaped from prison. But by this point, the criminals hardly ever displayed a Communist bent.

McCARTHY

THE MAN WITH A MISSION

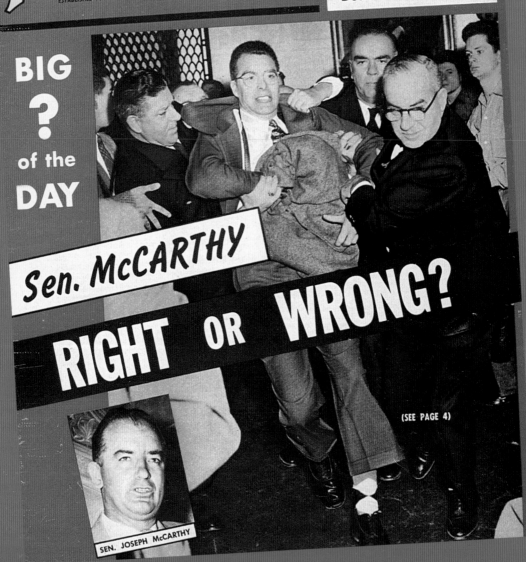

MAY, 25¢ ANC

The National
POLICE GAZETTE

ESTABLISHED 1845 SPORTS—TRUE ADVENTURE—PEOPLE

There's POLIO in Your Foods

Can SANDY SADDLER Beat the G. I. Jinx?

BIG
?
of the
DAY

Sen. McCARTHY

RIGHT OR WRONG?

(SEE PAGE 4)

SEN. JOSEPH McCARTHY

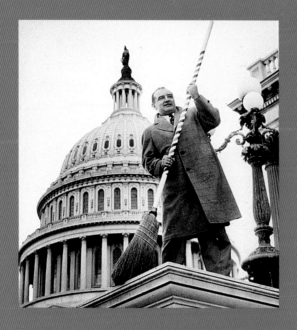

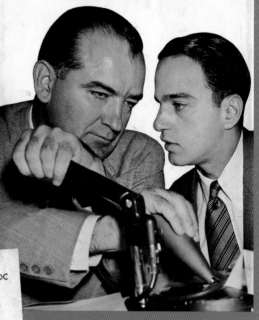

McCarthy
BY
ROY COHN

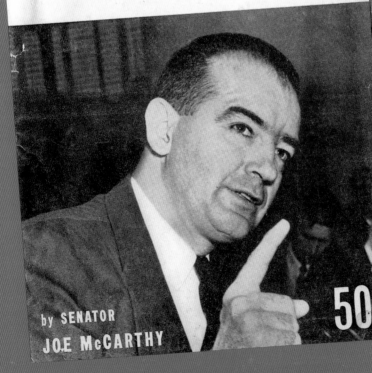

McCARTHYISM
THE FIGHT FOR AMERICA

IDC

by SENATOR
JOE McCARTHY

50c

REDS, BY GUM!

CHILDREN'S CRUSADE AGAINST COMMUNISM—1951 BUBBLEGUM CARDS

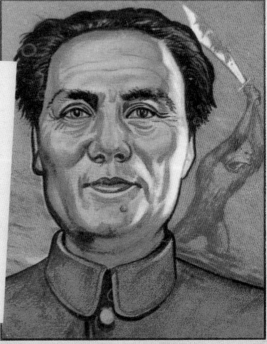

CHILDREN'S CRUSADE AGAINST COMMUNISM

47. War-Maker

Mao Tse-tung is the leader of the Chinese Reds who attacked the United Nations forces in Korea. His army was built up, in the first place, with the help of outlaws. Later the Russian Reds supplied him with arms and advisers. He captured the China mainland in three years of savage warfare against the Nationalist government. Mao delights in war. History, he says, "is written in blood and iron." The free world must find a way to keep war-makers like Mao Tse-tung from shedding the blood of innocent people.

 FIGHT THE RED MENACE

23. Ghost City

The picture is an artist's idea of what an atom bomb could do to a great American city. The Reds like us to think of this. They think it will make us afraid. But actually, we are growing stronger by realizing that this *could* happen to us. We are working to make America stronger day by day, week by week. We must continue to work for peace through the United Nations and in every possible way. But an America fully prepared to defend itself is not likely to be attacked. The Reds understand this language.

 FIGHT THE RED MENACE

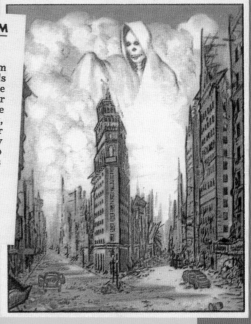

72. Olga And Ivan

A knock at the door — and the typical Russian family fears the worst. They are told where to work, where to live and what subjects they must master at school. Their daily routine insists on absolute obedience to their leaders and following Communist doctrine. A simple anti-communist remark by anyone of them could result in a visit by the police. An explanation will be demanded. Prison without fair trial or appeal faces all. This is life under Communism!

 FIGHT THE RED MENACE

49. A Heroes Reward

He had fought bravely to defeat the Nazi invaders. He had many military decorations to prove his loyalty to mother Russia. But one day, he questioned why his country was imposing, by force, conditions on other nations that they would not tolerate themselves. He was reported, court martialed and sentenced to death. He died by firing squad as he stared at an outline of the buildings of Moscow he loved so much. From hero to traitor for daring to speak.

 FIGHT THE RED MENACE

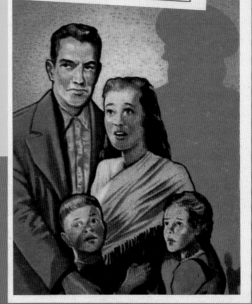

TIMELINE:

MARCH 5, 1953: Stalin dies at age seventy-three after a stroke, throwing the Communist Party into a free-for-all struggle for power that would not resolve itself for almost three years. MARCH 7, 1953: Georgy Malenkov inherits the two key leadership posts vacated by Stalin's death. MARCH 14, 1953: Nikita Khrushchev now assumes one of those top posts, deposing Malenkov as secretary of the Party Central Committee. APRIL 1953: The Permanent Subcommittee on Government Operations opens for business, under Chairman Joseph McCarthy. The Subversive Activities Control Board, whose five members had been selected by the president, also begins operations. JUNE 19, 1953: Julius and Ethel Rosenberg are executed in the electric chair at Sing Sing after President Eisenhower twice refuses to issue an order of executive clemency. It is later revealed, via the late Nineties opening of the archives of the Russian Republic, that the Rosenbergs were indeed guilty of passing secrets to their Soviet handler, Alexander Feksilov—but it was classified information about radar and sonar they gave him, not the atomic secrets which cost them their lives. JULY 1953: The Korean conflict comes to an end. AUGUST 20, 1953: The USSR tests its first hydrogen bomb. DECEMBER 1953: *McCarthy and His Enemies* by Yale graduates William F. Buckley Jr. and L. Brent Bozell is published by Regnery Press. Of McCarthy, Whittaker Chambers, who refused an entreaty to plug the book, maintains, "He is a raven of disaster." DECEMBER 23, 1953: Beria, the first deputy premier of the Soviet Union, is executed with six aides as the post-Stalin purges begin. MARCH 1, 1954: The U.S. tests its first H-bomb. MARCH 9, 1954: Edward R. Murrow's popular CBS-TV series *See It Now* features its "Report on Senator McCarthy," which includes clips of the pugnacious Red-baiter belching, picking his nose, and bullying witnesses while apparently in his cups. "Upon what meat does Senator McCarthy feed?" Murrow asked rhetorically. The show was a smash, and a follow-up critique of McCarthy aired on CBS the following week. APRIL 6, 1954: McCarthy is given the chance to answer Murrow on *See It Now*. APRIL 22, 1954: The U.S. Army vs. Senator Jos. McCarthy hearings commence, adding "point of order!" to the American lexicon. ABC, NBC, and the Dumont networks all make available a live television broadcast of the hearings, and Americans watch as Tail-Gunner Joe flames-out before the skilled probing of Army counsel Joseph Welch. By the time the hearings conclude on June 17, for all practical purposes McCarthy's career is as good as over. MAY 27, 1954: The Atomic Energy Commission's personnel security board, after interviewing former atomic scientist J. Robert Oppenheimer in a special hearing for three weeks, recommends that his security clearance be revoked. The reason: a long history of having Communist ties, both prior to and

1953-1957

during the time he served as director of the Manhattan Project. **NOVEMBER 27, 1954:** Alger Hiss is released from the penitentiary in Lewisburg, Pennsylvania, where he has served forty-four months of his five-year sentence. "Three years in jail is a good corrective to three years at Harvard," he quipped. **DECEMBER 2, 1954:** The Senate votes 67 to 22 to censure Senator Joseph McCarthy. **MAY 14, 1955:** The Warsaw Pact is signed. **JULY 18, 1955:** The leaders of the USSR, the United States, England, and France convene in Geneva to begin the "Big Four" conference. **FEBRUARY 24, 1956:** Khrushchev gives a closed-door, four-hour speech to the Twentieth Congress of the Communist Party, repudiating the actions undertaken by Stalin over the past thirty years, shocking Communists the world over. Khrushchev decries the "cult of personality" that Stalin had fashioned, the murders he had master-minded, his "persecution mania," and his abuse in application of the epithet "enemy of the people." Thousands of Stalin's political prisoners in gulags all over the USSR have their sen-tences commuted. The era of de-Stalinization had begun. **APRIL 17, 1956:** The Cominform is dissolved. **OCTOBER 23, 1956:** The Hungarian revolt against Soviet control begins. By November 4, it has been crushed. **APRIL 9, 1957:** Fidel Castro chooses the tenth anniversary of the Bogotá riots to launch his revolt against President Fulgencio Batista in Cuba. He makes his base in the Sierra Maestra, with an army of eighty-two men. **MAY 2, 1957:** Joseph McCarthy dies at the age of forty-seven from liver failure. He is buried five days later in his hometown of Appleton, Wisconsin. **MAY 1957:** Alger Hiss's *In the Court of Public Opinion* is published to largely scathing reviews. **JUNE 2,1957:** First Secretary Nikita Khrushchev makes his first appearance on U.S. television, taking questions from American correspondents with the help of an interpreter. At one point he remarks, "Your grandchildren in America will live under Socialism. And please do not be afraid of that." **JUNE 20, 1957:** A five-member UN special committee unanimously votes to indict the Soviet Union for its brutal repression of the Hungarian uprising eight months earlier. The UN General Assembly votes on September 14 to condemn the USSR on the same grounds. **JUNE 29, 1957:** Khrushchev ousts Party leaders and erstwhile Stalin deputies Malenkov, Molotov, and Kaganovich from the Kremlin, citing their illegal activities in support of Stalin during the purges of the 1930s. In effect, this gives Khrushchev sole control of the Communist Party, inspiring him to comment, "We had some bad sheep in a good flock [but] we took them by the tail and threw them out." One was sent to Outer Mongolia, one to a hydroelectric plant thousands of miles from Moscow, and one to a cement plant somewhere beyond the Urals. **JULY 8, 1957:** George Ziatovsky, once of the OSS, is indicted with wife Jane on charges of spying for the Soviet Union.

"WE WILL BURY YOU!"

THE KHRUSHCHEV YEARS

f Stalin ruled through fear and intimidation, Nikita Khrushchev's considerable success had to be attributed more to guile and an infallible sense of showmanship. Not that Khrushchev couldn't be ruthless when the situation demanded; his response to the Hungarian uprising in November of 1956 was Stalinesque in its brutality, and there were accounts that he was responsible for a death toll of 400,000 lives over a two-year period while overseeing the Ukraine before World War II.

But once he consolidated his power in 1957 by ousting Molotov, Malenkov, and Kaganovich—old Stalinites all—Khrushchev took and held center stage with an ease that Ike and Nixon were obviously unprepared for. The Sputnik triumph a few months later taught America the valuable lesson that Nikita, he of the gap-toothed grin and the mine-mechanic body, was not to be underestimated. The announcement on March 27, 1958, that Khrushchev had replaced Bulganin as premier of the Soviet Union, while remaining first secretary of the Communist Party, merely codified what everyone had known for the past year. But what Khrushchev had accomplished in five years while rising through the collective leadership to seize control was as impressive a display of political savvy as any machinations engineered by Uncle Joe.

The most instructive example of Khrushchev's genius came in 1959, when he trumped his September visit to the U.S., as the first Soviet chief of state ever to arrive on these shores, by seeing to it that a Russian rocket had hit the moon the day before. Vice President Nixon tried to downplay the impact of the news by announcing—typically, through sources he could not reveal (national security, no doubt)—that the Russians had missed the moon on three earlier tries. "It's nothing to get excited about," Nixon reassured *The New York Times*. "Scientifically and educationally we are way ahead of the Soviets." In the meantime, a large sphere bearing metal pennants decorated with the hammer and sickle was resting on the moon, near the Sea of Tranquility. Although our government rejected those Commie flags as proof of ownership, Khrushchev's earlier remarks about Russia's inevitable triumph in the world economy—the infamous

RED...OR DEAD!

The master plan of Communist terror that brought half the world to its knees!

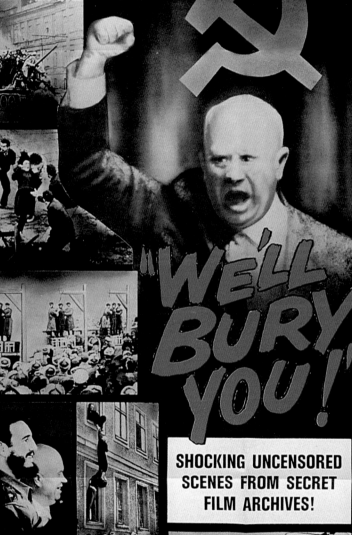

"WE'LL BURY YOU!"

SHOCKING UNCENSORED SCENES FROM SECRET FILM ARCHIVES!

SEE
THE MOST INFAMOUS CAST OF CHARACTERS EVER ASSEMBLED IN ONE FILM!

KHRUSHCHEV
WORLD ENEMY #1

CASTRO
BEARDED BETRAYER!

STALIN
MASS-MURDERER

MAO-TSE-TSUNG
RED CHINA'S TYRANT!

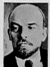

LENIN
GENIUS OF REVOLUTION!

TROTSKY
VICTIM OF REVENGE!

MALENKOV
TERRORIST IN EXILE!

MIKOYAN
KREMLIN'S CON-MAN

Written by JACK W. THOMAS · Produced by JACK LEEWOOD and JACK W. THOMAS · A CONTEMPORA PRODUCTION · A COLUMBIA PICTURES RELEASE

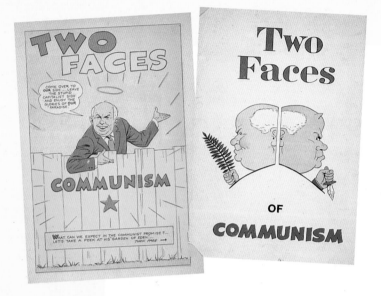

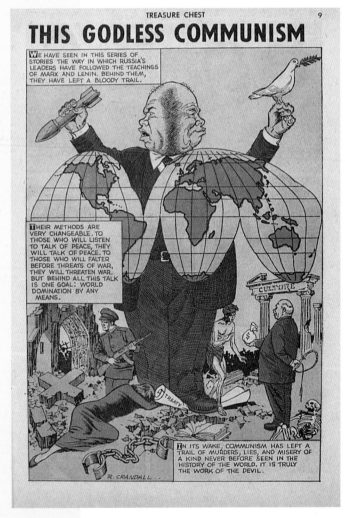

"We will bury you!" boast that had so rankled Nixon—now began to take on other implications.

Through the course of his U.S. visit, Khrushchev beamed. He gobbled hot dogs and evaluated corn crops in Des Moines, and charmed the initially hostile American crowds from Pittsburgh to Los Angeles to San Francisco. It was a performance marinated in good will, a harbinger of the beginning of the end of the Cold War. But on May 1, 1960, one of our U-2 "weather observation" planes was reported shot down over Sverdlovsk, an industrial city some 1,300 miles inside Russia's borders. Nikita the Jolly Farmer was quickly replaced by his evil twin, Nikita the rocket-rattling table-thumper, and hostilities resumed. It was as if Des Moines had been only a dream. (But when things settled down again, Iowa farmer Roswell Garst, who had hosted the Soviet delegation during their visit, managed to convince the State Department that he should be allowed to accept Khrushchev's invitation to visit the farmlands of Russia. According to Nikita's son, Sergei, Garst and Nikita went on to become fast friends.)

By 1962, when Columbia Pictures released the low budget documentary *We'll Bury You!* Khrushchev had taken on the aspect of King Kong, a fearsome monster who "brought half the world to its knees!" (Nikita earned top billing over hated rival Mao as "World Enemy #1!") With the perspective of forty years, we now understand that Nikita's monstrous

persona was a cannily crafted construct, created with one purpose in mind: to keep the U.S. in such a perpetual state of fear that it would never have time to tumble to the fact that the Soviet Union, on its best day, possessed one-tenth the weaponry, atomic and otherwise, held by the U.S. In his confession "The Cold War Through the Looking Glass" in the October 1999 issue of *American Heritage* magazine, Sergei Khrushchev tells of his father's many brilliant strategies that deceived the best minds of the American intelligence community. He was an utter genius at obfuscating the fact that his much-feared "evil empire" was essentially propped up with pâpier-maché and toothpicks. For the ears of the American press, Khrushchev boasted "we are making missiles like sausages"–but in reality, he had only a half-dozen working ICBMs. Privately, Nikita would admit to Sergei, "We're not planning to start a war, so it doesn't matter how many missiles are deployed. The main thing is that Americans think we have enough for a powerful strike in response. So they'll be wary of attacking us." Similarly, after ballyhooing a new super-missile, Khrushchev admitted, "the global missile is just a pro-paganda weapon. Let the Americans rack their brains over what I said."

Nikita S.

KHRUSHCHEV

For Victory in Peaceful Competition with Capitalism

With a Special Introduction for this
American Edition by Premier Khrushchev

The only AUTHORIZED EDITION

And did we ever! From the teeniest schoolchild to the most august head of state, we bought it all, lock, stock, and warhead. But Khrushchev's apparent failure of nerve during the Cuban Missile Crisis, late in 1962, and his stubborn refusal to cave in to the demands of his own military-industrial complex, which was asking him to authorize expenditures for defense on a par with what America was spending—an outright impossibility—fed the Politburo's perception that the Old Man was slipping. In 1964, while vacationing at his bucolic *dacha,* Khrushchev was deposed. His replacement was the vastly uncharismatic Leonid Brezhnev, who would hold the reins of power for eighteen long years. But without Nikita's gap-toothed grin and savage snarl, the Soviet Union would never again seem as fearsome—or as fascinating.

VOLUME 2 50¢

KHRUSHCHEV
on the FUTURE

This is the full, authoritative text of the Soviet Communist Party Central Committee Report to the 22nd Congress on the sweeping 20-Year Program for the construction of communism in the Soviet Union.

USSR
SOVIET LIFE TODAY
MAY 1964
25 Cents

SOVIET PREMIER: WORK AND LEISURE
see pages 2-19

The book every American must read in order to understand the enigmatic

KHRUSHCHEV AND THE RUSSIAN CHALLENGE

(Originally titled: ASK ME ANYTHING—OUR ADVENTURES WITH KHRUSHCHEV. With new chapters added.)

By three top correspondents:

WILLIAM RANDOLPH **HEARST, JR.**

BOB **CONSIDINE**

FRANK **CONNIFF**

"This lively, immensely readable book is ...impressive...highly informative... recommended fare."
—*Senator Hubert H. Humphrey in* THE SATURDAY REVIEW

SPUTNIK AND THE SPACE RACE

"SOVIET FIRES EARTH SATELLITE INTO SPACE; IT IS CIRCLING THE GLOBE AT 18,000 M.P.H.; SPHERE TRACKED IN 4 CROSSINGS OVER U.S."

THAT BANNER headline from *The New York Times* of October 5, 1957, sent chills down America's collective spine. Although Ike tried to downplay the significance of the Sputnik launch, he quickly learned that, to most of his constituents, the news was perceived as a harbinger of Armageddon. Not that the Sputnik satellite was itself so formidable; weighing 184 pounds, and with a diameter of twenty-two inches, it couldn't have dropped anything much bigger than an apple on us. But what it symbolized was like a million tons of TNT: The Russkies now controlled the heavens above. (And, irony of ironies, those godless Reds didn't even *believe* in heaven!)

Total panic didn't set in, though, for another two months. It was on December 6 that a disaster of unspeakable proportions took place: the Vanguard rocket carrying our answer to Sputnik–a puny, four-pound satellite about the size of a softball–had exploded after rising just two feet off its launching pad at Cape Canaveral. (Two feet! The Russians orbit the globe four times, and we get a lousy *two feet* closer to outer space!) The shock–and the humiliation–couldn't have been greater had the Commies set up a slave labor camp on Main Street in Muncie, Indiana.

Already sensitive over having lost the ICBM race earlier in the year (Russia had enjoyed the first successful launch of the super-missile in August), Americans were understandably a bit panicky at having also lost the Space Race at the starting gate. Across the nation, it was Red Alert time. Bomb drills became more familiar to schoolchildren than recess, and visionaries who splurged on backyard bomb shelters–considered quacks just a few months earlier–were suddenly the envy of their vulnerable neighbors. Exploitation flicks like *Spy in the Sky* and *War of the Satellites* appeared at drive-ins in 1958, while children's toys, like the Satellite Space Race Card Game, also cashed in on our new national obsession.

Then, on January 31, 1958, America recovered a small measure of self-respect. It was on that night that the army finally made a successful launch that put a satellite into orbit. So what if the Soviets in the meantime had put three satellites into orbit, including one that carried the dog that won Russia's heart, the brave little mutt Laika. At least we were on the scoreboard. Now the Space Race was once again a true contest.

In the years to come, there would be many points scored by each team. One of Khrushchev's most effective slaps in the face was on August 14, 1959, when the Soviet's 858-pound rocket hit a precise spot on the moon, near the Sea of Tranquility, just hours before Nikita began his first tour of the United States. It also didn't help our

SATELLITE
SPACE
RACE
CARD GAME

Copyright '957

national pride when Soviet cosmonaut Yuri Gagarin became the first man to orbit the earth. But the U.S. made up ground quickly from that point on, and by the end of the decade, we were able to declare ourselves the victor in what may have been the world's costliest race.

America's business community also took note of the Space Race, which had the salutary (for them, anyway) effect of helping an entire industry blast off. *Fortune* magazine produced at least two special issues devoted to the Race: the special issue of June 1962 was called "The Nation and Its Industry in Space," while the September 1963 special was cover slugged "The New Fight Over the Moon Race." Ever wonder who actually *made* those launching pads for rocket takeoffs? The answer is in the 1962 issue, which is chock-a-block loaded with advertisements by a plethora of bullish Space Race manufacturers, including Rohr Hydroclave ("large laminated nozzles for solid fuel rockets"), the Burroughs Corporation ("guiding missiles through Keyholes in the sky"), the Air Preheater company ("Heat—hottest problem in outer space"), Raybestos-Manhattan Inc. ("Re-entry temperatures can soar to a searing 5,000 degrees Fahrenheit—and above"), Sperry-Rand Systems Group ("Navigation for all phases of the moon"), Honeywell Military Products Group ("Honeywell teams with man-in-space"), Paul Hardeman, Inc. ("More than 120 Titan and Atlas installations, and approximately 50 recently-awarded contracts on all Titan II sites . . . Blast and shock resistant to all but a direct nuclear hit") and the A. P. Green Fire Brick Co. ("various types of heat resistant refractory surfacing materials to produce launching pads designed to withstand the tremendous heat and forces encountered when the countdown reaches zero").

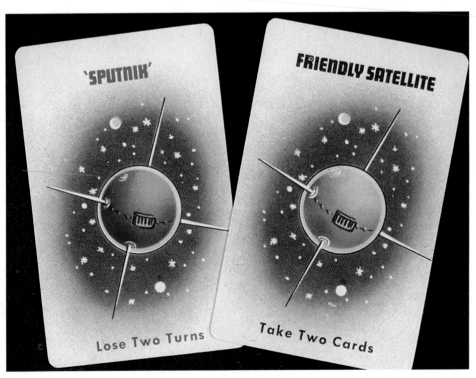

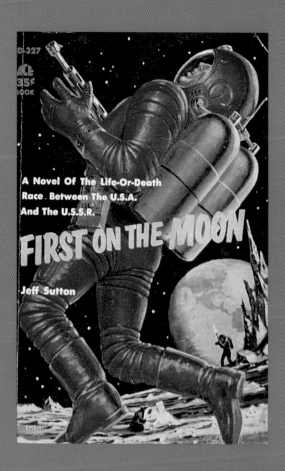

D-327

ACE
35¢
BOOK

A Novel Of The Life-Or-Death
Race. Between The U.S.A.
And The U.S.S.R.

FIRST ON THE MOON

Jeff Sutton

WHY IS THIS **SATELLITE WORTH $10,000,000?**

In 1957 a tiny, man-made satellite will be set whirling about the earth at an altitude of 250 miles, at a speed of 18,000 mph—and at the expense of the American taxpayer. Picture Week asked Willy Ley, a world-famous authority on space flight.

ON JULY 29, President Eisenhower announced the opening of the Age of Space. His revelation that the United States will launch a basketball-sized artificial moon within two years was hailed as man's first step in a journey to other worlds. What is the significance of this very costly bauble? What will it do? What won't it do? Most important, why is it worth $10,000,000 to you, the American taxpayer?

To answer these questions, PICTURE WEEK interviewed one of the world's foremost authorities on rocketry, and a leading champion of space flight. In such best-sellers as *Rockets and Space Travel* and *The Conquest of Space*, Willy Ley has given scientifically accurate predictions of man's future in space. He has been a leading voice in advocating the construction of an artificial satellite. On the following pages is his analysis of the man-made moon.

U.S. MAKES ITS COUNTERATTACK

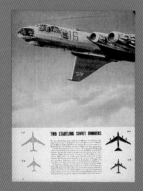

TWO STARTLING SOVIET BOMBERS

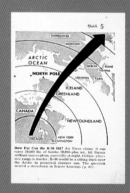

How Far Can the B-36 Hit? Air Force claim: it can carry 10,000 lbs. of bombs 10,000-plus mi., hit Russia without interception, especially at night. Critics' effective range is shorter; B-36 would be a sitting duck over the Arctic in perpetual summer sun. The question: answer a showdown in Senate hearings (p. 61).

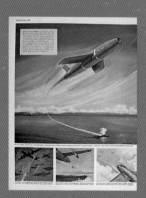

MARTIN

Underwater Aircraft Carrier...

VOUGHT AIRCRAFT

RED STAR OVER CUBA

"BATISTA AND REGIME FLEE CUBA; CASTRO MOVING TO TAKE POWER; MOBS RIOT AND LOOT IN HAVANA."

SO READ THE headline in *The New York Times* of January 2, 1959. The *Times* reported that Batista complained from his new home in the Dominican Republic that Castro's rebels had not only possessed superiority in arms in defeating Batista's army, but also had used guerrilla tactics "similar to those of the Chinese Communists." The nerve of them! (But then, any of us would feel cranky the next day if we suddenly lost all of our casinos.) Batista's eldest son, Ruben, now ensconced in new digs in Jacksonville, Florida, predicted trouble for Cuba because some of the rebels were "militant Communists and fellow-travelers." (Meaning, they wouldn't know how to run a capitalist casino properly?)

Señor Castro, as the *Times* referred to him, was that rarity, a genuinely charismatic Communist leader (although Khrushchev did possess his own, different kind of star quality). He even warranted a positive biography in the comic book *Battle,* which in its October 1959 issue ran the admiring story "The Man with the Beard" that posed the question then on everyone's mind: "What manner of man is this bearded one who now controls Cuba?" Its conclusion: "Castro the conqueror—brave, shrewd, confident, idealistic, generous, and—lucky! He has won the war, but that is only half the battle. Can he summon maturity, wisdom to surmount the flush of victory and power? . . . Can Fidel Castro win the more important peace?"

A revolutionary as far back as 1947, when he joined a group of 1,100 men invading the Dominican Republic to depose dictator Trujillo, Castro went on to become a lawyer and was running for Congress when Batista seized power in 1952. Arrested in 1953 after his July 16 attack on Batista's troops failed, he was captured, tried, and sentenced to a fifteen-year prison term. But in 1955, Batista released all political prisoners—a move he would soon have cause to regret. For Castro immediately went about the business of raising a new army, recruiting men from as far away as Mexico. A masterful guerrilla war ensued, ending late in 1958 when Castro's soldiers marched down from the mountains and captured Santa Clara. A week later, Batista fled as his army (many of whom sympathized with Castro) surrendered. The rebel forces sustained losses of only 250 men in seizing the country.

For all that he was a bona fide Communist leader, Castro also was a loose cannon, at least as far as Moscow was concerned. Khrushchev quickly learned he couldn't control him. And in the 1961 Bay of Pigs fiasco, President Kennedy and the CIA learned that Castro's popularity with Cuba's populace was not to be underestimated.

Leaving aside those mind-boggling (but apparently true) tales of the CIA's attempts to assassinate Fidel—the poisoned cigar and the exploding seashell (or was it the exploding cigar and the poisoned seashell?)—we now move ahead to October of 1962. With American missiles already installed in Turkey, Italy, and England, Khrushchev needed to show the U.S. that he could not be cowed. His answer was the deployment of SS-4 and SS-5 missiles to Cuba, along with light bombers and 40,000 Soviet troops. And there they sat, ninety miles from Florida. Khrushchev maintained that the missiles were

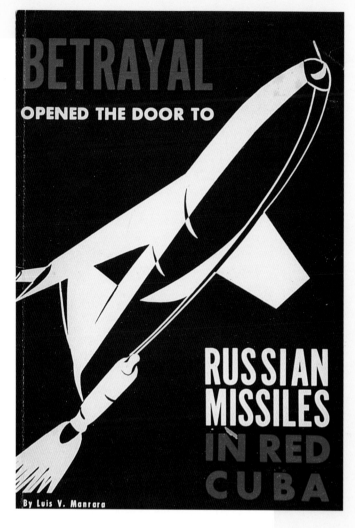

sent to protect Cuba from the big bully to the north, but it was really his last-ditch effort to balance the scales of power, which had lately tipped to the advantage of the U.S. But Kennedy managed to stare down the feisty premier, and the Russian missiles and troops were withdrawn.

With his days in power numbered, Khrushchev nonetheless invited Castro to visit the USSR, not once but twice. The first visit took place in 1963, when Castro flew to Moscow in secrecy to attend the May Day celebration, at which he shared the place of honor above Lenin's tomb with Nikita and the fellows from the Presidium. Castro's thoughts as the missile-floats rumbled past were kept to himself. In honor of Castro's presence, many of the marchers wore sombreros. (Again, Castro managed to hold his tongue.)

Later, in January of 1964, Castro visited Khrushchev at his woodsy *dacha,* where the two leaders strolled through the snow and talked about the good old days. It was to be their last get-together. But even without Nikita's machinations placing his island on the brink of nuclear war, Castro the charismatic has somehow managed to muddle on for what has now amounted to nearly forty years.

SPY VS. SPY

UNDER THE BED, REDS!

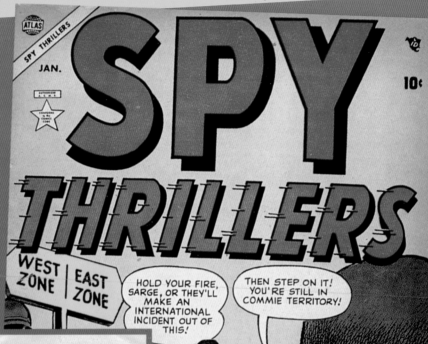

ADAMS · ADDAMS · JUIN

Quentin Reynolds' daughter Joan is in Hollywood getting screen tested.

Blame for Administration's patronage, appointments snafu being put on **Sherman Adams**; as Ike's military-type chief of staff, he took on so much routine for the Presi-

dent he was a bottleneck.

Screen's **Dawn Addams** to be Alan Young's CBS-TV leading lady.

Ike's old problem at SHAPE is plaguing General Ridgway: French Marshal **Juin**, Chief of Allied Land Forces, still prefers his own planning.

About 50, 5'9", 170 lbs. Fair hair, balding, grey at temples. Yellowish complexion, blue-grey eyes.

Uses pince-nez and heavy shell rim glasses to vary appearance. Squints. Underlip droops from scar.

TOP SOVIET AGENT NOW IN U.S.?

This is the face of Stalin's most dangerous secret agent—or rather, one of his faces. One of his many names is H. Karl. His blackest accomplishments for his Red masters so far are reported to be: enticing Prof. Bruno Pontecorvo to carry H-bomb secrets to Russia; abducting ex-U.S. State Dept. man Noel Field in Prague and trapping his family; blackmailing British Foreign Office officials Burgess and MacLean to desert behind the Iron curtain. According to Drew Pearson, H. Karl was supposedly born in Austria, spied for the Nazis (breaking Britain's code by planting an aide with camera on H.M. Ambassador in Istanbul). He is said to speak 6 languages, use at least 4 passports.

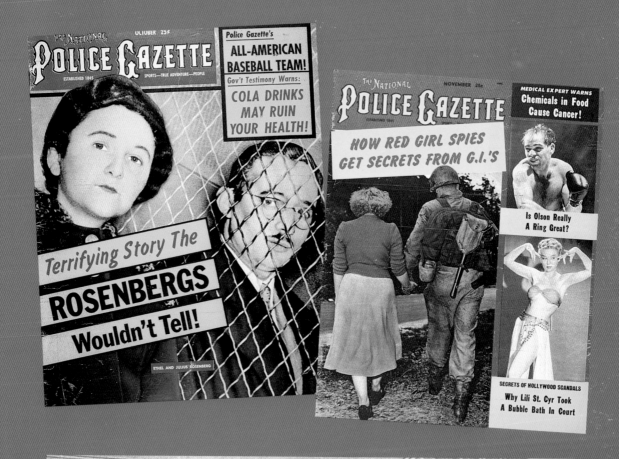

BEYOND STALIN:

AMERICA'S WEEKLY MAGAZINES ON THE NIKITA ERA

"OUR VOTE IS 'NYET' ON RETOUCHING HISTORY," editorial in *Life,* March 23, 1953 (about Russia's proclivity for retouching photographs of official events years after the fact). Also in this issue: "A Weapon for the West" by Isaac Don Levine. "Here is a way to induce Soviet occupation troops to desert."

"THE GHASTLY SECRETS OF STALIN'S POWER: PART II, INSIDE STORY OF HOW THE TRIALS WERE RIGGED," by Alexander Orlov (former general of the NKVD), in *Life,* April 13, 1953. "After 'legal' executions came blood bath in which victims died by the thousands." Also in this issue: "Russia's New Aircraft." Next week: "Stalin's Secrets, Part III: Treachery to His Friends, Cruelty to Their Children."

"BEHIND THE KREMLIN WALLS" by Frank Rounds Jr., in *Colliers,* May 2, 1953. "Clanging bells and flashing lights marked [the American author's] entrance into the fortress. And two secret police trailed him as he toured the forbidding control center of Communism.

"I WAS A PRISONER OF THE CHINESE REDS: A NUN'S STORY," by Sister Mary Victoria, in *Colliers,* May 9, 1953. "A new and realistic picture of tyranny behind the Bamboo Curtain."

"WE ARE IN A LIFE AND DEATH ATOMIC RACE," by Gordon Dean, in *Look,* July 14, 1953. Also in this issue: "Will India Turn Communist?" by Adlai Stevenson.

"WHAT IS A COMMUNIST?," by Whittaker Chambers, in *Look,* July 28, 1953. "The thing they dread most is that their party might be outlawed—that would destroy them."

"I WAS A SLAVE IN SIBERIA," by Henryk Zaborski, as told to Seymour Friedin and William Richardson, in *Look,* September 8, 1953. "The prisoners were surrounded by barbed wire, watchtowers, machine gun–posts, and blinding searchlights. One step out of line and the guards would shoot to kill."

"WILL RED CHINA BREAK WITH RUSSIA?," by George Weller, in *The Saturday Evening Post,* September 12, 1953. "Are the Chinese getting tired of providing cannon fodder for the Kremlin? Are they getting fed up with Russian arrogance behind the Bamboo Curtain? What can we do to hasten a falling out between these partners in crime?" Also in this issue: "Moscow's Mouthpiece in New York" by Craig Thompson. "The bible of U.S. Reds, the *Daily Worker,* has stayed in business 29 years despite a $5,000,000 deficit. Who finances this 'newspaper'? Who owns it? What role does it play in the underground communist conspiracy?"

"I'M IN HIDING FOR LIFE," by Igor Gouzenko, in *Look,* March 23, 1954. (He was the clerk at the Russian embassy in Ottawa who turned over documents verifying the theft of atomic secrets from the U.S. and Canada, inspiring the book and movie *The Iron Curtain*.) "Exclusive: His picture has never been published. His children do not know their real name. A man marked for death by the Soviet secret police here tells his own true story."

"KREMLIN, U.S.A.," by Andrew Tully, in *Colliers,* August 20, 1954. "It's the Soviet Embassy—a bit of Red Russia with its own spies and oppression."

"MURROW: THE MAN, THE MYTH, THE MCCARTHY FIGHTER," by Joseph Doyle, in *Look,* August 24, 1954. (That's Edward R. Murrow to you.)

"RED HUNTER'S RED JAILMATES," by J. Parnell Thomas, in *Life,* October 4, 1954. "Former congressman reveals encounters in prisons with men he helped convict and tells why he thinks lawmakers and judges 'should spend time behind bars'." (Illustration shows Thomas in the Danbury [CT] Federal Correctional Institute bumping into two of the Hollywood Ten convictees, Ring Lardner Jr., and Lester Cole, along with others HUAC sent to prison for contempt of Congress.)

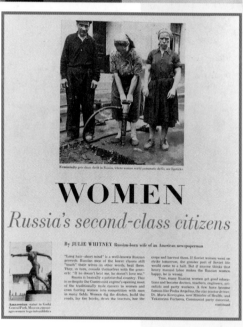

"WOMEN: RUSSIA'S SECOND-CLASS CITIZENS," by Julie Whitney, in *Look,* November 30, 1954. "Nowhere in the world is female beauty held in such low esteem—needless to say, there is no 'Miss U.S.S.R.'"

"FROM CONTINENT TO CONTINENT," in *Life,* March 7, 1955. "As U.S. reveals intercontinental missile program, weapons experts describe rocket Russians may have."

"H-BOMB HIDEAWAY," in *Life,* May 23, 1955. "Urged on by Administrator of Civil Defense Val Peterson, who advises all U.S. citizens to build some sort of shelter against the H-bomb 'right now,' the Walter Kidd nuclear laboratories have produced a shelter for a family of five. . . Luxury model ['the Kokoon'], 14 feet long and 8 feet in diameter, may be ordered for $3,000. A slightly smaller model costs $2,500."

"A NEW SOVIET AIR FORCE THREAT," in *Life,* June 6, 1955. "Has Russia equalled the U.S. in modern air might?" (with the Double Delta-Wing jet and the T-37 Bison and T-39 Badger long-range bombers). Also in this peril-packed issue: "Red Amateurs Are Pros" by Yuri A. Rastvorov ("Former Soviet Secret Agent"). "For '56 Olympics, Soviets regiment sports as a weapon of state." And more: An advertisement from the American Petroleum Institute headlined, "Iron Curtain Gasoline costs *5 times more* than you pay here." It continues, "'Service' stations are few and far between. In Moscow there are only five . . . This contrast between conditions here and behind the Iron Curtain points up the failure of State-controlled industry."

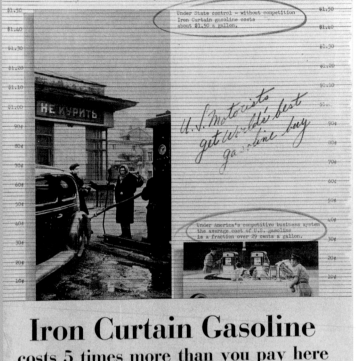

"RELIGION IN THE GODLESS STATE," by William O. Douglas, Associate Justice, U.S. Supreme Court, in *Look,* January 10, 1956. "In Russia, the Communist campaign against the church is incessant, but the will to worship remains incessant."

"U.S. RACES FOR A SUPERMISSILE," in *Life,* February 27, 1956. "As Washington worries about the Red advances in long-range guided missiles, *Life* examines the progress of the U.S. program for a 5,000-mile intercontinental weapon."

"ICBM," by Hanson W. Baldwin, in *Colliers,* March 16, 1956. "The U.S. and Russia are engaged in a race whose outcome may determine the course of history. The goal: development of the most frightful weapon conceived by man—a virtually unstoppable 16,000-mph intercontinental ballistic missile that can drop a hydrogen warhead on a city 5,000 miles away . . . What will happen if Russia gets it first?"

"I FOUND RUSSIA CHANGED: MOSCOW'S FLAMING YOUTH," by Charles W. Thayer, in *The Saturday Evening Post,* April 9, 1956. (About wild rich kids in Russia.)

"CARDINAL MINDSZENTY TODAY," by the Reverend Dr. Joseph Vecsey, in *Colliers,* April 13, 1956. "How the Reds still punish the captive [cardinal]—the first full, authentic story behind the Hungarian government's fake 'release' of the Roman Catholic prelate."

"THE SENSATIONAL SECRET BEHIND DAMNATION OF STALIN," by Alexander Orlov, in *Life,* April 23, 1956. "Ex-NKVD general is finally free to disclose deeds so shocking Reds must disown old idol."

"OUR GUIDED MISSILE CRISIS," by Trevor Gardner, in *Look,* May 15, 1956. "Even the President is unaware how gravely boggled this crucial operation has now become. What we need is a missiles boss with the power to solve all problems."

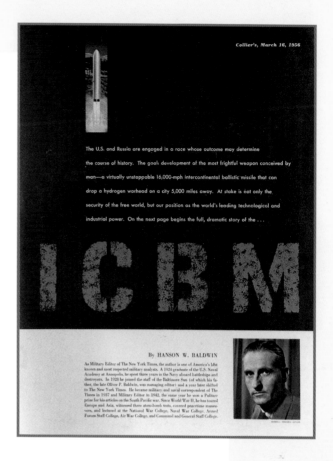

Collier's, March 16, 1956

The U.S. and Russia are engaged in a race whose outcome may determine the course of history. The goal: development of the most frightful weapon conceived by man—a virtually unstoppable 16,000-mph intercontinental ballistic missile that can drop a hydrogen warhead on a city 5,000 miles away. At stake is not only the security of the free world, but our position as the world's leading technological and industrial power. On the next page begins the full, dramatic story of the . . .

ICBM

By HANSON W. BALDWIN

As Military Editor of The New York Times, the author is one of America's best known and most respected military analysts. A 1924 graduate of the U.S. Naval Academy at Annapolis, he spent three years in the Navy aboard battleships and destroyers. In 1928 he joined the staff of the Baltimore Sun (of which his father, the late Oliver P. Baldwin, was managing editor) and a year later shifted to The New York Times. He became military and naval correspondent of The Times in 1937 and Military Editor in 1942, the same year he won a Pulitzer prize for his articles on the South Pacific war. Since World War II, he has toured Europe and Asia, witnessed three atom-bomb tests, covered peacetime maneuvers, and lectured at the National War College, Naval War College, Armed Forces Staff College, Air War College, and Command and General Staff College.

"REBELLION IN RED EUROPE," in *Life*, November 5, 1956. (Twelve pages of pictures and first-hand observation of the Polish and Hungarian uprisings.)

"SCIENTIFIC BLUEPRINT FOR ATOMIC SURVIVAL," in *Life,* March 18, 1957. "The drawings on these pages illustrate phases of a monumental scheme which, its designers say, may save the life of the U.S. in any future war. They are plans for a nationwide system of shelters to protect U.S. citizens in a nuclear attack."

"A REVOLT FAILS BUT DEFIANCE LIVES ON IN CUBA," in *Life,* March 25, 1957. Batista's army snuffs attack by young rebel forces of Menelao Mora; Castro not thought to be involved.

"HOW REDS USED CAPTIVE BRAINS," in *Life,* May 27, 1957. "Artful pressure on Germans yielded plane engine unequaled in the West."

"THE FEAT THAT SHOOK THE EARTH," in *Life,* October 21, 1957. "Russia's satellite, a dazzling new sight in the heavens." Also: "Why Did U.S. Lose the Race? Critics Speak Up" by Dr. C. C. Furnas, "Space Beyond Sputnik Lies within Our Grasp" by Don Schanche, and "Common Sense and Sputnik"—Editorial. (Cover story of Sputnik's impact on the U.S.)

"INTIMATE PORTRAIT OF A RUSSIAN MASTER SPY," by Frank Gibney, in *Life,* November 11, 1957. "In an exclusive report Col. Abel, most formidable U.S. agent ever caught, emerges as brilliant, gifted, and humorous—but lonely and still enigmatic."

"KHRUSHCHEV: MAN BEHIND THE MASKS," by Edward Crankshaw, in *Life,* December 2, 1957. "Russian expert reveals a dictator with four faces: babble, killer, shrewd plotter, visionary gambler."

"FIRST HARD FACTS ON ALL RUSSIAN SCIENCES," by Robert Wallace, in *Life,* December 16, 1957. "Field-by-field survey based on U.S. experts' knowledge and Soviet words and deeds shows that Sputniks are but one example of amazing progress." (Examines Russian advances in atomic physics, mathematics, astronomy, chemistry, cryogenics, earth science, etc.)

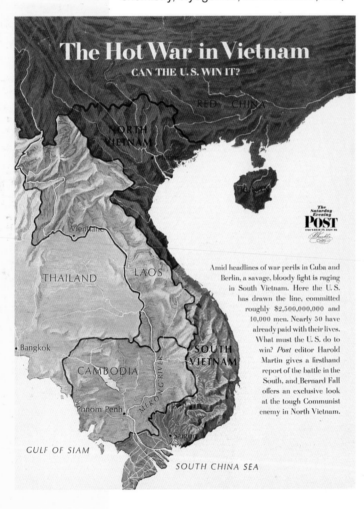

The Hot War in Vietnam
CAN THE U.S. WIN IT?

RED CHINA

NORTH VIETNAM

The Saturday Evening POST

Amid headlines of war perils in Cuba and Berlin, a savage, bloody fight is raging in South Vietnam. Here the U.S. has drawn the line, committed roughly $2,500,000,000 and 10,000 men. Nearly 50 have already paid with their lives. What must the U.S. do to win? *Post* editor Harold Martin gives a firsthand report of the battle in the South, and Bernard Fall offers an exclusive look at the tough Communist enemy in North Vietnam.

Vientiane

THAILAND
LAOS

Bangkok
SOUTH VIETNAM

CAMBODIA
MEKONG RIVER

Phnom Penh

GULF OF SIAM

SOUTH CHINA SEA

"TWILIGHT OF THE CZARS," Part I of "The Russian Revolution" series by Alan Moorehead, in *Life,* January 13, 1958. (Cover illustration: "In front of the Narva Gate in Petrograd, mounted Cossacks cut down a delegation of workers on the way to present a petition to the czar. This brutality on 'Bloody Sunday' was a prelude to the great revolution of 1917, which is the subject of a new *Life* series starting in this issue.")

"RELENTLESS RISE OF THE CONSPIRACY," Part II of "The Russian Revolution" by Alan Moorehead, in *Life,* January 20, 1958. "As Lenin built strength, others incited real violence."

"RED AGENT'S VIVID TALES OF TERROR," by Peter Deriabin and Frank Gibney, in *Life,* March 23, 1959. "A historic defection [by Deriabin, a former officer of the Soviet security police] gives U.S. first full story of secret police." (Cover slug: "By the most valuable Soviet agent ever to escape—and talk.")

"A FIST SHAKEN IN RAGE THAT SHOOK THE WORLD," by Robert Manning, in *Life,* May 30, 1960. "No vision so chilling had thrust itself before the world since Hitler. Here was a man abandoned to ostentatious rage. If he meant that shaken fist to shake and appall the world, he got his wish." (U.S. refusal to apologize for U-2 spy plane, shot down on May 1, leads Khrushchev to cancel Paris Summit and call press conference instead.)

"BIG PUSH IN SOVIET PROPAGANDA," by Eugene Bordick and William J. Lederer (authors of *The Ugly American*), in *The Saturday Evening Post,* August 19, 1961. "To present a brotherly and beneficent image, Russia backs a global organization with tremendous power and big money."

"MY LIFE ON THE BLACKLIST," by Ring Lardner Jr., in *The Saturday Evening Post,* October 14, 1961. "A famous writer reveals that he was once a Communist, and tells about his career since he 'declined to testify.'"

"WHAT WE MUST DO TO DEFEAT COMMUNISM," by John K. Jessup, in *Life,* November 10, 1961 (Part III in the series "How We Can Fight Back"). Also in this issue: Editorial—"K's Play for Total Power" ("The corpse-mover, bomb-tester, and heretic-hunter has made frightening bid for more might.")

"CRACKPOTS: HOW THEY HELP COMMUNISM," editorial in *Life,* December 1, 1961. "'Superpatriots' are not needed to win Cold War.'"

"THE HOT WAR IN VIETNAM—CAN THE U.S. WIN IT?," in *The Saturday Evening Post,* November 24, 1962. "Amid headlines of war perils in Cuba and Berlin, a savage, bloody fight is raging in South Vietnam. Here the U.S. has drawn the line, committed roughly $2,500,000,000 and 10,000 men. Nearly 50 have already paid with their lives. What must the U.S. do to win? *Post* editor

Master of the Red Jab

Ho Chi Minh is waging the kind of war that he knows best. An inside report on America's enemy, North Vietnam.

By BERNARD B. FALL

North Vietnamese army, 400,000 strong, is rated one of the world's best infantry forces.

Ho (at left), still spry at 72, was a leading Communist long before Nikita Khrushchev.

Harold Martin gives a firsthand report of the battle in the South." Also in this issue: "Master of the Red Jab" by Bernard B. Fall. "Ho Chi Minh is waging the kind of war that he knows best. An inside report on America's enemy, North Vietnam."

"SUDDENLY, NIKITA'S DAY WAS DONE," in *Life,* October 23, 1964. "Two protégés, Brezhnev and Kosygin, seize the reins of Russia." Also in this farewell-to-Khrushchev issue: "He Gave the World the Wildest Ride in the Park," by John K. Jessup.

BOMB SHELTER CHIC
BETTER LIVING THROUGH RADIATION

This family is building a basement compact shelter of sand-filled concrete blocks. Solid concrete blocks are used for the roof shielding.

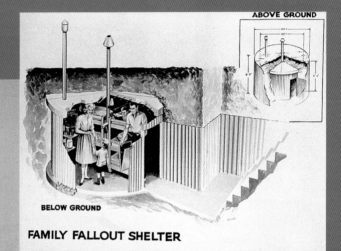

ABOVE GROUND

BELOW GROUND

FAMILY FALLOUT SHELTER

FALLOUT PROTECTION
WHAT TO KNOW AND DO ABOUT NUCLEAR ATTACK

DEPARTMENT OF DEFENSE • OFFICE OF CIVIL DEFENSE

TYPICAL FAMILY SHELTER DESIGNS

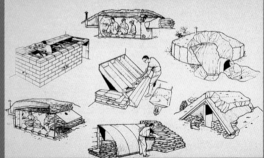

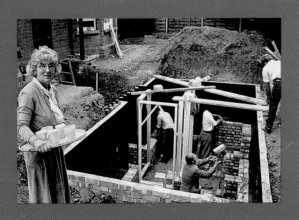

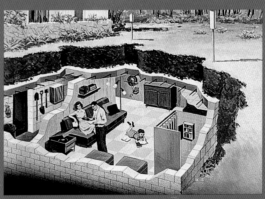

All photos except top and center left courtesy Archive Photos

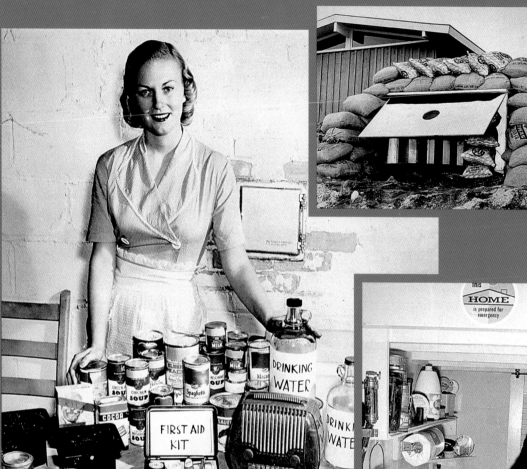

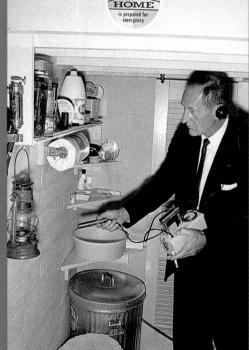

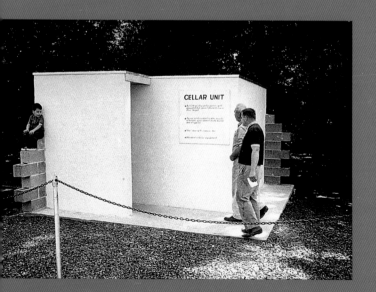

TIMELINE:

JULY 19, 1957: Playwright Arthur Miller is fined $500 for contempt of Congress. He had refused to answer questions before a House committee in 1956 involving Communist writers he had worked with a decade earlier. **AUGUST 7, 1957:** Soviet Counter-Intelligence Colonel Rudolph Abel is arrested in Brooklyn, where he had resided since 1948 under an alias, and is indicted as a Soviet spy for conspiring to obtain and transmit national defense information to Moscow. He is the highest-ranking Communist spy ever caught in the U.S. He is convicted on October 25 and sentenced to thirty years in prison. **AUGUST 26, 1957:** Russia announces it has successfully tested an ICBM, temporarily giving them the edge in "the missile race." The first two ICBM tests by the U.S. in 1957, however, are failures. **SEPTEMBER 21, 1957:** Air Force Captain George French is sentenced to life imprisonment for offering to sell secrets about atomic weapons in jet bombers to the USSR. His method was to drop a letter with his price ($27,500) onto the grounds of the Soviet embassy in Washington, D.C. But an FBI agent intercepts the letter before it can be read by the Russians. **OCTOBER 4, 1957:** Sputnik —short for "fellow traveler of the Earth"—is launched by the Soviet Union, becoming the first satellite to orbit the earth and sending America into a state of utter shock. **NOVEMBER 3, 1957:** The second Sputnik, much larger, is successfully launched. It carries a dog named Laika, who survives part of the adventure. **NOVEMBER 7, 1957:** The annual Moscow Military Parade, held this year on the fortieth anniversary of the Bolshevik Revolution, disappointed observers when no ICBM or tactical atomic weapon was included in the parade of new weapons. **DECEMBER 6, 1957:** The first U.S. attempt to put a satellite into space ends in disaster when the Vanguard rocket explodes on its launching pad at Cape Canaveral. The terms "Flopnik" and "Kaputnik" appeared in papers around the world the next day. **DECEMBER 17, 1957:** First successful ICBM launch by the U.S. **JANUARY 31, 1958:** The U.S. successfully launches its first satellite, the Explorer. **MARCH 1, 1958:** Khrushchev is named Soviet premier. **JANUARY 2, 1959:** Fidel Castro and his rebel forces, having overthrown Batista's corrupt but U.S.-friendly government, take control of Cuba. **JULY 1959:** Vice President Richard Nixon flies into Moscow and spends the night at Premier Khrushchev's *dacha*. The next day they engage in their impromptu "kitchen debate" at the U.S. National Exhibition in Moscow. **SEPTEMBER 1959:** A major Cold War thaw is indicated by the debut of the animated television series Rocky and His Friends, an ABC afternoon broadcast which brings the first broad lampoons of Russian spies— Boris Badenov and Natasha Fatale—to the youth of America. **SEPTEMBER 14, 1959:** The Russians successfully hit the Sea of Tranquility on the moon with an 858-pound missile

1957-1962

SEPTEMBER 15, 1959: Khrushchev visits Eisenhower in Washington, and, in a puckish mood, tells CIA Director Allen Dulles, "I believe we get the same reports—probably from the same people." Dulles was not amused. The premier then proceeds to Los Angeles, although his visit to Disneyland is cancelled because of security concerns. San Francisco, Des Moines (where Nikita eats his first hot dog), and the presidential retreat at Camp David complete the pleasant tour. It all seems to signal a thaw in the Cold War. MAY 1, 1960: The Soviets shoot down the U-2 reconnaissance plane of American airman Gary Powers over the Urals. The embarrassed U.S. at first tries to fob off the flight as "weather observation." But, caught red-handed, Powers admits he was taking pictures of Soviet airfields. MAY 16, 1960: Khrushchev rips into Ike at the Paris peace talks over the U-2 fiasco, demanding an apology. Infuriated, the president refuses. The next day, Khrushchev departs the talks, but not before giving a two-and-a-half-hour press conference full of vitriol and outrage. The Cold War descends into a new deep freeze. 1960: The U.S. Olympic hockey team upsets the Russian team, the defending medal winners from 1956, in Squaw Valley, California. JANUARY 20, 1961: President-elect John Fitzgerald Kennedy is inaugurated, while erstwhile President Eisenhower's departing speech about the growing danger of the U.S. military-industrial complex is still echoing. FEBRUARY 14, 1961: Jim Webb is appointed by JFK to take over NASA. He vows to put America ahead in the Space Race. APRIL 12, 1961: Yury Gagarin, son of a Russian farmer, becomes the first man to orbit the earth. He returns safely after making a single orbit. APRIL 17-24, 1961: The Bay of Pigs fiasco —an ill-advised, poorly planned, and abysmally executed attempt to invade Cuba using CIA-trained Cuban expatriates—embarrasses the U.S. as never before. MAY 5, 1961: Navy Commander Alan Shepard becomes the first American to leave Earth's atmosphere when his Mercury capsule makes a 300-mile flight into the heavens. Although his flight does not achieve orbit, he still gets a ticker-tape parade along Wall Street. AUGUST 1961: The East Germans erect the infamous Berlin Wall—twenty-eight miles of concrete, steel, and machine gun–nests—to impede the exodus to the Western sector of its citizens, who had been emigrating at the rate of more than 100,000 a year since 1959. Over the next twenty-eight years, five thousand East Berliners escape. OCTOBER 1961: Stalin's body is removed from its hallowed resting place next to Lenin's in Red Square, and reinterred in an obscure gravesite. OCTOBER 30, 1961: At 8:33 A.M., the Russians secretly detonate a 58-megaton bomb over the Novaya Zemlya area. Its explosive force is 3,867 times more powerful than the bomb dropped on Hiroshima. OCTOBER 22, 1962: The Cuban Missile Crisis begins. It ends nearly a month later when President Kennedy and Premier Khrushchev agree that the Soviet missiles and troops that have been sitting in Cuba would be withdrawn.

PAMPHLETS ON PARADE ★?

OR, BIG STATEMENTS IN LITTLE PACKAGES

nlike the books and magazine articles surveyed in earlier chapters, the pamphlets and privately published tomes presented here generally were not available to the American public through the normal commercial channels for reading matter—newsstands, department stores, bookstores, and the like. But if history has taught us anything, it is that when there's a will, there's a way. Through word-of-mouth, mail order, and distribution through organizations, these small but potent packages of propaganda had circulation figures which will forever remain a mystery— although at least one, the 1964 paperback None Dare Call It Treason, *claimed to have sales of one million copies in its first year. But even the tiniest pamphlet did its part in helping to fuel the anti-Communist movement for many decades. And, while many of these crudely printed tomes appear to have been cobbled together out of someone's garage, the observant reader will note that at least a few were the work of the United States government. Shades of old Tom Paine!*

From *THE RED FOG,* **by Bonnie Busch and Lucia Ramsey Maxwell (Washington, D.C.: The National Patriotic League, 1929).**

Looking toward the horizon, we see a RED FOG rising slowly and aggressively; a lethargic, stupefying, poisonous mist, settling over the earth, blinding the guardians of our heritage. Its dense threatening clouds directed and driven by the master Machiavellian are massing ominously above our United States . . . To the dupe, the RED FOG is but a pastel pink. The adept sees it in its true light, a colorful background for the far-flung Red Flag with its sickle, hammer and star, a flag as red as the blood of its dupes and victims, which they plan shall flow in the streets of America as it did in Russia, to cleanse America of its capitalistic government while they, the avengers, become dictators for the proletariat.

COMMUNIST-SOCIALIST

PROPAGANDA

IN

AMERICAN SCHOOLS

VERNE · P · KAUB

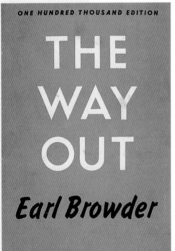

The methods of accomplishment will include force and violence, though they are now singing the siren song of "peace on earth, good will toward men." The United States of America is their goal, for if they take our country they gain the world!

From *EARL BROWDER: COMMUNIST OR TOOL OF WALL ST., STALIN, TROTSKY OR LENIN,* by George Marlen (New York: Van Rees Press, 1937).

I heard Browder and his flunkies delivering fiery denunciations of Hitler. What intense conviction vibrated in their voices! ...These efforts of the Browders, owing to the total absence of genuine Leninist exposure, accomplished the purpose of retaining for them the leadership over the Communist workers. The glib-tongued demagogues loosed a barrage of wild vehemence against all critics, particularly against Trotsky; and so great was the flurry of slander and lies that they succeeded in completely befogging the workers. . .

Stalin's tight-rope walking between proletarian revolution and imperialist intervention did not begin with the German betrayal of 1933. It had its starting point in the revolutionary situation in Germany in 1923 . . . to preserve the bureaucratic centralism in the Soviet Union, the Stalinist clique ten years later sacrificed to Fascism *the most trustworthy ally of the Russian revolution!* . . .

These are gloomy days for the international proletariat, for all the exploited and oppressed. But different days are coming. . . Under the pressure of events and relentless exposure by true followers of Marx and Lenin, the dark flood of the Stalinist reaction will recede. The skies will brighten. . . Today, as ever, the toilers have nothing to lose but their chains. Out of the fire of Marxist understanding will burst the mighty Red conflagration which will forever destroy oppression, exploitation and misery. LONG LIVE THE FOURTH INTERNATIONAL! (The author was a member of the Comintern until 1933.)

From *THE WAY OUT,* by Earl Browder (New York: International Publishers, 1941).

In the United States today, there are laws being multiplied everywhere which make it heresy to utter the only possible answer to the question of "The Way Out." This book is therefore a "dangerous" one. If the reader should become convinced that its answer to the question is true, and if he should publicly proclaim this fact, he may by the authority of the laws of the United States be deprived of employment, public or private; he may be deprived of his right to vote or to run for public office; he is subject to all sorts of spying, snooping, wire-tapping, stool-pigeonry, and slander, from which he will have no legal recourse, and for which his tormentors will be rewarded, some of them most richly. If he is stubborn about it, he may find himself suddenly arrested and sent to prison on the most sophistical pretexts. . .

At the recent Conference of the Communist Party, they began to draw up a fifteen-year plan. They are now finishing up the third Five-Year Plan. That of the next

fifteen years is going to be a plan made in one piece, and in those fifteen years, the Soviet Union is going to overtake and surpass, economically as well as in every other respect, every other country in the world, including the United States.

From *IT ISN'T SAFE TO BE AN AMERICAN,* by Joseph P. Kamp (New York: Constitutional Educational League, 1950).

Here is concrete evidence of how the New Deal and the Fair Deal Administrations have coddled, and then connived and cooperated with, the Communists.

Here is the sordid story of how the Communists, their Fronters and Fellow-travelers, their Red and Pink "liberal" friends, and their dupes and stooges, maneuvered in high places in Washington; how they misused the power of the Government, of the Congress and of the Courts for their own evil purposes; and how the political prostitutes who cooperated with them were promoted to higher public office, even to the Federal Court Bench, and to the President's Cabinet.

Here are damning facts no Tyding's Committee can whitewash.

These facts are matters of *official* public record.

And even Harry Truman can't suppress them!

(Other publications of the Constitutional Educational League: *High Taxes: The Quick Way to Communism, Behind the Lace Curtains of the YWCA, America Betrayed, Wage Slaves in America.*)

From *THE NEGROES IN A SOVIET AMERICA,* by James W. Ford and James S. Allen (New York: Workers Library Publishers, 1935, 1945).

We believe we express the minimum desires of the Negro masses when we say that they want at least:

- A decent and secure livelihood;
- The rights of human beings;
- An equal, honorable, and respected status in all public and social life.

Capitalism has not been able to provide these needs, and is less and less able to do so. There are those who say that by reforming capitalism it can be made to fill the needs of the masses. We will show why this is impossible.

There is only one real, effective way out for the masses. It is not an easy one. But no basic change in society is easy. This way leads to a Soviet America. This is the only realistic vision of freedom possible today. It must be achieved, it can be achieved.

We must begin now—begin by organizing, by preparing our forces in our daily struggles to improve our conditions, by learning to "take over." Above all we must build and support the *only* revolutionary party of the working class, the Communist Party. This Party, composed of staunch revolutionists and militant workers, is training and leading the working class and the oppressed masses toward their great objective.

Come join the Communist Party, help create the powerful, great vanguard which is leading the masses toward Socialism.

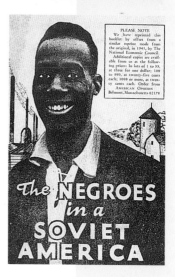

From *U.S.A.– U.S.S.R.: ALLIES FOR PEACE* (New York: National Council of American-Soviet Friendship, 1945). (Primarily a transcript of addresses by under-secretary of state Dean Acheson, Joseph E. Davies, Paul Robeson, Hon. Nikolai V. Novikov, et. al., at the American-Soviet Friendship Rally in Madison Square Garden, November 14, 1945, salutations by various celebrities follow).

The work of the National Council of American-Soviet Friendship which is developing greater understanding of the Soviet Union among the American people and is combating anti-Soviet drive of the reactionary forces which are sowing discord between our country and Russia is an important contribution to world peace and security. Success to your future endeavors! – *Katharine Hepburn*

American-Soviet friendship is one of the cornerstones on which the edifice of peace should be built. To achieve this friendship nothing is more important than mutual understanding on the part of each of the institutions, traditions and customs of the other. In the military field we found the Red Army ready to cooperate promptly and effectively with our own forces.

Moreover the extremely able Soviet leaders with whom we have come in contact have exhibited always an attitude of personal friendliness, consideration, and patience. As an American soldier and lover of peace, I wish your Council the utmost success in the worthy work it has undertaken.
–*General Dwight D. Eisenhower, Chief of Staff,*
 United States Army

Our choice is simple, the end of war or the end of the world. The peoples of the United States and of the Soviet Union of Russia are meant to be friends. It is up to them to crush all conspiracies against that friendship. It is up to them to march forward together into a free world. – *Orson Welles*

From *100 THINGS YOU SHOULD KNOW ABOUT COMMUNISM IN THE U.S.A.*, prepared and released by the Committee on Un-American Activities, U.S. House of Representatives; J. Parnell Thomas, New Jersey, Chairman (Washington, D.C., 1948).

#4. *What would happen if Communism should come into power in this country?*
Our capital would move from Washington to Moscow. Every man, woman, and child would come under communist discipline.

#20. *Could I have friends of my own choice as I do now?*
No, except those approved by the Communists in charge of your life from cradle to grave.

#34. *Where are their headquarters in the United States, and who is in charge?*

Headquarters are at 35 East Twelfth Street, New York City. William Z. Foster, of 1040 Melton Avenue, New York City, has the title of "Chairman of the Communist Party of the United States," but Foster is actually just a figurehead under control of foreign operatives unseen by and unknown to rank and file Communists.

#62. *How can a Communist be identified?*

It is easy. Ask him to name ten things wrong with the United States. Then ask him to name two things wrong with Russia. *His answers will show him up even to a child.* Communists will denounce the President of the United States but *they will never denounce Stalin.*

#65. *What do Communists call those who criticize them?*

"Red baiters," "witch hunters," "Fascists." These are just three out of a tremendous stock of abusive labels Communists attempt to smear on anybody who challenges them.

#95. *What is Communism's greatest strength?*

Its secret appeal to the lust for power. Some people have a natural urge to dominate others in all things. *Communism invites them to try.* The money, hard work, conspiracy, and violence that go into Communism, add up to a powerful force moving in a straight line toward control of the world.

(Other booklets in this series: *100 Things You Should Know about Communism in Religion, 100 Things You Should Know about Communism in Education, 100 Things You Should Know about Communism in Labor, 100 Things You Should Know about Communism in Government.*)

From *RED SHADOWS*, by Kenneth Goff (Ft. Worth, TX: The Manney Co., 1959).

Red's Blueprint for World Control by 1970:

To understand the communists and their world-wide program of enslavement, one must go back into their own teachings and the Bible of their faith. From the very beginning, they have declared: 'Our task is terrible, total, universal and merciless destruction.

Today, we are conscious of the fact that Russia is gradually preparing herself for World War III. . . The concentration of the best Red armies in Siberia spells a warning to our nation. Alaska is the doorway to North America, and Russia is posing [*sic*] to plunge through that doorway without warning, in hopes of capturing the United States.

From *FOR THE SKEPTIC: SELECTED READINGS OF COMMUNIST ACTIVITY IN THE UNITED STATES OF AMERICA*, edited by Lyle H. Munson (New York: The Bookmailer, 1959).

This volume is for the skeptic. It consists entirely of quotations from official government documents. The material here has been selected from more than 100 published hearings.

No reader will be more grateful than I, for the continuing vigil of our Congressional investigating committees . . . How little any of us would know about our Communist enemy if this Committee work had not been done!

From *AN EVIL TREE: THE STORY OF COMMUNISM,* by Agnes Murphy, Ph.D. (Milwaukee: The Bruce Publishing Co., 1962).

The new revised, enlarged edition includes three new chapters focusing on the Communist Conspiracy —a history of Communist espionage in the United States, the laws enacted, and the organizations formed to combat this threat.

Your reaction to this sinister spectacle, starring Satanic hatreds and perversities, may understandably be one of fear and hopelessness . . . You, her children, must enlist under the banner of Mary Immaculate. You are infallibly sure of victory . . . Only thus shall we see that the godless Red tree never blossoms on this soil.

From *THE RED FOG OVER AMERICA,* by William Guy Carr, R.D. (Los Angeles: St. George Press, 1964).

From Appendix III, "The McCarthy Case":

The progress of the continuing Luciferian conspiracy moves at such a pace that we had no sooner included the Norman case in Appendix II than Senator Joseph McCarthy died under mysterious circumstances in Bethesda Hospital . . . The circumstances surrounding the death of Senator McCarthy should be probed to the bottom. WHY WAS NO AUTOPSY DONE ON McCARTHY IN COMPLIANCE WITH THE LAW? WHY DID THE AUTHORITIES REFUSE TO COMPLY WITH THE LAW IN SPITE OF INSISTENT DEMANDS FROM THE PUBLIC? WHAT MURDEROUS GANG COMMITTED THIS MURDER?

Suggested Reading for Better Knowledge Regarding the International Conspiracy:
Thugs and Communists by Louis Zoul
The Death of Joe McCarthy by F. X. Ranuzzi
America's Retreat from Victory by Sen. Joseph McCarthy
No Wonder We Are Losing by Robert Morris

From *FREEDOM MUST NOT PERISH,* by William H. Wilbur (Deerfield, IL, 1964).

Communism is a menace for several reasons.

The record of the United States in meeting the problem is far from creditable. In 1933, the administration reversed the established American policy and recognized the Soviet Union. At that time, Russia was in considerable domestic difficulty. The communist experiment has been tried and found to be a failure: a failure in industry, a failure

in education, a failure in human relations. Left to its own devices, the communist government would probably have collapsed. Our State Department, with the strange imbalance that so often appears in glib, brilliant liberals, decided to help this moribund Russia.

In 1933, Russia solemnly promised not to propagandize, not to try to subvert the United States. The ink was hardly dry on the agreement before the Soviets launched a full-scale campaign in direct violation of its pledged word . . . During World War II, we supplied the Soviet Union with tremendous quantities of military equipment and transportation.

At this distance, it seems incredible that the United States government could have followed such a consistently stupid policy, could have continued to take one major step after another to build up our present enemy.

From *COMMUNIST-SOCIALIST PROPAGANDA IN AMERICAN SCHOOLS,* **by Verne P. Kaub (Boston: Meador Publishers, 1953). From the back jacket of the fifth edition (1960):**

The book makes amazing, yet, appalling disclosures about NEA's pattern of teaching for American youth. So-called progressive education . . . is based on un-American and anti-American aesthetic philosophies. Progressive education is . . . worse than reactionary, actually subversive.

(Kaub, the president of the American Council of Christian Laymen, also is the author of *Satan Goes to School* and *The Yale Whitewash.)*

From *A PROGRAM FOR COMMUNITY ANTI-COMMUNIST ACTION,* **by the Chamber of Commerce of the United States (Washington, D.C., 1948).**

Introduction: "How Communism Threatens You"

You may never have seen a Communist. You may never have read their *Daily Worker* or heard a Communist on the radio. So, you ask: What is all the fuss about? You say: Maybe the Reds are a problem in Europe or Asia, but they are no threat to me.

But they are a threat to you, to your home, to your community . . .

You know that they hate us and our freedom. They would destroy us if they could. If we are not alert, they may do just that. Fantastic? Just look at some examples . . .

Communism will be met only if Americans in every *community* make this their *personal* job. It is your responsibility and your duty. You are the Minutemen of today. Here is what you can do:

• Learn why Communism is a menace. Read the pamphlets listed in the bibliography. Tell your friends, your neighbors, your associates at work.

• Discuss the calling of a representative meeting to do something about Communism in your community.

• Form local committees to get information, to give it out, and to start community action programs.

• Use your community influence and aid to set up state and national programs so as to fight Communism on a broader scale.

AMERICA BETRAYED: THE TRAGIC CONSEQUENCES OF REDS ON THE GOVERNMENT PAYROLL, by Joseph P. Kamp (New York: Constitutional Educational League, 1950).

When the Chinese Communists triumphed over the Nationalist forces, *Soviet Russia won a major victory* . . . and the United States suffered a crushing catastrophic defeat.

It is . . . to our eternal disgrace that traitors in our own State Department were permitted to betray American security, and to jeopardize the safety of the American people by helping to assure a Communist conquest of China. This smashing Russian victory imperils the whole American security position in the Pacific. It dooms Korea, all Southeast Asia, the Philippines, perhaps even Japan, to early and certain conquest by Communism.

It is no exaggeration to say that in its potentialities it is by far a more ghastly American defeat than Pearl Harbor. *It is an appalling disaster that should be of grave concern to every alert American."*

How did it happen?

Who caused it to happen?

Who permitted it to happen?

These questions are inescapable—and demand answers—if we are not to repeat our tragic China experience with Communist Russia, euphemistically called a "cold" war.

From the Preface to *A BUSINESS MAN LOOKS AT COMMUNISM,* by Fred C. Koch (Wichita, KS, 1960).

Please consider these points:

1. There will *never* be peace in the world as long as Communism exists. We are in a war to the death, and not of our choosing. Unhappily few people are aware of this fact.

2. You can *trust* a Communist to always be a Communist in the end – to work for complete governmental control by violent, bloody revolution.

3. The United Nations was conceived by Communists in Moscow in World War II. The United Nations, the World Court, and World Government are instruments the Kremlin intends for the subtle takeover of America.

4. "What does it matter if three quarters of the world perish, if the remaining one quarter is Communist?"–*Lenin*

From *THE IDEOLOGICAL WAR: COMMUNIST MYTHS & AMERICAN TRUTHS,*
by Joe Crail, president of Coast Federal Savings and Loan Association, Los Angeles (Free
Enterprise Seminar Progress Report, March 20, 1961).

*Myth #7: The magnitude of the Communist propaganda effort as compared with
that of the U. S. has been exaggerated.*

Truth: The Soviet Union spends approximately $2,000,000,000 annually to propagandize one billion people outside Communist dominated countries. This equals $2
per person as contrasted with a U.S. estimated expenditure of 1 1/4 cents per person.*

**The Technique of Soviet Propaganda.* Report of the Internal Security
Subcommittee, Senate Committee on the Judiciary, 1960, p. 17.

From the *INTRODUCTION TO COMMUNISM: DIAGNOSIS AND
TREATMENT,* by Dr. Fred Schwarz (Los Angeles, CA: World Vision Inc.,
undated).

Communism is a disease: it is a disease of the body, of the mind,
and of the spirit. It is a disease of the body because it has already
destroyed the health and lives of many men. It is a disease of the mind
because it is associated with a systematized delusional pattern of
thought not susceptible to rational argument. It is a disease of the spirit
because it denies the existence of God and the spirit of man, and
degrades man to the level of the beast of the field.

The Ideological War

Communist Myths & American Truths

From the Introduction by Thomas A. Lane, Major General, Ret., to
BETRAYAL OPENED THE DOOR TO RUSSIAN MISSILES IN RED CUBA,
by Luis V. Manara, President, The Truth About Cuba Committee, Inc.
(Miami, FL, 1968).

Today, the United States has no time for patriots. Its obsession is
to court the favor of the Communist tyrants. All the enslaved peoples
who yearn for freedom know the United States has defected . . . We
know, of course, that there are Communists in the United States
government. Even the FBI doesn't know who they are. That is the kind
of world in which we live.

It is readily discernible that the decline of the United States began
with the administration of Franklin Delano Roosevelt and that it has
proceeded without interruption . . . The augury for freedom is very bad
indeed. One hope remains—that the American people are not as decadent
as their leaders and that they may yet be aroused to destroy Communism.

From *WIN NOW OR LOSE ALL,* by Reverend Paul C. Nepp (Ridgecrest,
CA: Through to Victory, 1964).

*Our Choice—Victory Over Communism Now or Mass Executions
and Slavery Under the Reds.*

By the publisher of the monthly periodical *Through to Victory* and the book *Let's
Take the Offensive.* "Here is a book to challenge every red-blooded American to
action!" With an introduction by Karl Prussion, counterspy for the FBI (1948-1959).

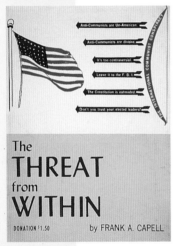

From _THE THREAT FROM WITHIN,_ by Frank A. Capell, editor & publisher, _The Herald of Freedom_ (1963).

About the Author: Frank A. Capell has been fighting Communism and its agents for twenty-five years—as chief of the Bureau of Subversive Activities of Westchester County, N.Y. . . . He has devoted most of his adult life to warning America and to fighting the enemy at all levels and in every way possible. [He] is the editor of _The Herald of Freedom,_ an anti-Communist educational publication which exposes the enemy by name without regard to race, creed or color. He has supervised the investigation of over five thousand individuals and organizations and has files on over two million people who have aided the International Communist Conspiracy.

From _COMMUNISM: AMERICA'S MORTAL ENEMY,_ by Dr. Fred Schwarz , Executive Director, Christian Anti-Communism Crusade, Inc. (1956).

Delivered by Dr. Fred Schwartz to Freedom Forum XX, The National Education Program, Searcy, Arkansas, under the date of April 27, 1956:

The communist [_sic_] say their victory is certain because the average American is so . . . INTELLECTUALLY LAZY, INTOXICATED WITH ENTERTAINMENT, LIMITED IN HIS HORIZON, INHERENTLY SELFISH.

They believe [that] world victory will inevitably be theirs. The year they have set for that is the year 1973. Now I can't give you that date out of Communist literature, but Senator Knowland had it read into the Congressional record . . . it is believed that [1973] was the year tentatively decided by Mao Tse-Tung and Stalin in their last conference.

From the Epilogue to _COMMUNIST AMERICA: MUST IT BE?,_ by Billy James Hargis (Tulsa, OK: Christian Crusade, 1960).

Today, this nation is engaged in a battle as fierce and urgent as any which we have ever encountered on an actual battleground. We are struggling to stamp out Communist infiltration in this nation. We have only one opportunity to win. Our defeat means the abyss of godless Communism . . .

Because THIS IS AMERICA, we have lulled ourselves into believing that we are safe and secure from any force on earth! . . . The Rand Corporation, in cooperation with the Defense Department, announced recently that within the next four years Communist Russia will have the power to destroy our Air Force and to devastate 85% of our big industry and 43 of our 50 largest cities in one lightning blow. Add to this the fact that the Communists have averaged 7,000 newly enslaved subjects every hour of the day. The question is no longer "CAN the Communists overthrow us or WILL they try to overthrow us," but _"WHEN will they overthrow us?"_

From *THE HEART, MIND AND SOUL OF COMMUNISM,* by Dr. Fred Schwarz (Houston, TX: Christian Anti-Communism Crusade, 1952, 1962).

History records no movement growing, conquering, consolidating, and expanding as Communism has unceasingly done . . . The statistics are startling, even terrifying. In 1917 they had 40,000 followers; in 1958 they were in absolute control of 950,000,000. They have multiplied those under control by 20,000 in forty years, an increase of 2 million percent. To consummate their dream of world conquest they need merely to multiply the present population under their control by less than 3.

From *NONE DARE CALL IT TREASON,* by John A. Stormer (Florissant, MO: Liberty Bell Press, 1964).

From Chapter I: "Have We Gone Crazy?"

In 1945, the communists held 160-million Russians in slavery. They controlled a land area smaller than the Russia of the Czars. Soviet industry had been largely destroyed by the Nazi war machine. Communism was a third-rate power, militarily, industrially, and economically.

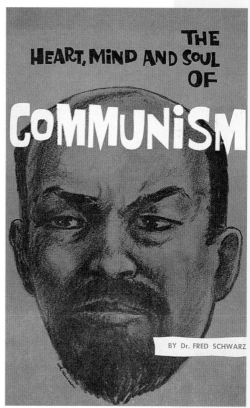

Today, after the United States has spent $600 billion to fight communism and sacrificed the lives of 50,000 of its youths to thwart Red aggression, the Kremlin has grown to become the absolute slave-masters of one billion human beings. The communists openly control 25% of the earth's land mass. Their puppet, Fidel Castro, has been installed in Cuba, just 90 miles from our shores. The hidden tentacles of the communist conspiracy exert unmeasured influence over the rest of the world.

Where have we failed?

. . . That is the task. To educate and alert the great mass of apathetic Americans to the danger and to show them what they can do.

HELP AWAKEN OTHERS! Give *None Dare Call It Treason* to Friends, Relatives, Neighbors, Clergymen, School Teachers, Libraries.

From the jacket copy to *PAWNS IN THE GAME: THE INTERNATIONAL CONSPIRACY EXPLAINED,* by William Guy Carr (Hollywood, CA: Angriff Press, circa 1950).

Here is a TRUE story of international intrigue, romances, corruption, graft, and political assassinations, the like of which has never been written before. It is the story of how different groups of atheistic-materialistic men have played in an international chess tournament to decide which group would win ultimate control of the wealth, natural resources, and manpower of the entire world . . . The International Communists, and the International Capitalists (both of whom have totalitarian ambitions), have temporarily joined hands to liquidate Christianity. The cover design shows that all

moves made by the International Conspirators are directed by Satan and while the situation is decidedly serious it is definitely not hopeless. The solution is to end the game the International Conspirators have been playing right now before one or another totalitarian-minded group impose their ideas on the rest of mankind. The story is sensational and shocking, but it is educational because it is the TRUTH.

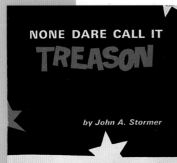

From *THE COMMUNIST CONSPIRACY VERSUS OUR DEMOCRATIC HERITAGE,* **by Michael Urgo (New York: Carlton Press, 1964).**

Communism is a worldwide movement fostering intrigue on innocent peoples. Party agents are working in every country taking orders directly from Moscow and Peiping. Communism is like an epidemic or plague that causes many problems. People who believe in the tenets of Communism are known as Communists. The leaders are a relatively small group of men and women from a few large countries who wish to become rulers of the world, and, above all, to destroy Democracy and Free Enterprise (Capitalism) . . . It is imperative for us to learn about Communism because the life of every American is in jeopardy.

From *THE CHURCH AND STATE UNDER COMMUNISM: AN ILLUSTRATED DIGEST,* **by the Students of St. Mary's School of Religion for Adults (Staten Island, NY: St. Mary's School, 1964).**

I rejoice that my students offered up this effort as prayer and penance in reparation for the blasphemies against the rights of God committed by those enslaved by satan, the "father of lies" and hatred.—*Rt. Reverend John J. Cleary, Principal, St. Mary's School of Religion for Adults*

From *THE COMMUNIST ATTACK ON U.S. POLICE,* **by W. Cleon Skousen (Salt Lake City: Ensign Publishing, 1966).**

The official Communist Party hate campaign against the police of the United States is now reaching a full crescendo in many parts of the country. It is a concerted, well-organized broadside of unmitigated venom against those who have the responsibility of protecting life and property and preserving the peace.

One of the most effective devices to help rehabilitate the legitimate image of the police is to have the mayors of several cities in an area issue a proclamation for a "Police Appreciation Week."

(The author is the editorial director of *Law and Order,* "the most widely distributed police magazine" in the U.S. He was an FBI agent from 1935 to 1951, and was Chief of Police in Salt Lake City from 1956 to 1960. He also authored *The Naked Communist.*)

RED READINGS

BOLSHEVISM ON OUR BOOKSHELVES

CLOCKWISE, FROM ABOVE: 1958, 1937, 1956, 1958

by JOHN ROY CARLSON

AUTHOR OF
Under Cover

THE Plotters

PERSONAL EXPERIENCES OF AN UNDER COVER AGENT
INVESTIGATING INDIVIDUALS AND GROUPS THAT
MENACE OUR NATIONAL UNITY • A SMASHING EXPOSÉ

1946

DI 803
SIGNET

IRVING R. LEVINE

MAIN STREET, U.S.S.R.

SELECTIONS FROM THE ORIGINAL EDITION

What is everyday life in the Soviet Union really
like? A top N.B.C. reporter who covered the
Moscow scene for four years gives surprising
answers to the questions Americans ask. With
eight pages of photographs.

A SIGNET BOOK

1934

I
SEARCH
FOR
TRUTH
IN
RUSSIA

SIR WALTER
CITRINE

1937

RED RAPE!

CONNIE
SELLERS

50¢
ASH

HEADLINE BOOKS
105

IT CAN HAPPEN HERE!

1963

CRAIG THOMPSON

The
POLICE STATE

WHAT YOU WANT
TO KNOW ABOUT
THE SOVIET UNION

1950

BABIES
WITHOUT TAILS
BY WALTER DURANTY

John Groth

1938

THE RED EXECUTIVE

A Study of the Organization Man in Russian Industry
DAVID GRANICK

A DOUBLEDAY ANCHOR BOOK

1961

RUSSIA'S
IRON AGE

By the author of
SOVIET RUSSIA
"The best book on
Soviet Russia in the
English language"
—*New York Times*

WILLIAM HENRY CHAMBERLIN

1960

MP398
60¢

BERNARD PARES

RUSSIA

HISTORY... PEOPLE... POLITICS

The Classic Brief History of Russia

A Mentor Book

1949

TIMELINE:

MAY 1, 1963: Cuban Premier Fidel Castro, paying his first visit to Moscow, attends the annual May Day parade, standing on the reviewing stand atop Lenin's Tomb at the side of Khrushchev as the latest in missiles rumble past. **JUNE 6, 1963:** Washington and Moscow agree to implement a "hot line" between the two seats of government, to be used only in emergency situations so as to prevent "accidental war" or "war by miscalculation." The hot line would soon become a staple in such films as *Fail-Safe* and *Dr. Strangelove.* **JULY 25, 1963:** A limited test-ban treaty is initialed in Moscow by the U.S., England, and the USSR. **NOVEMBER 22, 1963:** JFK is assassinated during a motorcade in Dallas. Lee Harvey Oswald, a self-professed and, possibly, self-employed operative for the USSR and Cuba, is arrested for the crime, but is himself assassinated by Dallas club owner Jack Ruby before he can be properly interrogated. **DECEMBER 2, 1963:** On behalf of the Atomic Energy Commission, President Lyndon Johnson presents a $50,000 check, along with a gold medal and a citation, to J. Robert Oppenheimer. He earlier had been classified a security risk by the AEC because of his ties to Communist organizations, and barred from further work for them. **DECEMBER 16, 1963:** The U.S. Court of Appeals reverses the year-old conviction of the Communist Party for failure to register under the provisions of the Internal Security Act. In essence, the court agreed with the officers of the CPUSA who complained that registering was by definition an act of self-incrimination, since the CPUSA had been defined legally as "a criminal conspiracy." **MARCH 1964:** *Playboy* publishes its pictorial, "Girls of Russia and the Iron Curtain," signaling (according to one reader's letter, published a few months later) a major thaw in the Cold War. **OCTOBER 15, 1964:** While on holiday near the Black Sea, Khrushchev learns that he is out of a job. The Presidium, his onetime plaything, has decreed that Leonid Brezhnev (as first secretary) and Alexis Kosygin (as premier) will succeed him. It is the end of an era. **NOVEMBER 3, 1964:** China detonates its first atomic bomb. **AUGUST 20-21, 1968:** Czechoslovakia, now under the liberal guidance of Alexander Dubcek, is invaded by Russian forces. **OCTOBER 25, 1971:** Communist China is admitted to the United Nations, while Nationalist China is expelled. **FEBRUARY 18, 1972:** President Nixon and Secretary of State Henry Kissinger visit Mao Zedong in his study in Zhongnanhai, China. They later continue their travels with a visit to Moscow **MAY 22, 1972:** The Anti-Ballistic Missile Treaty is signed by the U.S. and Russia. **JUNE 25-JULY 3, 1974:** Nixon and Brezhnev sign an agreement curbing the testing of nuclear weapons. A month later, Nixon resigns from office. **1975:** The Committee for Internal Security, known prior to 1969 as the House Un-American Activities Committee, is

permanently disbanded SEPTEMBER 9, 1976: Mao Zedong dies after suffering his third heart attack. JANUARY 16, 1977: The FBI captures Christopher Boyce, who along with Andrew Daulton Lee had been selling highly classified documents involving CIA encryption ciphers and satellite intelligence to the Russians. Their espionage exploits, among the most damaging of the decade, become the basis of the best-selling book *The Falcon and the Snowman* (which itself is adapted into a movie in 1985). DECEMBER 25, 1979: The USSR invades Afghanistan with a contingent of 80,000 soldiers. Over the next ten years, they would be responsible for the deaths of over a million Afghanis, largely through the planting of thirty million land mines. FEBRUARY 22, 1980: The U.S. Olympic hockey teams defeats the Soviet team, which was composed almost entirely of seasoned veterans, 4-3 in the semi-final contest in Lake Placid, New York. Their victory was hailed recently by *Sports Illustrated* as the greatest American sports feat of the twentieth century. To actually win the gold medal, the U.S. team then has to beat Finland, which they do, 4-2. 1984: Tom Clancy's first Cold War novel, *The Hunt for Red October*, is published. President Reagan soon names it his favorite bedside read. MARCH 10, 1985: Mikhail Gorbachev replaces Konstantin Cherneko (who died after just over a year in office) as general secretary, ushering in the era of glasnost and perestroika. OCTOBER 1988: Loutish Detroit Red Wings forward Bob Probert, serving an indefinite suspension, is denied entry to the United States under the "undesirable alien" provision of the old McCarran Act. NOVEMBER 9, 1989: The Berlin Wall is demolished. JANUARY 1990: Moscow's first McDonald's opens, with a Big Mac priced at 3.75 rubles. By November of 1991, inflation would take the price to a dizzying 13.95 rubles. OCTOBER 3, 1990: Germany is reunified. JUNE 12, 1991: Boris Yeltsin is elected president of the Russian Republic. DECEMBER 22, 1991: The USSR is dissolved. Three days later, Gorbachev resigns. MAY 23, 2000: The Air Force implodes its Minuteman ICBM base—home to silo D-32 —in Langdon, North Dakota, as part of its ongoing Strategic Arms Reduction Treaty (START) with Russia. The base, which commenced operations on December 7, 1966, housed one of 450 missile silos scattered throughout Missouri, South Dakota, and North Dakota. The majority of those silos now have been imploded, examined by the Russians, covered with concrete, topped by gravel, and sold back to local farmers. One such imploded silo and command bunker, located in southwest South Dakota, recently was designated the Minuteman Missile National Historic Site and made part of the National Park system.

KREMLIN KOMICS

"IS THIS TOMORROW" AND OTHER FEVERISH FANTASIES

he first of the postwar "Imagine if . . ." dramatizations of the Russians conquering and enslaving America, Is This Tomorrow was published in 1947 by the Catechetical Guild Educational Society of St. Paul, Minnesota. At ten cents a copy, this fifty-two-page, full-color comic book was a smashing success. It enjoyed several reprintings, and was used as a giveaway, distributed primarily to church groups. Ultimately, some four million copies were printed, which would suggest a readership in the neighborhood of ten or twelve million, factoring in the normal pass-along life of a comic book. Pleased by the success of Is This Tomorrow the Guild went to work on its next exercise in Red-hot hysteria, Blood Is the Harvest, which was produced in 1950. But, for some reason, it was withheld from wide distribution.

Many other explicit Commie-takeover fever-dreams would emerge in the mass media in the years to come, including Life magazine's 1948 scenario "The Reds Have a Standard Plan for Taking Over a New Country," MGM's 1948 cartoon "Make Mine Freedom," Columbia's 1952 film Invasion U.S.A., and the Warner Bros. 1962 television special Red Nightmare ("Presented by the Department of Defense"). But none of them could top Is This Tomorrow for depicting pure, holy terror.

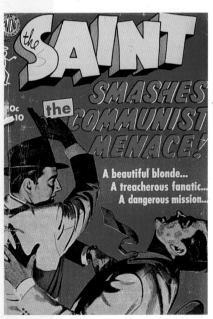

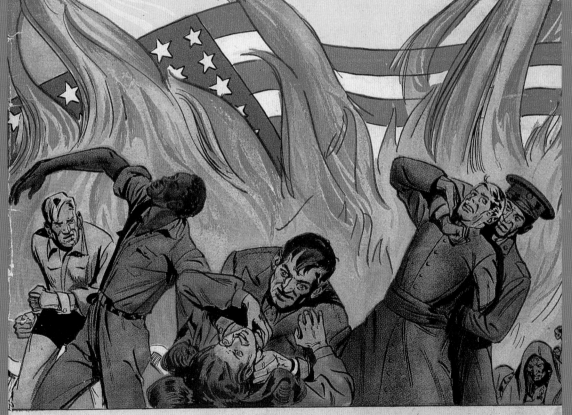

From the back cover of *IS THIS TOMORROW*—**"THINK!"**

IS THIS TOMORROW is published for one purpose—TO MAKE YOU THINK!

To make you more alert to the menace of Communism.

Today there are approximately 85,000 official members of the Communist Party in the United States. There are hundreds of additional members whose names are not carried on the Party rolls because acting as disciplined fifth columnists of the Kremlin, they have wormed their way into key positions in government offices, trade unions, and other political positions of public trust.

Communists themselves claim that for every official Party member, there are ten others ready, willing and able to do the Party's bidding.

These people are working day and night—laying the groundwork to overthrow YOUR GOVERNMENT!

The average American is prone to say, "It Can't Happen Here." Millions of people in other countries used to say the same thing.

Today, they are dead—or living in Communist slavery. IT MUST NOT HAPPEN HERE!

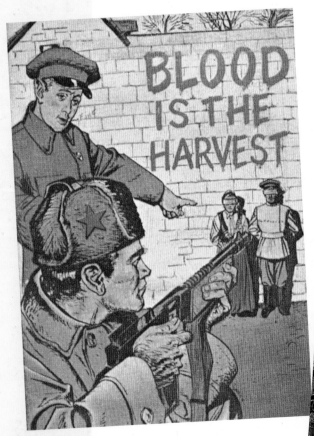

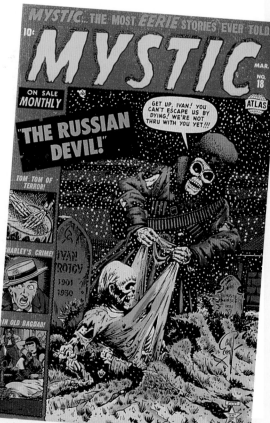